everyday
chic

DEY ST.

AN IMPRINT OF
WILLIAM MORROW *PUBLISHERS*

MOLLY SIMS

with TRACY O'CONNOR

everyday chic

MY SECRETS for ENTERTAINING,
ORGANIZING, and DECORATING AT *home*

DEY ST. | **HarperCollins** PUBLISHERS · Since 1817 ·

EVERYDAY CHIC. Copyright © 2017 by Molly Sims. All rights
reserved. Printed in the United States of America. No part
of this book may be used or reproduced in any manner what-
soever without written permission except in the case of brief
quotations embodied in critical articles and reviews. For infor-
mation, address HarperCollins Publishers, 195 Broadway, New
York, NY 10007.

HarperCollins books may be purchased for educational, busi-
ness, or sales promotional use. For information, please email the
Special Markets Department at SPsales@harpercollins.com.

FIRST EDITION

Library of Congress Cataloging-in-Publication Data has been
applied for.

ISBN 978-0-06-243963-5

17 18 19 20 21 QDG 10 9 8 7 6 5 4 3 2 1

TO THE SUPERSINGLES,
SUPERMOMMAS, AND SUPERMOMMAS-TO-BE . . .
Trust the journey and embrace the happy mess.

TO MY FAMILY, TO SCOTT,
AND TO MY TRIBE OF FIVE . . .
You are my magic and my everything.

AND TO MY GIRL TRIBE . . .
You are my village. You keep me sane,
you keep me smiling, and you keep sh*t real.

CONTENTS

introduction

How I went from a single girl who stored cashmere sweaters in her oven to an entertaining expert, organization guru, home chef (sort of), and blessed mother of three! I've been lucky enough to learn from the experts—a group of incredibly talented chefs, interior designers, party planners, and home stylists—all of whom have taught me so much. I've mined their best advice, and I'm going to share it with you in this book! *My team is your team.*

Feeding my family of five is no small task. I fully acknowledge that putting healthy meals on the table, day in and day out, is a lot of work! But after lots of trial, error, and study, I've got an arsenal of time- and sanity-saving tips, tricks, recipes, and techniques up my oven mitt.

At this point, I've planned more dinner parties, birthday parties, and baby and bridal showers than I can count. An elegant printed menu or a beautifully set table makes my heart melt. Entertaining takes effort—but I'll give you the tools to make it look effortless and to entertain like a pro.

Your home is the heartbeat of your family. Kick clutter—mental and physical—to the curb and have a family plan for keeping things organized and Zen. As a wife, parent, mother, and friend, I'm always a work in progress, but as I earn my stripes, I'd like to share some of the wisdom that comes with it *with you.*

I'd rather buy a *dresser* than a dress. I tear up at the sight of a sconce. I am obsessed with interior design. So let's get down to the brass tacks and discuss the essentials for putting together a functional and stylish home that you and your family will love.

Let's support one another and recognize once and for all—*there is no such thing as perfection.* Perfection is a unicorn! Work hard, do your best, and shoot for the stars. But most important, focus on what matters most: have some fun, live with heart, and build meaningful, honest relationships with yourself and others.

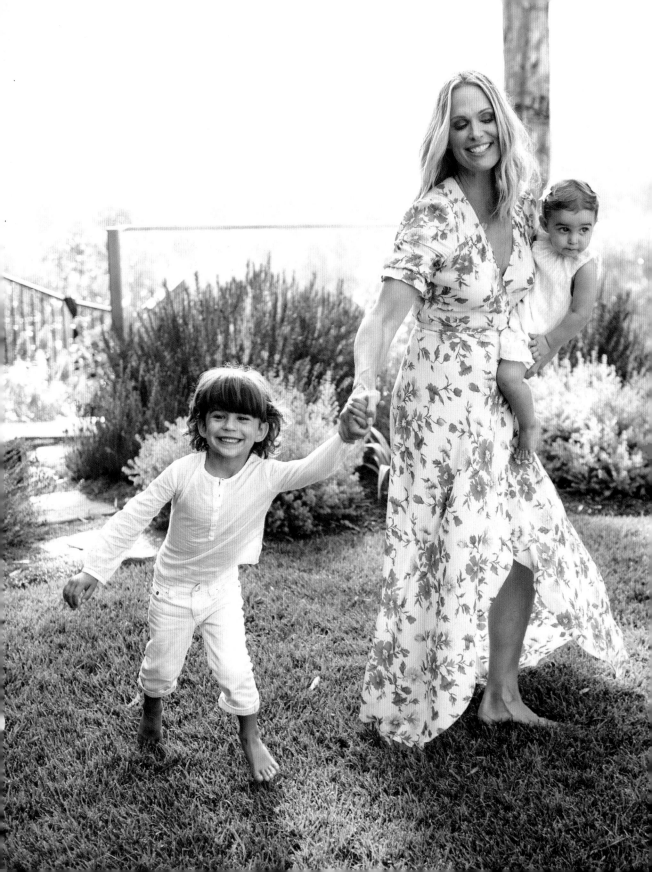

introduction

SINGLE GIRL TURNED SUPERMOMMA

Hello, everyday supermodels and supermommas! Do you remember your single days? I know I do, and how things have changed! It's actually pretty incredible how fast life moves. Let me bring you up to speed on mine. (Are you sitting down? You might want to be.) Over the past five years, I've gone from being a singleton with more free hours in the day than Carrie Bradshaw has high heels, to a mother of three who takes thirty-seven-second showers. Whether you have kids or not (but *especially* if you have kids), you will immediately relate to how drastically life changes from your twenties to your thirties and beyond.

For me, this change has been rapid fire. In five years, I got engaged, then married, then I had baby #1 (boy), baby #2 (girl), and now, baby #3 (boy), all while still caring for my three original canine babies. In that same time, I also started a blog and a YouTube channel, hosted television shows, and published a bestselling book. I've celebrated my career achievements and cheered on my husband's, and I've walked the red carpet (usually while pregnant, good times!). I've also changed more diapers than I care to count (pretty sure I need to change one right now); made kiddie Halloween costumes by hand; (sort of) planned a wedding, baby showers, birthday parties, and dinner parties; and designed, renovated, and even built a house from the ground up. Phew! Girls' Night Out has suddenly become Mom's Night In (aka *Come on over and let's drink wine and talk about the insane preschool application process*). My titles and responsibilities have grown exponentially (as did my waistline during pregnancy #1—seventy-

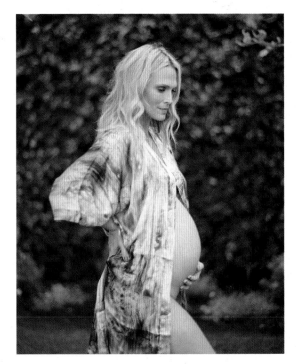

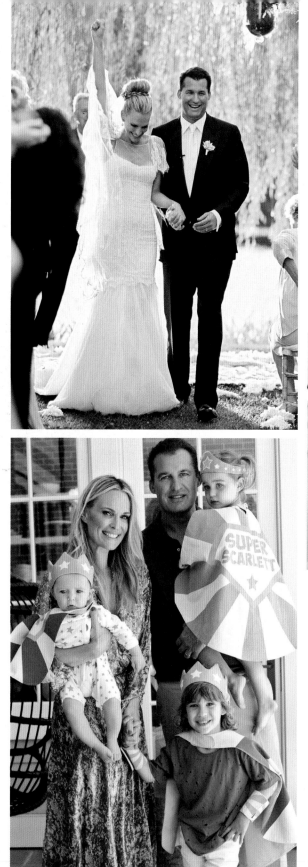

Nothing could have prepared me for the 24/7 marathon/roller-coaster ride known as motherhood.

two pounds for those of you who didn't know), and the learning curve has been steep. As in, Brian Atwood stiletto heel steep. *Now that's steep.*

I like to think that I'm always up for a challenge, but nothing could have prepared me for the 24/7 marathon/roller-coaster ride known as motherhood. My acting/hosting/modeling schedule has often been grueling, but it did nothing to prepare me for sleep deprivation, temper tantrums, and the insane, out-of-this-world, heart-bursting L-O-V-E I have for these eating, sleeping, pooping mini-people with big, beautiful eyes that stare into your soul (but usually just want a snack. Right?). Daily, it's a mental, physical, and spiritual ropes course, harder than Barry's Bootcamp and Bikram yoga combined. One minute I'm headed out the door for a meeting and the next I'm cleaning projectile vomit off my floor. *And my blouse. And shoes.* Inside, I'm ugly crying. Like really, really, really ugly crying.

All this has changed me, and you know what? I wouldn't change any of it for the world. I am happier. More capable. More loving. More forgiving. More patient. More kind. And more open. I have to tap in and dig deep often. It is truly the hardest job in the world, but the most meaningful one, and somehow I feel more *me* than I ever have. As my roles and my joys have grown, I feel more complete. I'm inspired to do more because I want to *be* more—for my baby boys and my baby girl. They are my number-one priority. I absolutely continue to chase my professional goals, I nurture close friendships, and I strive be a great partner to my husband and to be the best daughter I can be to my parents. I take pride in all that. But being a supermomma and nurturing our superfamily is my absolute favorite gig. It is deeply satisfying and rewarding, if at times traumatizing (and I mean that in the best way possible).

As my priorities have shifted, home has truly become my happy place. It is Grand Central Station, St. Peter's Basilica, Disneyland, and the Grand Canyon all rolled into one. I love my tribe with every last vessel in my trying-to-age-gracefully

body. I feel so lucky and so blessed to have them, which is why I put so much energy and enthusiasm into our home. A home is about so much more than wood, steel, paint colors, fixtures, and floors (though I love all those things too, and we'll get to them!). The way a home functions, the way it feels, what we do in it, and how we care for it—these things are truly important.

Our home is the heartbeat of our family. It's where we all gather, sleep, snuggle, eat, dream, play, and hope together. Our home is our shelter—it's where we create memories, and it's where our memories make us who we are. With each of my pregnancies, I've found myself "power nesting" (it's not a pretty sight), preparing our home like a maniac to be a place where my children can enter the world and feel safe and loved and free and where Scott and I can feel all those same things too. We might not be able to control what's beyond the four walls of our home, but inside we can try. Inside we can create our sacred space. Scott and I want to instill a sense of security and confidence, and the belief that anything is possible, in our children. And I believe that all starts in the home and with the experiences we share together in it.

My first book, *The Everyday Supermodel*, was about honoring and taking care of yourself, inside and out, and being the best version of "you" that you can be. This book brings that idea home, literally. It's about cultivating an environment, family life, and lifestyle that you love and doing it all in supermodel style. My life today feels so full—we are constantly welcoming friends into our home, hosting events, dinners, and playdates. I won't pretend that it's all effortless, but I like to think that I've learned to make it look that way, thanks to the collective wisdom from my team of experts whom you will meet in this book.

I've worked with some of the most talented chefs, interior designers, party planners, and organization experts in the business, and they have become my teachers. Inside these pages, I'm going to share their secrets and advice so that we can all live more beautiful and harmonious lives. As Henry Miller said, "Cluster together like stars!" Because that is how we all shine more brightly. I went from having an always-empty fridge to being someone who is *almost* confident in the kitchen (I make a mean Moroccan chicken; see Molly's Moroccan Chicken with Green Olives and Lemon on page 29) and who can plan a very cool-girl soiree

while *still* driving carpool. I'm not lying. And you can do it too. The same goes for home design—don't be intimidated. Home decor is my secret passion, and after decorating and designing at least six or seven houses and apartments over the years, I've learned a thing or two! And I'm going to share all I know with you.

There is one wish I know that every busy woman on the planet shares. The wish for *more time*. If I knew how to bottle up (or better yet, freeze) time so that there were more than twenty-four hours in a day, *you know I would, supermommas.* But since I have yet to figure that one out, at the very least I hope the collective advice in this book gives you just a little bit more of this precious commodity. If I can save you from stressing over what to cook for dinner, and help you to organize a pantry and style a room, set up a chic DIY bar, or a stunning holiday tablescape, then my job here is done. If you know what is truly important in life but are a sucker for the details, then this is your book. Plus, you never know when your superchic neighbor (Rachel Zoe's style doppelganger) might drop by after work for a nibble—and you'll want your charcuterie platter to be on point! Ultimately, I hope this book inspires you to live life to the fullest, and to respect and love yourself, your home, your family, and everything in it.

what is *everyday* chic?

Living *everyday chic* means living your life with style, grace, passion, and purpose. It means having respect for yourself, your things, and your tribe. It means making the most of what you have, being the most of who you are, and creating a life, a home, and a world you cherish, honor, love . . . and love to share with others. Everyday chic is not about perfection, but rather is about living with intention, connection, style, and that extra bit of love in every way that you can!

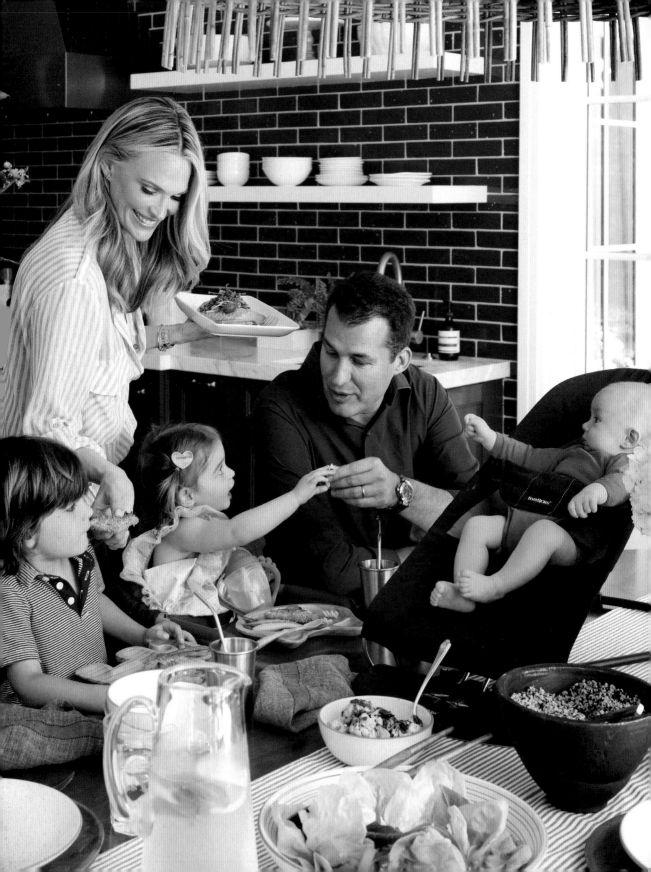

ch/1

feeding a family

efore I had a family, I didn't know how to cook, and to be honest, I wasn't that interested in learning. Can you blame me? As a model, I was expected to be a clothes hanger, and I'm naturally built more like a clothes *horse*. You can understand why I avoided food and stayed out of the kitchen! Food was my sworn *frenemy*. My oven was used for storing cashmere sweaters rather than baking quiches and casseroles. Talk about a fire hazard. In those days, I was busy traveling all the time for jobs and working really hard. I wasn't exactly drawn to cooking, and I sure didn't make time for it.

At age thirty, I still could barely turn on the oven without setting off the fire alarm. That might sound pathetic to some of you. To others, I'm sure it's totally relatable (I know that you are not *all* natural-born Betty Crockers out there, right?!). The kitchen was a place where I'd admire the grain in a marble countertop (and still do) while sipping a glass of sauvignon blanc or rosé. Cooking was something other peo-

ple did, as in professionals, in cafes and restaurants. But I am happy to report that things have changed. (Boy, have they!) It has just taken me some time to get there.

After Scott and I got married, I suddenly had the time and motivation to learn to cook! It wasn't just me—now it was "we." I had recently ended a long run on a television series, was working from home, and had bit of newly found freedom. Scott, on the other hand, had an insanely long commute on L.A. freeways, and he'd arrive home hungry and exhausted. So I started looking up elaborate recipes, hoping to whip up something new and exciting for the two of us every single night. Rookie move. I was constantly running to the store for this or that special ingredient and finding myself completely overwhelmed when it came to actually putting these meals together. It took *so* much time. Eventually, I burned out and resorted to ordering dinner in for us . . . *a lot.*

That lasted for a while, and then when I got pregnant with my first baby, the real wake-up call hit me—like a hundred-pound sack of Idaho potatoes. I was going to be a momma! And that *Lion King* song went off in my head. You know the one. I was overcome with excitement. We were going to have a family. That meant I could no longer cook haphazardly or rely on ordering takeout for us every other night. And I definitely couldn't slip back into the unhealthy eating patterns from my modeling days (eating turkey slices and celery sticks or skipping meals altogether and calling it a day)! Now "we" were about to be "three." It wasn't just about me anymore.

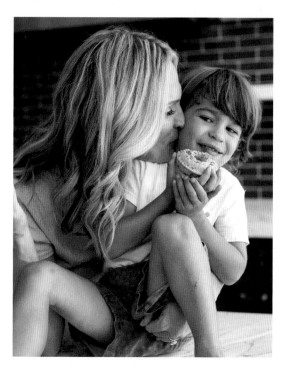

The meals I chose to eat would be nourishing our baby-to-be. I had a responsibility to eat consistently and healthily for the hot cross baby bun in my personal oven (aka uterus). The moment I peed on that HCG-detector stick and learned I was going to be a mother, it all changed. What I hadn't been able to do for myself, I was finally able to do for my future little boy. I committed to learning to cook, and to eat, for real. As in whole, healthy foods. I wanted to be a good example for my future children,

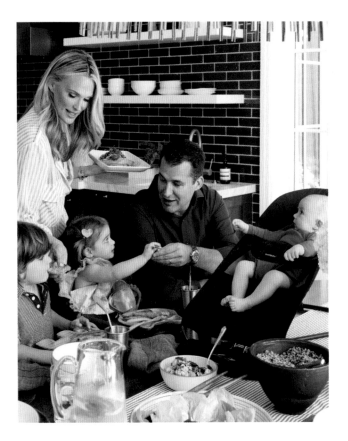

and I wanted to start them off right, even in the womb. So I took a couple of cooking classes and learned some easy, go-to meals that I could actually make. Those classes really helped me gain confidence in the kitchen with the basics. I learned how to roast chicken and vegetables. I could make a mean tomato sauce and spiralize squash into noodles for dinner on Meatless Mondays. But more often than not, I still found myself running out of steam when it came to meal ideas. Can you relate, supermommas?

Once we had our first baby, there was zero room for time wasting. I couldn't go to the market five days a week to pick up random ingredients for dinner. And once I had baby #2, I had even less time. Free time was like an endangered species in my life. *I had no choice but to finally get organized and be more efficient about shopping for the family, cooking meals, and eating healthy.* How? I took group cooking classes with friends, learned some vital tricks of the trade, and established an arsenal of no-fail standby recipes I could count on. On weekends, I began planning snacks and meals ahead, and I learned to buy in bulk so that I could shop less frequently.

If you are wondering about Scott's role in all this, he helps out so much with the kids and is a total hands-on dad, but cooking is just not his thing. And that is 100 percent okay by me. What's great about my husband is that he will honestly eat anything I make and he never complains. Bless his heart! He appreciates the effort that I go to, whatever the outcome, even when the meal is an epic failure. In fact, the first time I cooked for him, I'm pretty sure he was sick *the entire next day.* Not my finest moment. Plus, on nights when we do order in for the family, Scott can place an order like nobody's business. There is no one more patient or loving with our children, so it's a win–win.

Feeding a family of any size is a lot of work, but when you are a parent, it's important work. My children and my husband are my treasures; it is my responsibility

my *gurus* of good food

DANA SLATKIN Dana is a chef who trained formally in France and started the beautiful Beverly Hills Farmers Market. I have taken more cooking classes from her than I can count, and she has taught me tons of tips and tricks for turning meals up a notch! (DanaSlatkin.com, @dana.slatkin)

CATHERINE MCCORD Author of the *Weelicious* blog and Weelicious cookbook series dedicated to feeding busy families, Catherine is a supermomma of three and the queen of kids' cuisine. She has given me many essential strategies for dealing with picky eaters and a few great recipes included in this chapter. (Weelicious.com, @weelicious)

CHEF MICHAEL DRABKIN He is our family chef extraordinaire, who has helped me develop specific recipes and realistic weekly food-prep strategies for my family.

PAMELA SALZMAN This woman is magic in the kitchen. She is a certified holistic health counselor and knows how to make healthy food delicious. I have taken classes from her and watch her videos, and she has a go-to cookbook, *Kitchen Matters*, I use weekly. (PamelaSalzman.com, @pamelasalzman)

to care for them, and feeding them well is part of that. But I'm hardly a homesteader. You don't have to grow all your own vegetables or bake your own bread to feed your family well. I want the very best for my brood, but I am not going to make everything from scratch. That's just not realistic, so I have had to come up with practical, healthy solutions that work for us. I also try to keep in mind that food is about so much more than what we eat. It is about love, reward, and ritual. Food is essential not just to our bodies but also to our souls. Cooking and eating together connect us as a family, and it's major bonding time.

While it has taken some time, most days I've got this feeding-the-family thing down. I am not claiming to be some sort of Martha Stewart–Giada De Laurentiis–Ina Garten hybrid. However, after three kids, I have learned a thing or two through trial and error and from a team of experts whom I call my "Gurus of Good Food." I hope that the strategies I share in this chapter will help you undertake the hourly, daily, weekly, monthly, yearly, forever task of feeding your family with a bit more confidence and joy.

This is our family's Bill of Rights when it comes to the food we put in our bodies. We do all that we can to follow these rules when we shop, cook, eat, drink, and connect over food.

1. **EAT WHOLE FOODS.** This seems like a no-brainer, but in a pinch, and when we are busy, it's often harder than it seems. I try my very best to choose real foods over packaged and processed foods for my family. I define a whole food as something that comes from the earth rather than from a factory or a lab. In my first book, *The Everyday Supermodel*, I talked about the fact that I spent many of my younger years eating foods low in fat (and high in artificial sweeteners, salt, or unpronounceable chemicals!), thinking I was being healthy. We know so much more today. Healthy eating is about eating foods *in their more natural state*—with fewer preservatives and added artificial ingredients. That means having a little bit of real butter on whole grain bread or eating an entire egg.

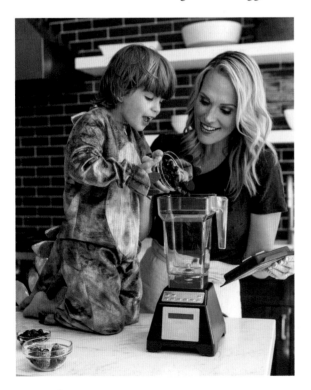

2. **EAT FOOD THAT IS PLANT BASED.** Plant-based, whole foods are much higher in fiber and nutrients than most packaged foods and meat products. Plant-based foods tend to be more nutrient dense, so you get more nutritional bang for your calorie buck. Fruits, veggies, nuts, legumes, and grains are the primary staples of a plant-based diet. Animal proteins, like pork, poultry, fish, and occasionally red meats, are important too, but in moderation. In our family, we believe they are secondary.

3. **EAT TOGETHER.** Each day, Scott and I try our hardest to eat at least one meal with the kids. Many studies show that eating family meals together builds stronger bonds and . . . even bones! Eating dinner together as a family has been linked both to a higher intake of protein, calcium, fruits, and veggies by children and to numerous psychological and social benefits. When we sit down together, we talk. We pay attention to one another. We ask one another about our days. I always ask each of the kids at dinner, "What was your rose and what was your thorn today?" In other words, what was the best part of your day and what was your least favorite? It's a way to get kids to think and share.

4. **PRACTICE GOOD TABLE MANNERS.** My kids are southern by blood, and they will behave at the breakfast, lunch, and supper table! We say grace before the meal, and they know to say "please" and "thank you." We eat with napkins in our laps, we ask to have the salt and pepper passed, and we always ask to be excused. My kids know better than to eat only one bite of broccoli and then ask for seconds of cheesy pasta! Modern-day manners also means no electronic devices for any of us at the table, Scott and myself included. No watching cartoons on the iPad . . . no checking emails . . . no Instagraming dessert when we are in front of them. I was talking to Cindy Crawford about this, and she said the same thing. Her kids are teenagers and are at that age when phones are all important—their connection to friends and everything cool that is happening on the planet. But not at dinnertime. According to Cindy, when they eat, "Phones go in a different room. And no—they're not even in eyesight. Because when you are spending quality time with one another, even your phone just sitting there on the table is a mental distraction." We all know there are exceptions to this rule. But always try your best.

5. **KEEP TO A SCHEDULE.** We eat three meals a day, and my kids know they are allowed a piece of fruit or a small, healthy snack in between meals. This is important. And they have to ask. Just yesterday Brooks asked me if he could take a snack with him in the car, because he said, "I ate all my healthy breakfast, Mommy." I said yes. If we didn't stick to a schedule, my kids would snack themselves sick and they would not

want a healthy lunch, dinner, or complete meal *ever*. I am pretty lucky because all my children are hungry, hungry hippos. They are great eaters, but that doesn't mean that they won't try to game the system! And that goes for me too. I used to pick and pick and pick and never really eat. Old habits die hard. As a mom, if you aren't eating regularly and are instead running around and snacking on your kids' cheddar bunnies or gluten-free granola, you aren't setting a good example. And that's no kind of fuel for a supermomma. And trust me. No one wants to gain the "Toddler 10."

6. **CONNECT WITH YOUR FOOD.** Food and water are our primary life sources! And we have got to treat them with respect; we can't just ignore what we are eating, scarf it down, and move on to whatever is next. One way to connect with our food is by cooking for ourselves and our families. Another way is to grow a bit of food ourselves, perhaps some favorite herbs on the kitchen windowsill, tomatoes in the backyard, or something leafy and green in a community garden. Getting in touch with where your food comes from, how it is made, how and where it is grown, is a great way to truly connect with your food. Which brings me to our next rule . . .

7. **KNOW THE SOURCE.** The more informed you are, the better choices you can make for yourself and your family. I make an effort to buy wild-caught fish over farm raised when it's most appropriate, and I only buy free-range eggs because they come from chickens that are raised ethically, and that is in line with our beliefs. We shop mostly organic, because mounting research shows it's healthier for our bodies and a lot healthier for our environment. Visit your local farmers' market and chat with the vendors. You can learn a lot if you ask.

everyday *superkiddo* secret

How can we get our kids to care about and "connect" with food? One really fun and educational way is to take your kids to visit a local farm or orchard so that they can learn firsthand where their food actually comes from (not just the kitchen cupboard or the supermarket!). Every summer when we vacation in the Hamptons, I take the kids to a local berry farm called Seven Ponds Orchard where they get to pick their own berries and sink their baby toddler teeth into sweet, juicy, berry goodness!

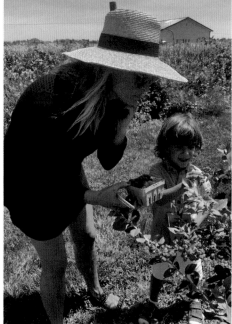

What carrots are the best for roasting versus eating raw? When are apples the freshest? When you know your sources, you will not only be making more ethical food choices, you'll also be a better cook for it! And, if all else fails, at the end of the day . . . just do your best.

8. **BE THANKFUL.** Every day should be Thanksgiving when it comes to our food. Make an effort to appreciate every bite like a Buddha. Thank the farmer, thank the growers, thank the pickers, and thank whoever cooked up that delicious meal for you! When you cook, remember to enjoy the process. Appreciate the presence it takes to chop vegetables. There is meditation and madness in cooking, and it's as much about the process as it is about the final bite. In America, many of us are blessed with abundance on our plates. So let's teach our children and remind ourselves of our truly incredible food fortunes. When the kids don't want to eat something that is good for them, I don't force it, but I don't give in, either. I remind them to be thankful for the good food that we have, and I try to teach them that the green in the spinach means strong bones for sports, strong teeth for smiles, and strong lungs for running all over the place.

9. **NAIL A FEW SIGNATURE DISHES.** This is a no-brainer food rule. You do not have to be Julia Child mastering the art of French cooking to make satisfying meals. Instead, have a few great dishes that are in *your arsenal*, that you know will absolutely hit it out of the park. This is one of my rules because it personally takes the pressure off, gives me confidence, and saves me headaches. Find a few recipes you love, practice them, refine them, and make them all your own. They will become your claim to fame, and you can rely on them in a pinch. Unexpected guests? Family in town? No matter how strong or weak your cooking game, *you can do this.*

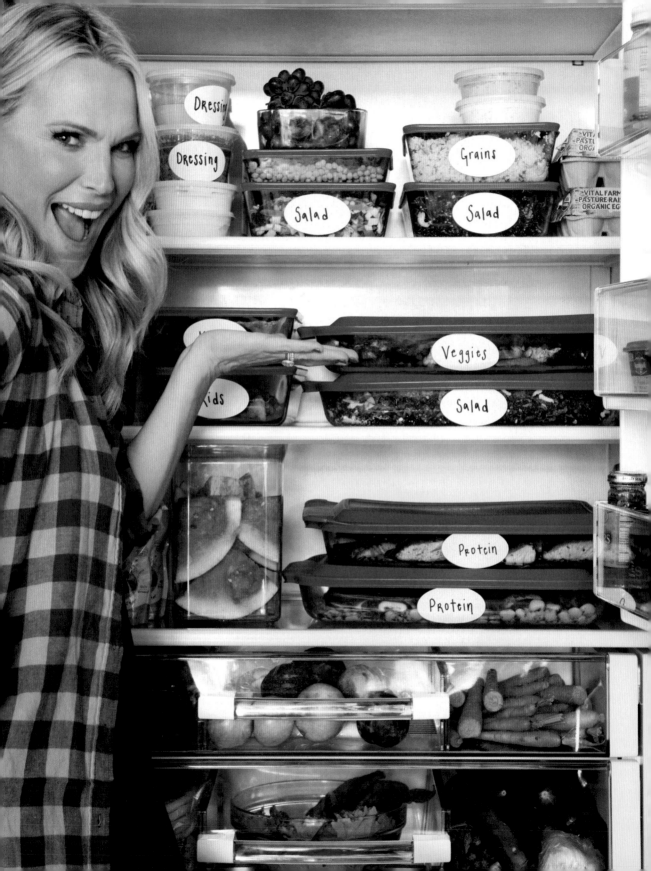

Another key to healthy eating? Planning and preparation. (These are the keys to most things in life, don't you think?) Ultimately, we will eat what is in front of us—the good, the bad, and the Krispy Kremes. If you are zipping around all day and you haven't planned out healthy meals in advance, chances are you will find yourself at the drive-thru with your kids or eating something packaged or processed. Lots of salt, sugar, additives, and other not-so-nice stuff is hidden in fast food and packaged convenience foods. I am not judging, because once upon a time I was that girl with only the following in her kitchen: *Wine. Yogurt. Turkey wraps. Fat-free hot chocolate. Crackers.*

After a lot of trial and error, and training with Chef Michael, I've come up with a shopping and food-prep strategy that works brilliantly, *most of the time.* It's harder to maintain when we are superbusy and I am traveling a lot, but for the most part these strategies are a saving grace for our superfamily. While meal planning might take more time when you first get started, it saves time overall—and before long you'll have it down to a science. No more decision making before each and every meal. No more multiple trips a week to the grocery store. By planning, shopping smartly, cooking in bulk and in advance, you will save so much time and effort down the line. Not to mention, you'll be saving money for treating yourself to other things . . . a blow-out, a mani-pedi, that pair of strappy summer sandals you've had your eye on—you name it!

my *weekly* meal prep strategy
2/2/2 + 1 = THE WEEK IS DONE!

For easy, everyday lunches and dinners, I don't waste time planning a whole bunch of different menus. Instead, before the start of each week, I follow what I call my 2/2/2 + 1 strategy. This allows me to cook all my dishes for the week ahead of time, and I store my entrees, sides, and salads in large glass storage containers, tightly sealed with a few slices of lemon inside to keep the food fresh. This strategy is the brainchild of our home chef, Michael, and it's a godsend. It's economical, it means I only have to cook on average two nights a week, and I never find myself staring blankly into the freezer, fridge, and pantry!

The 2/2/2 + 1 Strategy

2 Protein Dishes

2 Salads

2 Veggie/Grain Sides

+

1 "Top It Off" Dish (a one-pot meal, casserole, stew, or very simple dish)

HOW DOES IT WORK?

On Saturday or Sunday

* I choose 2 Protein Dishes, 2 Salads, and 2 Veggie/Grain Sides from my recipe arsenal (see recipes below).
* I shop for groceries, and then I cook all my dishes, which I will mix and match throughout the week. (I tend to cook and shop on Saturday, since I like to chill out on Sunday, but it can change week to week based on our schedule.)

On Wednesday or Thursday

* I prepare my + 1 "Top It Off" dish. My slow cooker is my best friend on "Top It Off" days, and I'll often choose to make a simple one-pot meal, stew, or casserole—anything that doesn't require a ton of prep or cleanup.
* I try to use ingredients that I already have in the fridge or freezer from my Saturday/Sunday shop so that I don't have to head back to the grocery store.

On the following Friday and Saturday

* This strategy usually gets us through the week because we like to order in on Friday and often eat out on Saturday with friends or as a family.

In our house, as much as is humanly possible, Brooks, Scarlett, and Grey eat what Scott and I eat. No special meals for picky kiddos! So I have to keep this in mind when selecting recipes and choosing sides. A healthy version of mac and cheese does make an appearance most weeks as a side, because I know the kids love it! Day to day, I want no-brainer recipes that are nutritious, quick to whip up (no more than 30 minutes) and clean up (duh!), and that we can enjoy together. When we have guests, I'll bust out a more complicated recipe, but in our house, everyday family meals must be:

- ✳ Easy to cook and assemble and not require too many ingredients.
- ✳ Healthy and nutritious. Gotta build healthy bodies and brains.
- ✳ Yummy to the tummy. Goes without saying.
- ✳ Easy to clean up. Not getting a million dishes dirty is an important time saver!
- ✳ Simple and not require a bunch of high-tech kitchenware or appliances.
- ✳ Great as leftovers. Um, yeah momma. Saves sanity and time.
- ✳ Kid-friendly (as mentioned, the kids generally eat what we eat).
- ✳ Able to be prepped in advance and mixed and matched.

It's sometimes difficult to balance between what the kids want to eat and what Nick and I want to eat. Like most families, we rotate the same meals every week. It's fun to switch it up every now and then but not with a picky eater. There's nothing worse than spending hours in the kitchen, only to have a kid say, I want something else. *So I try to experiment on days when Nick and I are having dinner after the kids are down for the night.*

—VANESSA LACHEY

2/2/2 + 1 MENU IDEAS

PROTEIN DISHES

We usually go with a fish and a poultry dish, or sometimes I'll switch in a plant-based protein (tofu, beans, quinoa). We aren't big meat eaters, so once or twice a month we'll do a dish with red meat. Here are some of our favorite protein dishes, which might serve to inspire your weekly menu.

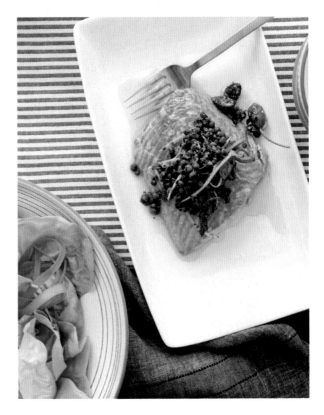

* Oven Poached Salmon with Lemon and Dill
* Salt and Pepper Cod
* Spicy Turkey Meatballs or Patties
* Grilled Herbed Salmon with Lemon and Basil Relish
* Baked Chicken with Fava Beans, Roasted Garlic, and Fresh Parsley
* Vegetarian Chili
* Pounded Chicken Breasts with Mushroom Sauce
* Lentil, Wild Rice, and Vegetable Soup
* Triple Green Soup (made with our veggies from the garden)

If any of these meal ideas sound delish to you, look for versions of them on recipe sites, such as Epicurious.com, TheDailyMeal.com, Saveur.com, Cooking Light.com, TheKitchn.com, AllRecipes.com, Food52.com, and Delish.com. Also, check out MollySims.com for a list of my favorite chefs, cookbooks, and cooking websites.

SALADS

Our favorite weekly salads tend to be a Caesar-style salad made with kale or a traditional and simple Greek salad. Of course my and Scott's all-time fave is inspired by the chopped turkey salad from La Scala in Beverly Hills. It's just perfect. When it comes to salads, I always consider what is seasonal and therefore most scrumptious. Here are some salad suggestions to get your mouth watering:

- ✳ Salad with Market Greens and Herbs in a Creamy Avocado Vinaigrette
- ✳ Spinach Salad with Melon and Poppy Seed Vinaigrette
- ✳ California Slaw with Savoy Cabbage, Fennel, Citrus, Radishes, Toasted Pistachios, and Goat Cheese

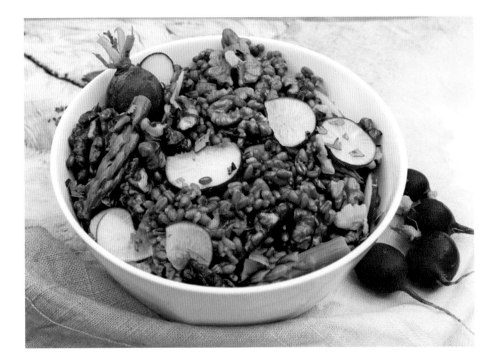

- ✳ Chopped Kale Salad with Dried Cherries, Almonds, and Smoked Mozzarella
- ✳ Shaved Jicama and Carrot Salad with Date Vinaigrette
- ✳ Garden Chopped Salad (with anything and everything!)
- ✳ Farro Salad with Sugar Snap Peas, Mint, and Parmesan
- ✳ Wheat Berry Salad with Walnuts, Asparagus, and Radishes
- ✳ Quinoa Salad with Sweet Potato, Lime, and Chiles
- ✳ Chopped Turkey Salad with Italian Vinaigrette

VEGGIE/GRAIN SIDES

I always do one vegetable and one grain side (incorporating a healthy grain like quinoa, brown rice, or a whole wheat mac and cheese). Here are our go-tos:

- ✳ Sautéed Spinach with Salt and Pepper
- ✳ Steamed Broccoli with Garlic and Lemon
- ✳ Sautéed Green Beans with Chile Flakes and Garlic (Can you tell I love garlic?)
- ✳ Baked Spaghetti Squash

- ✳ Slow Roasted Caramelized Cauliflower
- ✳ Pan Roasted Zucchini Slices
- ✳ Roasted Yukon Gold Potato Wedges with Rosemary
- ✳ Mashed Sweet Potatoes with Fresh Herbs
- ✳ Brown or Tomato Rice with Sesame Seeds
- ✳ Seasonal Vegetable Pasta
- ✳ Healthy Whole Wheat Mac and Cheese
- ✳ Roasted Root Vegetable Medley (my all-time *fave!*)

+ 1 "TOP IT OFF" DISHES

The only rule here is that these have got to be easy! My favorites:

- ✳ Whole Wheat Vegetarian Lasagna
- ✳ Turkey Chili
- ✳ Pad Thai Noodles with Tofu or Shrimp
- ✳ Five-Bean Soup
- ✳ Molly's Moroccan Chicken with Green Olives and Lemon (page 29)

one-pot *love*

I love, love, love one-pot meals. They save time and the aggravation of doing a lot of dishes, and best of all, most one-pot meals taste even better a day or two later once the flavors have blended. Molly's Moroccan Chicken with Green Olives and Lemon (page 29) is my one-pot claim to fame in the kitchen. It's the one recipe I can consistently nail, it's not fussy, and when presented in beautiful enamel cookware, it wows even the most discerning dinner guest! Despite that fact, I make it for my family on a regular basis because it's so straightforward. Try it—I promise it won't disappoint!

molly's moroccan chicken
with green olives and lemon

I serve this rich, flavorful chicken dish over whole wheat couscous that's been cooked with a touch of good olive oil and tossed with sliced green onions and fresh parsley. If you prefer using boneless chicken, substitute 2 pounds of boneless, skinless thighs for the bone-in thighs and skip the browning step.

yield: *4 to 6 servings*

INGREDIENTS

2 tablespoons olive oil

6 bone-in, skin-on chicken thighs
 (about 2¾ pounds)

1 very large onion, chopped

4 garlic cloves, minced

1 tablespoon paprika

1 tablespoon ground cumin

1 tablespoon ground coriander

1 teaspoon turmeric

2½ cups chicken broth

12 ounces carrots, peeled and cut
 into thick slices (about 3 cups)

½ cup brine-cured green olives

¼ cup chopped fresh Italian parsley,
 plus more for garnish

2 teaspoons grated lemon zest

2 tablespoons fresh lemon juice

1 lemon, thinly sliced

Salt and pepper

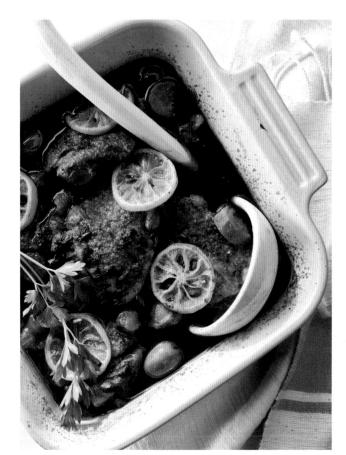

DIRECTIONS

Heat the oil in a large cast-iron skillet over medium-high heat. Add the chicken and cook until browned on both sides, turning once, about 6 minutes. Transfer the chicken to a large bowl. Pour off all but 2 to 3 tablespoons of fat from the skillet. Add the onion and sauté until golden, about 8 minutes. Stir in the garlic, paprika, cumin, coriander, and turmeric and cook for 1 minute. Mix in the broth, carrots, olives, parsley, lemon zest, and lemon juice. Return the chicken to the skillet and bring to a boil. Reduce heat to medium-low, top the chicken with lemon slices, cover, and simmer until the chicken and carrots are just tender and cooked through, about 12 minutes. Uncover and continue to simmer gently until the carrots are very tender and the cooking liquid reduces slightly, about 15 minutes. Season to taste with salt and pepper. Garnish with parsley and serve.

everyday *supermomma* secret

The bouquet garni or herb sachet. I learned about this while I was in France and thought it was so chic and complicated. But turns out it's actually ridiculously easy—and a very French way to cook! A bouquet garni or herb sachet is a little bundle of aromatic herbs used to flavor slow-cooked meals, like soups, stews, and virtually any stock. To make one, tie a bunch of herbs about the size of your palm together with kitchen twine or wrap with cheesecloth—and that's pretty much it. It's an incredible way to infuse your food with sophistication and flavor. I love to add an aromatic bouquet garni when I'm cooking at home and want to elevate a dish.

CLASSIC MIXED DRIED SACHET: Use thyme, parsley, bay leaves, and black peppercorns, and tie up with kitchen twine in a square of cheesecloth.

FRESH HERB SACHET: Use rosemary, tarragon, and thyme, and simply tie together with kitchen twine.

MIX & MATCH & *strrrrretch*!

My 2/2/2 dishes are meant to be versatile and easy, and there are lots of quick delicious ways to stretch and convert them into even more than meets the eye. Here are some tips for getting the most out of your pre-prepared meals:

* Have corn tortillas or whole wheat wraps on hand to turn protein dishes into tacos, burritos, or wraps in a pinch.
* Throw a protein, a salad, and a side all together into a giant bowl for a whole new meal: aka the Kitchen Sink Salad.
* Mix and match different proteins with different sides on different days. That way, even though the foundation of your meals might be the same, you still get day-to-day diversity.

My Gurus of Good Food have taught me to buy seasonal, local, and organic foods whenever possible. Why should you opt for seasonal and locally grown fruits and veggies? First of all, vine-ripened fruits and veggies—as opposed to those that are picked before they're ripe and then shipped thousands of miles—generally have higher nutrient value, and they taste better! Second, locally grown foods haven't spent weeks getting to you on polluting trucks, planes, and cargo boats. Carbon footprint, anyone? Buying organic is equally important too; these are foods that have been grown without the use of pesticides, some of which have been found to be harmful (or questionable at best) to our families and to the earth. Buying organic and with smaller farm vendors (at markets or with local organic co-ops) also means supporting independent farmers and helping preserve food diversity, which is important not only to our diets but also to our planet. But the truth is, sometimes we can't get it all and are forced to pick—because of cost, availability in your area,

and convenience—between buying locally or buying organic. Do your very best to get to know your food and food sources, and make the best decisions you can for you and your family.

Here is a general list of foods that are ripe and available by season (which may vary a bit depending on where you live):

seasonal cheat sheet

WINTER	SPRING	SUMMER	FALL
Apples, bananas, beets, Brussels sprouts, cabbage, carrots, celery, grapefruit, kale, leeks, lemons, onions, oranges, pears, pineapple, potatoes, pumpkins, sweet potatoes and yams, turnips, winter squash	Apples, apricots, asparagus, bananas, broccoli, cabbage, carrots, celery, collard greens, garlic, lettuce, mushrooms, onions, peas, pineapple, radishes, rhubarb, spinach, strawberries, Swiss chard, turnips	Apples, apricots, bananas, beets, bell peppers, blackberries, blueberries, carrots, celery, cherries, collard greens, corn, cucumbers, eggplant, garlic, green beans, kiwifruit, lima beans, mangoes, melons, nectarines, peaches, plums, raspberries, strawberries, summer squash and zucchini, tomatillos, tomatoes, watermelon	Apples, bananas, beets, bell peppers, broccoli, Brussels sprouts, cabbage, carrots, cauliflower, celery, collard greens, cranberries, garlic, ginger, grapes, green beans, kale, lettuce, mangoes, mushrooms, onions, parsnips, pears, peas, pineapple, potatoes, pumpkins, radishes, raspberries, spinach, sweet potatoes and yams, Swiss chard, turnips

everyday *supermomma* secret

Frozen veggies! Chef Dana Slatkin has taught me that when vegetables are flash frozen, they are actually incredibly healthy (because they were frozen at peak freshness), and easy to cook with. Frozen artichoke hearts are my favorite. Whether roasted or thrown on the grill, all they need is just a pinch of salt and a drizzle of olive oil. Believe it or not, frozen is sometimes better than certain so-called fresh veggies at your grocery store, which are often actually out of season and have traveled many miles to get to you.

supermomma food sourcing

While we can't stick to these rules 100 percent of the time, here are some guidelines that I try to follow when making food-purchasing choices:

* **FRUITS AND VEGGIES** As mentioned, go for local, organic, and in season.
* **EGGS** Choose organic and free-range. Free-range means the chicks have more space to graze and cluck and be chickens. Farmers' markets often have the best eggs!
* **DAIRY** Look for organic, whole, and unsweetened dairy products that don't contain rBST and rBGH (growth hormones given to cows to increase milk production). While evidence about whether these hormones are harmful to humans is inconclusive, we know that they cause ill effects in cows.
* **NUTS, SEEDS, GRAINS, AND LEGUMES** When possible, choose organic and raw versions of nuts, seeds, and grains. When buying

canned beans, select those that aren't packed with added sodium or preservatives, and buy cans with a lining that doesn't contain bisphenol A (BPA). Scientists have found that low-dose, long-term exposure to BPA can have adverse health effects.

* **FISH AND SEAFOOD** This is not as cut and dried as it appears. Wild-caught and farm-raised fish both have their positives and negatives, depending on the type of fish and its location. Visit the Monterey Bay Aquarium Seafood Watch website (SeafoodWatch.org) for more info on choosing seafood that is fished or farmed in ways that have the least impact on the environment.

* **POULTRY** Choose organic whenever possible. Studies have shown that organic chicken contains more heart-healthy omega-3 fatty acids than conventionally raised chicken and that eating organic may also lower your food-poisoning risk.

* **MEAT** Local and pasture raised is best. Look for organic meat that is free of growth hormones and antibiotics. It's also best to eat red meats in smaller than traditional portions (think a deck of cards) and less frequently (no more than once a week).

Keep in mind that these are just guidelines. Depending on where you live and your budget, you may need to compromise, and that's okay! While most organic products tend to have a slightly higher price tag, some do not. Pay attention. Often, buying organic fruits and vegetables in season is very affordable. Currently, organic poultry and meat products do ring in at a higher price, but when we eat less of them, the cost can balance out. The goal is to do our best with what we have. This doesn't mean clearing out your bank account, but it does mean shopping and eating as responsibly as we can. Do your research and find the brands, stores, and selection that are best for your family and budget.

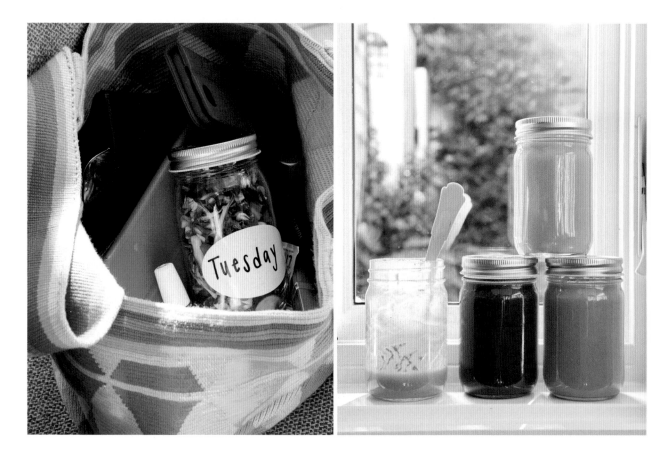

SALADS + SOUPS: GRAB AND GO!

I love salads and soups. Prepared in advance and packed in mason jars, they are delicious and great for grabbing for a light and healthy lunch on the go. When I'm busy, I know that I need to make meals *extremely easy* on myself. Can you relate? So I just tie a spoon or a fork around the neck of the jar and keep it in the fridge. Then I toss it in my purse, tote, or a small cooler on my way out the door, and hit the ground running.

my all-time *favorite* salad dressing

A year and a half ago I did a cleanse with nutritionist Elissa Goodman, who gave me this recipe for her dressing, which is heaven on earth. I could practically drink it out of the bottle, it's that good. It's also perfect on *every salad known to man*, as well as on crackers, sprinkled over steamed veggies, or spread on a sandwich or wrap. Note: If you can get your hands on them, it's best to use fresh herbs. (We grow parsley, basil, and cilantro in our garden.) I blend this up once a week and by the end of the week, it is *gone, girl*.

Elissa Goodman's Fresh Herb Vinaigrette

yield: 1 cup

INGREDIENTS

1 handful fresh basil, chopped
1 handful fresh parsley, chopped
1 handful fresh cilantro, chopped
2 cloves garlic, very finely
 chopped
2 to 3 tablespoons Bragg apple
 cider vinegar
⅓ cup extra-virgin olive oil
Pinch of sea salt
Pinch of pepper

DIRECTIONS

Place all the ingredients in a blender and blend until smooth. Store in the fridge in a tightly sealed, glass jar for up to a week.

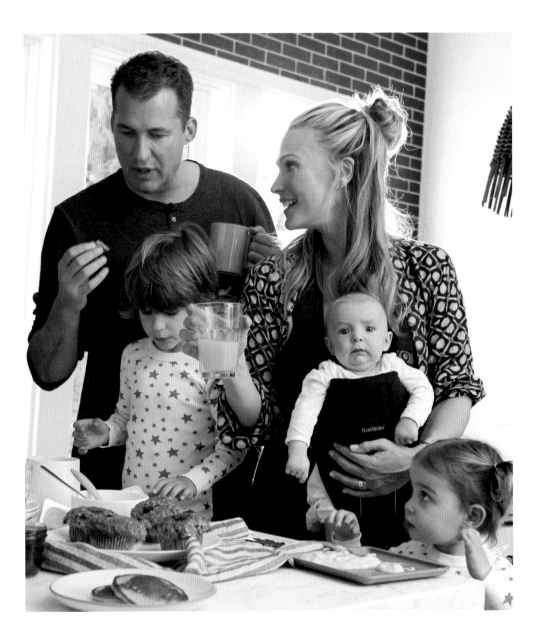

OUR MEAL IS BREAKFAST

Breakfast has always been my favorite meal of the day, hands down. I love omelets. I love biscuits. I love toast. I love granola. I love quiche. I love it all, including the fatty, not-so-good-for-you breakfast classics! I could eat a pound of turkey bacon. And my baby boy Brooks has inherited that from his momma. He loves

turkey bacon so much we nicknamed him "the Bacon-ater." Not so sure how he'll feel about this nickname once he gets a little older, but for now it sticks. The real reason breakfast is my favorite meal is not the food, though. It's because it's *our meal*. It's the meal we eat together as a family as often as we can. We try to do it every day, but realistically, we probably average four to five times a week. We wake up, have a few cuddles in bed, and then it's go time. That's my favorite way to start the day.

When we designed our kitchen in Los Angeles, we built it for breakfast. Our breakfast nook is in a cozy corner of our kitchen that looks out onto the backyard. The table in the breakfast nook is not a big, heavy table—it's quaint and low to the ground so the kids can easily climb into the seats. And it's not precious—we

don't have to chase the kids around with coasters and paper towels. This is where we begin each day and share some of our most treasured family moments. At least one Sunday a month, we also make a big, elaborate breakfast that we can spend a little more time on. It's usually just the five of us, or when the grandparents are in town, it's a few generations of fun. We get out the stepstool for the kids and we cook breakfast together. Scarlett loves cinnamon rolls and blueberry muffins, so we make those. The kids help measure the flour, add the blueberries, sprinkle the cinnamon, or stir the batter. The finished product is delicious, but the process of making it together is even more special.

With small children, no two mornings are ever the same and you never know what they are going to be in the mood for. But these are my general go-tos for family breakfast:

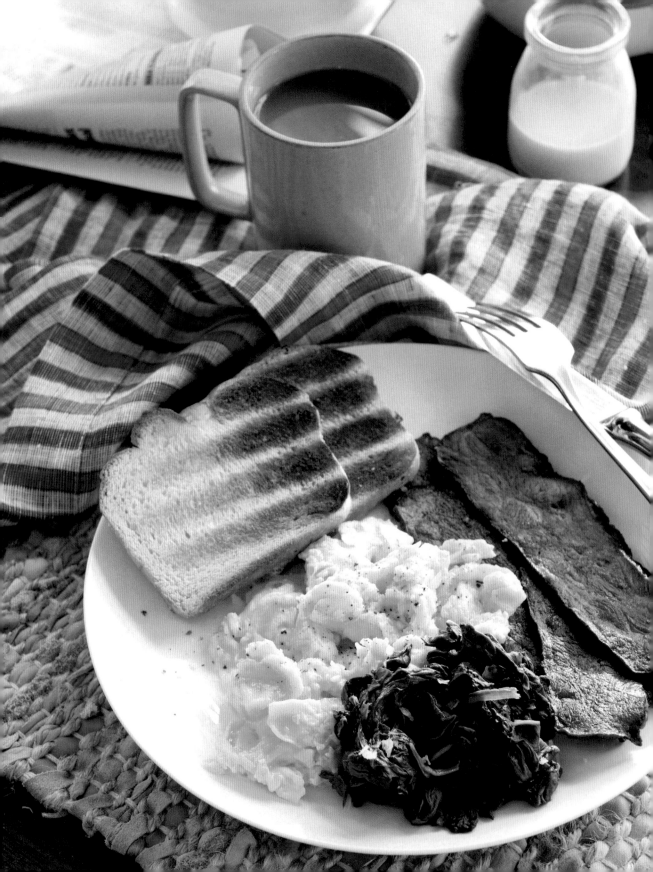

everyday *superfamily* breakfast basics

The fab four Scrambled eggs, steamed spinach, gluten-free bread, and the almighty turkey bacon. This is definitely our go-to family breakfast. My kids get full eggs with yolks and I usually do one full egg and the rest whites for myself. Pile it all on multigrain toast for a delicious and nutritious breakfast sandwich! When the grandparents are visiting, we serve a slightly gussied-up version of the Fab Four—see below.

gussied-up family brunch On Sundays, we love to wake up late, linger in bed, and then—eventually—jump up and cook together. We have a lot of favorites, but the Eggy Omelet Muffins with Spinach, Feta, and Herbs (page 43) and "Baconator" Turkey Bacon (below) are in regular rotation. We'll serve them with a side of Greek yogurt topped with berries and honey and call it a morning!

"baconator" turkey bacon

The sprinkle of pepper and dash of herbs in this recipe will delight your taste buds.

yield: *2 to 3 slices (per person)*

INGREDIENTS

2 to 3 slices turkey bacon per person

Pepper

Chopped fresh or dried herbs

DIRECTIONS

Preheat the oven to 400°F. Line a baking sheet with foil and place a cooling rack on top of the lined baking sheet. Line a plate with paper towels.

Arrange the turkey bacon flat on the rack and sprinkle with a little ground pepper. Depending on bacon thickness, cook for 10 to 20 minutes. Remove from the oven and place the bacon on the prepared plate to absorb excess grease. To serve, place the bacon on a platter and sprinkle with fresh herbs. Try your hardest to wait until cool enough to eat!

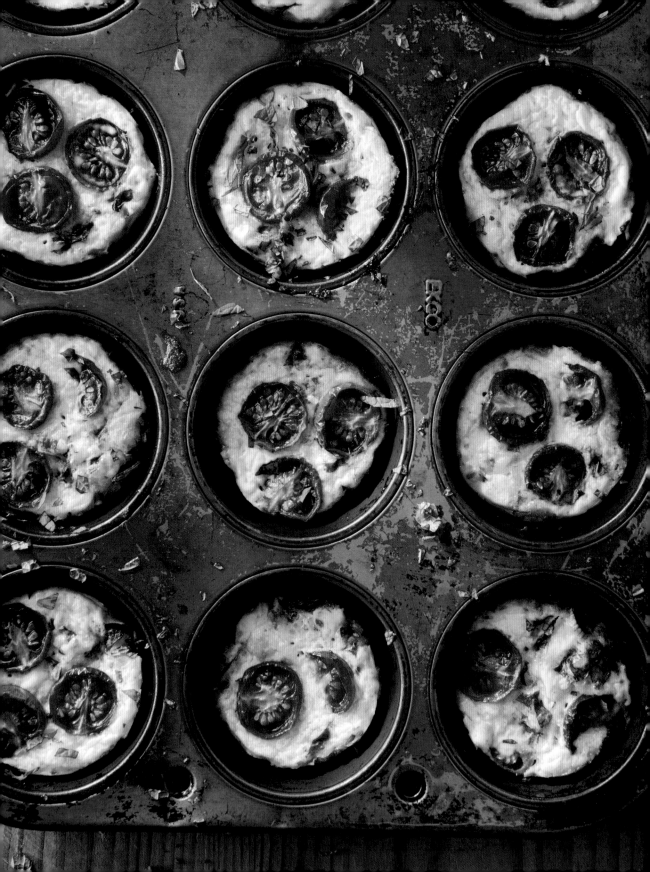

eggy omelet muffins
with spinach, feta, and herbs

Kids love that these are made in muffin tins because it reminds them of a cupcake. Sneaky, right?

yield: *12 muffins*

INGREDIENTS

Extra-virgin olive oil

6 large egg whites

2 large eggs

1 cup cooked quinoa or brown rice

1 cup roughly chopped baby
 spinach

½ cup sliced green onions

½ cup crumbled feta cheese

⅓ cup chopped fresh mint or dill

¼ teaspoon salt

1 cup halved very small cherry
 tomatoes

Pepper

DIRECTIONS

Preheat the oven to 350°F. Brush a 12-cup muffin tin with olive oil. Beat the egg whites and eggs in a large bowl until well blended. Stir in the quinoa, spinach, green onions, feta, mint, and salt. Divide the mixture among prepared cups. Arrange tomato halves on top of the muffin mixture in the tins, dividing evenly. Season generously with pepper. Bake until the muffins are just firm to the touch and golden brown, about 15 minutes. Cool slightly, unmold, and serve.

supermomma shortcut These babies can be prepared ahead! After cooling, transfer the muffins to an airtight container or wrap them well in plastic and refrigerate. If frozen, they will keep fresh for up to a month. Enjoy chilled or reheat in the toaster oven for about 4 minutes.

everyday breakfast foods
to have on hand

- ✳ Free-range eggs
- ✳ Whole wheat or fresh corn tortillas
- ✳ Whole grain cereals
- ✳ Quinoa, millet, and steel-cut oats
- ✳ Almond milk and regular milk (whole or skim depending on your preference)
- ✳ Greek yogurt
- ✳ Spices like cinnamon and cardamom
- ✳ Seasonal bananas, apples, and berries
- ✳ Kona coffee and loose-leaf tea
- ✳ Avocado and tomato for toast
- ✳ Chopped nuts, such as walnuts, and seeds, like chia and sunflower; all great for throwing into smoothies or sprinkling on hot or cold cereals
- ✳ Smoothie boosters like maca powder for energy, spirulina or power greens for nutrition and plant protein, and vitamin C powder for immune-boosting benefits

CHEF. IT. UP.

I've learned a lot taking classes with my Good-Food Guru Dana Slatkin. She specializes in cooking up delicious dishes with families in mind, and she always finds some way to punch them up a pinch. Here are some of her easy tips for turning up the fancy on your food, without actually sweating for hours in the kitchen:

- ✳ **EXPERIMENT WITH SPICE BLENDS.** Za'atar is a Mediterranean spice blend with a nutty, fruity, herby flavor that's amazing on veggies and poultry. Herbes de Provence is a classically French spice that's suitable for literally everything from baked chicken to roasted potatoes to fish dishes. Dukkah is a nutty and yummy Egyptian

spice blend that you can swirl into hummus or yogurt, add to an omelet, or sprinkle on fried eggs. These spice blends are adored in their native regions for a reason and add layers upon layers of flavor!

* **INVEST IN A MANDOLINE SLICER.** Again, thank you, Dana, for this tip! With my mandoline, I can julienne and thinly slice vegetables like a pro, from zucchini to sweet potatoes to cucumbers. You can also try making different vegetable shapes, which always adds a little style to the plate and makes food more visually interesting.

* **DON'T CHEAT—USE REAL INGREDIENTS.** Instead of using vanilla extract, try using real vanilla bean. It's not hard. Split the bean in half with a knife and scrape out the twenty-five thousand tiny seeds with the dull edge of the knife. The textural quality of the miniature seeds is really interesting when added to a dish and totally worth the extra effort.

* **PLATE UP YOUR PASTA PRETTY.** Don't just plop pasta on the plate. Use salad tongs to grab a serving of linguini or spaghetti, twist and swirl the pasta in the air with the tongs, as if it were one thick strand

or a piece of rope, and then lay it gently on the plate or onto a family-style platter. It will look Instagram-worthy, and it only took an extra second.

* **USE HIGH-QUALITY, SMALLER BATCH EXTRA-VIRGIN OLIVE OIL.** It does wonders. Need I say more? Don't ask, just try it.

* **PAY ATTENTION AND BE PRESENT WHEN GROCERY SHOPPING.** Don't be afraid to stray from your list if something looks extra fresh or is recommended by the butcher. You don't always have to stick to the script. If you have never seen riper, more juicy strawberries but had planned to serve pears for dessert—forget it. Go rogue and buy the strawberries!

* **KEEP FRESH HERBS ON HAND.** I love to keep them in water, displayed in pretty vase in my kitchen. The herbs last longer this way, and when they're out on display, you will actually remember to use them. Everything tastes better with fresh herbs!

* **TRY MY SECRET SHAVE.** I love using my Microplane to shave the rind of a lemon, orange, or lime and then sprinkling the shavings onto almost anything—a salad, a dessert, or chicken or fish straight out of the oven. Shaved citrus always adds freshness and another layer to a dish. Try it on a simple scoop of vanilla ice cream, then sprinkle with real vanilla seeds, and you're in heaven!

* **EXPERIMENT WITH COLOR.** Use a purple potato in your salade niçoise. Serve a mix of colorful heirloom carrots—white, purple, yellow, and red as opposed to good old orange! This is superfun for kids too.

* **STEAM VEGGIES TO BRING OUT RICHER COLORS.** Steaming is also one of the healthiest forms of cooking, and it preserves the nutrient integrity of the food better than boiling does; with boiling, you lose water-soluble vitamins.

eating the
rainbow

Colorful foods aren't just pretty. They can be great for your family's health! Here's a quick cheat sheet on what colors mean and a few of their body benefits.

RED: Phytonutrients such as lycopene, quercetin, anthocyanins. Supports urinary and prostate health and protects against chronic diseases.

ORANGE/YELLOW: Phytonutrients such as carotenoids, flavonoids, hesperidin. Encourages healthy eye sight and immune function.

GREEN: Phytonutrients such as EGCG, lutein, potassium, vitamins C and K, folic acid. Supports liver function, lung and cell health, and overall health. Protects against chronic disease.

BLUE/PURPLE/VIOLET: Phytonutrients such as resveratrol, phenolics, flavonoids. Supports heart, brain, bone, and cognitive function.

WHITE/TAN/BROWN: Phytonutrients such as allicin, flavonoids, beta-glucans. Supports healthy bones and circulation.

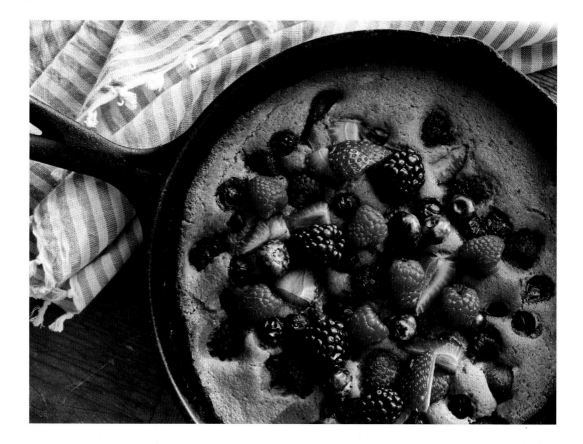

You have got to have at least one family-friendly dessert in your back pocket. Here is mine.

whole wheat mixed berry cobbler

Baked in a skillet, this dessert takes just minutes to prepare. Lightly sweetened with coconut sugar, the cobbler makes a stylish finish to a dinner party or a comforting end to a cozy family supper. Serve with Greek yogurt, ricotta cheese, or if you're feeling indulgent, vanilla ice cream.

Note: In warm weather, when my crew and I are outside enjoying an alfresco evening, I like to bake this cobbler up on the gas barbecue grill (see instructions on the next page).

yield: *6 to 8 servings*

INGREDIENTS

4 cups mixed fresh berries, such
as stemmed and quartered
strawberries or blueberries,
blackberries, and raspberries

1 teaspoon lemon zest

1 tablespoon fresh lemon juice

1 cup whole wheat flour

¾ cup coconut sugar

1 teaspoon baking powder

½ teaspoon sea salt

½ cup whole milk

1 egg

¼ cup unsalted butter

DIRECTIONS

Preheat the oven to 350°F. In a large bowl, gently toss the berries with the lemon zest and juice to combine. In a medium bowl, whisk together the flour, sugar, baking powder, and salt. Add the milk and egg to the flour mixture and whisk to combine into a batter.

Melt the butter in a 10-inch cast-iron skillet. Pour the batter into the butter and stir until just combined. Scatter half of the berries over the batter and bake until the edges of the cobbler are golden brown and a toothpick inserted into the center of the cobbler comes out clean, about 25 minutes. Top with the remaining berries and serve.

To cook the cobbler on the grill: Preheat the grill to 350°F. Turn off the heat on one side of the grill. Make the batter as above and pour into the skillet. Place the skillet on the unheated side of the grill, close the grill lid, and cook until the edges of the cobbler are golden brown and a toothpick inserted into the center of the cobbler comes out clean, about 25 minutes. Top with the remaining berries and serve.

Snacking has become an American pastime. The snack market geared toward kids is huge, but all those bags and pouches and bars are not necessarily great for our kids' health. Many of these snacks, even the so-called healthy ones, are processed and contain a ton of sugar, preservatives, and hidden chemicals. And remember, children shouldn't be snacking 24/7 in the first place. If your kids are snacking so much that they aren't hungry for regular meals, stop with the snack attack! Here are some healthy snacking tips that I rely on:

* If a snack isn't healthy, try not to buy it unless it's a special treat. Avoid stocking shelves with unhealthy snacks for special occasions. If it's not there, you can't eat it and your kids won't ask for it. I love potato chips, but I am just as likely to snack on sugar snap peas or baby carrots if that's what's available to me.

* Choose real foods like fruits, nuts, and veggies as snacks. Your kids' snacks shouldn't all be coming out of pouches, snack packs, and cardboard boxes.

* Read labels and watch out for sugar like a hawk. That includes cane sugar and all the other so-called healthy sugars that masquerade as being good for you but aren't.

* Prepare snacks in advance. This is huge. We're much more likely to grab healthy foods if they are conveniently cut up and prepared. Cut up celery sticks, watermelon, pineapple, cucumbers, you name it. This will satisfy the kids, and it's great for grown-ups, too!

* Put healthy snacks within your kids' reach in the fridge and the pantry. Designate a little basket or cubby that's only theirs and that they can reach for as long as they ask first. Leave apples and fresh fruit on the counter so that when kids are tempted to snack, they will see the healthy stuff first.

* Style out your fridge and pantry. A clean, well-organized fridge and pantry is always more inviting than the reverse. (I show you how to do this later in the chapter!)

* Keep healthy grab-and-go snacks in your purse or car to avoid unhealthy spur-of-the-moment snacking as much as possible. I keep snack-size portions of almonds, walnuts, and other healthy treats in little pre-prepped resealable plastic bags for the kids that I can grab on the run and toss in a backpack, beach bag, or purse.

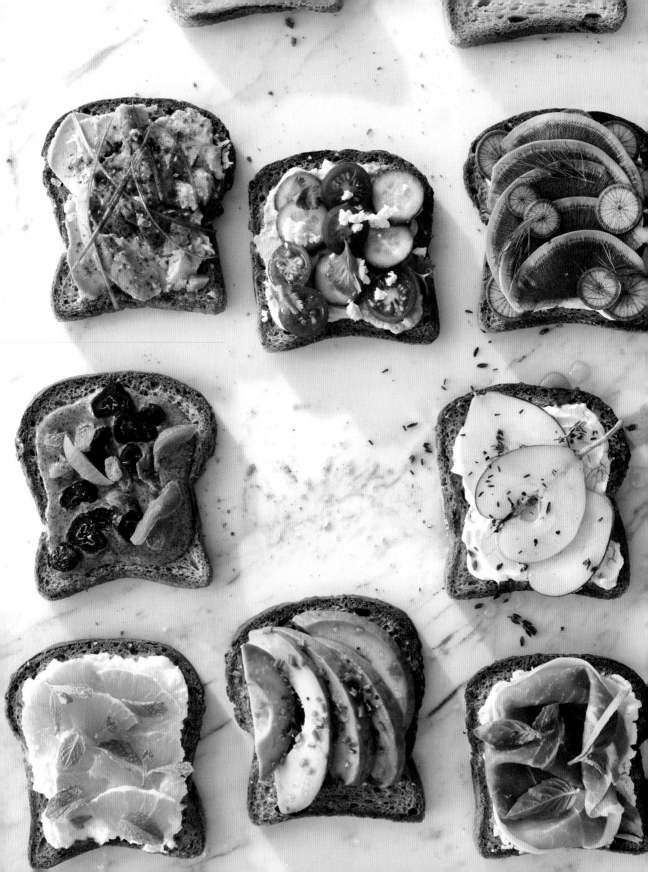

just *say no* to processed foods!

Here are some easy, healthy, and tasty snacking alternatives:

1. **MAKE THE MOST OF TOAST**
Basically, these are like little open-faced sandwiches and are so satisfying and delicious. Top your favorite whole-grain toast with the following healthy toppings:

* Rainbow radishes with cream cheese and dill
* Almond butter with dried fruit and honey
* Ricotta, orange, mint, and honey
* Hummus with cucumber, cherry tomatoes, feta, and cilantro
* Mashed or sliced avocado with lemon zest, lemon juice, red pepper, and green onion
* Avocado with chives and black pepper
* Pears with goat cheese, thyme, and honey

2. **CREATIVE KABOBS FOR KIDS**
These kabobs can all be prepared in advance and stored in the fridge. Poke a hole in a paper or foil cupcake wrapper or a small square of butcher paper with the kabob stick and position it at the base of the kabob skewer. This helps catch drips and crumbles. Stack your ingredients on the kabob and go to town nibbling (and hopefully not dribbling):

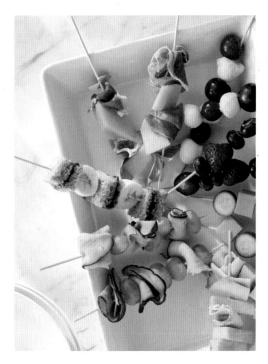

* *fruit + berry kabob*
 Strawberries, grapes, blueberries, and cantaloupe
* *sandwich on a stick kabob* Soft cubes of wheat bread, cubes of cheddar cheese, small pieces of chicken, and arugula

* *veggie + cheese please kabob* Cherry tomatoes, Persian cucumbers, little mozzarella balls
* *dessert kabob* Marshmallows stacked with grapes and chocolate-covered raisins (Brooks and Scarlett's favorite! Could you guess?)

3. FROZEN YOGURT BLUEBERRY BITES

We make these at least once a week and can't get enough!

2 cartons fresh blueberries
½ cup Greek yogurt
2 teaspoons honey

In a medium bowl, gently mix together the blueberries, yogurt, and honey. Scrape out the mixture onto a baking sheet lined with parchment paper. Cover the baking sheet and put in the freezer for 1 to 2 hours. Cut into bite-size pieces and enjoy! Store in an airtight container in the freezer for up to 3 weeks.

While our kids do generally eat what we eat from our prepped 2/2/2 + 1 meals, I still sometimes whip up easy kids' meals. Below are three of Catherine McCord's healthy kids' recipes that we make often and that my kids absolutely love (adults love them too!). Check out her Weelicious book series for more amazing family recipes and ideas.

everyday *superkiddo* secret

A truly great resource for family-friendly eating can be found at TheFamilyDinnerProject.org, which contains excellent ideas for bringing the family together over food. I adore the site's recommendations for one-line conversation starters at the dinner table. They have loads of ideas and interesting/silly/fun questions to spark thoughtful conversation. Like these: "What is your favorite silly face?" or "What is the strangest thing that happened to you today?" or "What animal would you most like to be?" or "What do you love most about being a part of this family?" Sometimes as parents you are tired, and you can't think of anything interesting to ask or even say. You are burned out! These questions are fun for everyone and they make us all look forward to the mealtime musings.

blueberry-lemon whole wheat pancakes

How delicious do these sound? They are amazing. My kids love them . . . Strike that. We *all* love them. Catherine, my friend, these are scrumptious!

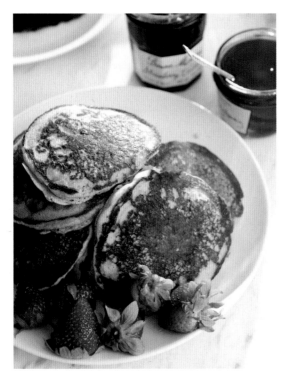

yield: **4 servings**

INGREDIENTS

1⅓ cups whole wheat flour

1 teaspoon baking powder

½ teaspoon baking soda

½ teaspoon salt

2 tablespoons vegetable or canola oil, plus more for cooking

1 large egg

1 cup milk

1 tablespoon honey

1 teaspoon lemon zest

1 tablespoon fresh lemon juice

1 cup fresh or frozen blueberries, unthawed if frozen

Maple syrup, honey, butter, or raspberry jam, for serving

DIRECTIONS

In a large bowl, whisk together the flour, baking powder, baking soda, and salt.

In a medium bowl, whisk together the oil, egg, milk, honey, lemon zest, and lemon juice.

Whisk the dry ingredients into the wet ingredients until just combined (it's okay if there are a few lumps).

Heat a large pan or griddle over medium heat and grease with oil.

Pour about 1 heaping tablespoon of the pancake batter onto the griddle and top with 2 or 3 blueberries. Repeat to make more pancakes.

Cook the pancakes for 2 minutes, then flip and cook for 2 more minutes.

Serve with maple syrup, honey, butter, or raspberry jam.

lunch

For a quick and healthy lunch for my kids, we most often grab from our 2/2/2 + 1 pre-prepped meals and combine them with other special items to create a kiddie bento box that they can take to school.

kiddie bento box lunch formula

- ✳ **PROTEIN** Almond butter and jelly sandwich or almond butter and banana roll-up. Or a few slices of chicken from one of the weekly protein dishes.
- ✳ **FRUIT** Strawberries, watermelon, and cantaloupe all do well. (Sliced apples turn brown and kids don't love that. Squeezing a little lemon over chopped fruit can keep it a bit fresher and slow oxidation.)
- ✳ **VEGGIE + DIP** Cucumbers, baby carrots, or sugar snap peas with hummus are a great way to go.
- ✳ **GRAIN** This is usually covered in the sandwich or wrap, but sometimes I'll add some popcorn, healthy crackers, or side of healthy mac and cheese or pasta salad.

dinner

I keep these kid-friendly dinners in my back pocket for when we are headed out and have babysitters or in case of emergencies. This recipe from Catherine McCord's book is one of my all-time favorites because Scott and I love it too!

turkey pesto meatballs

yield: *4 to 6 servings*

INGREDIENTS

1¼ pounds ground turkey

¼ cup store-bought basil pesto

¼ cup bread crumbs

¼ cup grated Parmesan cheese

1 teaspoon salt

2 cups tomato sauce

DIRECTIONS

Preheat the oven to 350°F.

Place the turkey, pesto, bread crumbs, cheese, and salt in a large bowl and use clean hands to combine thoroughly.

Roll the mixture into tablespoon-size balls and set them aside on a plate.

Pour the tomato sauce into a 9 × 9-inch baking dish and arrange the meatballs evenly over the sauce.

Cover the baking dish with foil and bake for 20 to 25 minutes, until cooked through. Check with a toothpick if unsure.

Serve with pasta, broccoli, or a yummy salad as a side.

better than juice:
agua fresca!

There is so much sugar in commercial juices, even the so-called healthy ones. Agua fresca is a great alternative when you want something cool and refreshing, with no added sugar. Here's a version I like to make that quenches any kiddo's thirst!

berry refreshing fresca!

yield: 2 servings

INGREDIENTS

1 cup chopped strawberries

1 cup chopped raspberries

2 cups coconut water

3 teaspoons fresh lemon juice

DIRECTIONS

Place the strawberries, raspberries, and coconut water in a blender, add 2 cups cold water, and puree until smooth. Pour into a pitcher, stir in the lemon juice, and let sit for 1 hour at room temperature. Pour over ice when ready to serve.

not-so-happy meals and what we can do about them

Premade/store-bought meals, snacks, and juices designated for kids can be some of the most nutritionally bankrupt foods on the planet. *Supermomma, puh-lease.* Big food companies spend hundreds of billions of dollars every year marketing to our children's vulnerable brains, taste buds, and eyeballs in the form of commercials on kids' television networks and by partnering with children's films on action figures, toys, and collectibles that end up in these snack packs and so-called kid-friendly meals. It's a big industry, and it feels nearly impossible to avoid. Don't even get me started on the junk that's available to kids through school lunch programs and vending machines. According to the research, we may be raising the first generation of children who will, on average, live shorter and less healthy lives than their parents.

As parents, we must take back the power. We have got to protect our children.

In her book *The Family Cooks* (which I highly recommend), Laurie David asks us why we would let multinational companies feed our children, when whatever we make at home, "even the most budget-conscious, simple meal, will be way more nutritious than whatever is in the box." We occasionally eat out as a family, but when we do I try to keep my children away from the unhealthy "kids' menu." I am trying to teach them healthy habits that are sustainable for life. Not to mention, cooking at home is budget-friendly and better for the environment because there is less packaging. Plus you know exactly what's in it. You bought it. You cleaned it. You know what you are getting.

no picky eaters policy

Before my son Brooks turned three, I couldn't understand why other parents had trouble getting their kids to eat. He loved green smoothies. He loved broccoli. My baby was a little Michael Pollan in the making, with the appetite of a little Michael Phelps. Then one day, he refused to eat anything. No more eggs. No more turkey bacon. Those cute little broccoli trees? Now his sworn enemy. I went to one of my parenting classes and told our teacher, "He's not eating." Her response: "What are you doing, Molly, chasing him around with cheese?" The truth was that yes, *I was literally running around after Brooks trying to get him to eat something, anything.* This teacher told me to stop, and she gave me some incredibly helpful tips for dealing with picky eaters, combined below with the advice of Catherine McCord. I am proud to say that Brooks, now five, is a much more adventurous eater than he was at three. Now, none of this is foolproof, supermommas, as you know, but here are some strategies that may help if you are in this situation:

* **BE A GOOD EXAMPLE.** Study after study suggests that our own eating habits will dictate what our children eat. Momma, in particular, has the most influence. Researchers conclude that a positive parental role model may be a better method for improving a child's diet than attempts at dietary control.
* **DON'T FORCE IT.** Positive encouragement is good, but forcing is not. Some studies have shown that exercising excess control over what your children eat could negatively affect their eating habits in the future. In other words, don't chase your kids around with cheese sticks like I did.

* **PROVIDE LIMITED CHOICES.** This is a powerful strategy with food. If my daughter asks for a cookie, but I want her to have a healthy snack, I will let her know that she can definitely have a delicious treat but that she must choose among a granola bar, sliced apple with nut butter, or trail mix with chocolate. Her choices are actually my choices. She almost always likes one of these options!

* **AVOID USING FOOD AS A REWARD.** This is tricky, because I think we all do this, but we aren't supposed to. Experts believe that using food as a reward can create weight problems later in life. So try to avoid this if at all possible. Instead, reward good behavior with spending quality time together, reading a book, or walking to the park.

* **START FOOD EXPOSURE EARLY.** Studies show that what we eat while we are pregnant and what we feed to our kids as babies has an effect on the development of their palates as they get older. So try to eat a healthy and balanced diet while pregnant, and introduce a variety of healthy foods at an early age. There is some research that shows that eating nuts during pregnancy may help prevent allergies in your children. Want your child to love veggies? Start early. Very early. Research shows that what a woman eats during pregnancy not only nourishes her baby in the womb but may shape food preferences later in life.

* **TAKE TIME TO ENJOY FOOD TOGETHER.** I've mentioned this before, but it bears repeating. In homes where parents are strapped for time, kids are more likely to be overweight. Try your best to sit down with your children when they eat and to eat together as a family. So many more healthy things happen at that table beyond just eating.

* **GIVE THEM SOME CONTROL.** What plate would they like to use? What cup would they like to drink out of? When they get to pick their favorite plate with Elmo on it, it makes food and eating more interesting, layered, and that much more fun.

* **MAKE FOOD FUN.** Speaking of fun, children love to dip and dunk things. They love Popsicles and small bites. They love to eat off their favorite superhero

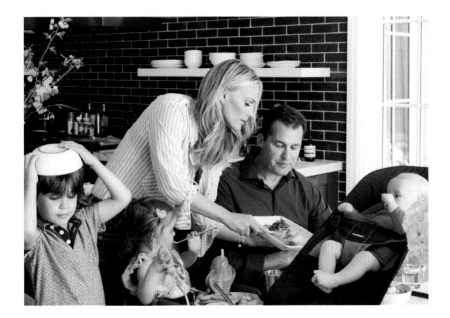

plate with their favorite colored fork. They love food in funny shapes. Pasta with shapes. Fruit with shapes. Sandwiches with shapes. It does take some work and creativity. But it's work that is worth it.

* **GROW SOMETHING WITH THEM.** Even if it's just a few strawberries or sprouts in the kitchen, they will feel more connected to the food they are eating. Find a local farm to visit and help with the harvest.

* **SHOP AND COOK WITH THE KIDDOS.** Get them involved in the kitchen. Have a scavenger hunt at the grocery store. Ask them to weigh the apples on the scale. Teach them to measure ingredients with you while baking. They're learning and helping, and it's a challenge. Brooks loves smoothies, so he always helps me pick the ingredients and we pour them all in, and blend! When Big Momma is over (my mom/their grandma), we love to bake goodies together. Last week she was in town and we made a delicious red velvet cake together, using her secret southern recipe (which I share on my blog).

* **TRY NOT TO LABEL.** Don't designate foods as "Good" or "Bad" because kids will always want what they can't have. Our children should learn that healthy eating is about moderation, and the occasional dessert is 100 percent okay. No food villains here!

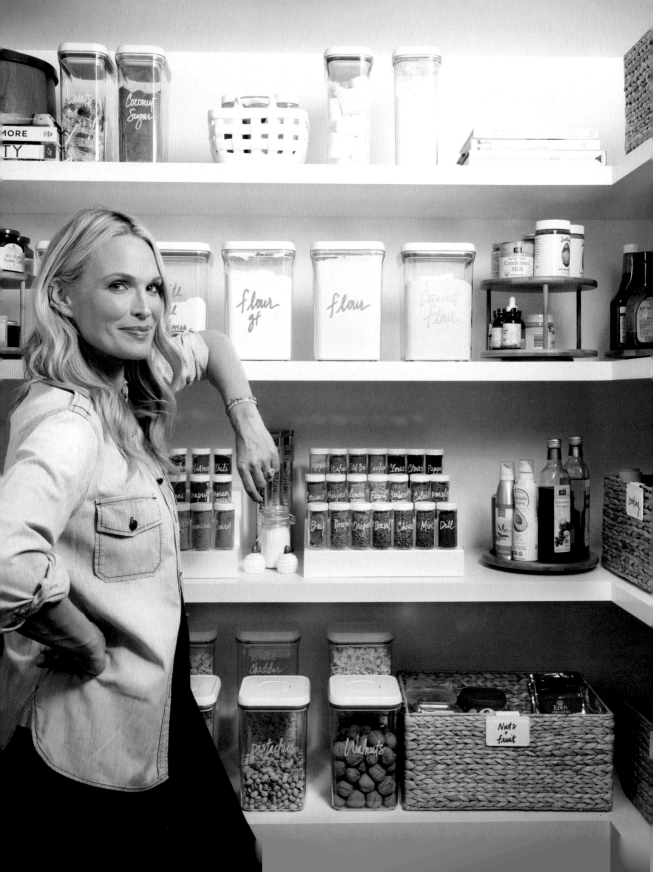

TOTAL PANTRY MAKEOVER

When it comes to healthy eating and meal planning, an organized pantry is key. I hired the absolutely amazing women behind the blog, website, and business the Home Edit (Joanna and Clea) to help me organize and beautify my pantry, and *it was one of the best things I've ever done.* Just looking at my new and improved pantry once we'd finished brought tears of joy and relief to my eyes. It wasn't just because my pantry was suddenly glam (though that was great) but also because I could finally find things! And now I am saving money because stuff isn't hidden behind other stuff, and I can see what I have, so pantry items are no longer going bad because they're forgotten.

To organize, we used clear canisters, baskets, and a few other containers, all in various sizes, to organize foods by category. And then, in addition to the physical

makeover, we also swapped out processed pantry staples for their healthier versions. Seriously #pantryporn.

1. Clear, airtight storage containers are best for a variety of foods, especially loose ingredients, baking ingredients, pastas, and grains. They come in large, medium, or small sizes, and are excellent for storing the following:

healthy swaps:

* *flours* We use whole wheat flour, such as spelt or kamut, instead of enriched, bleached white flour, which has been refined and stripped of minerals and other nutrients.

* *pastas* We use whole wheat pasta instead of regular white. And we empty bags of pasta into airtight containers. Even tall spaghetti noodles fit in the right container, and it keeps the pasta easy to reach and fresh.

* *cereals* For mornings when we are on the run, cereal is an easy go-to. We stock a variety of the lower-sugar Kashi cereals and Udi's granola.

* *grains* We tend to stock quinoa, millet, brown rice, gluten-free oats, and buckwheat (actually not a grain at all and totally gluten-free!) for healthy wheat alternatives. We empty the bags and place in storage containers for ease of use. That way you don't have to mess with rubber bands or worry little bugs will get into your goodies. Quinoa is probably our favorite alternative to white rice, and it takes less than fifteen minutes to cook. Brown rice is great too. It takes longer to cook but can be made in big batches, frozen, and heated up quickly later.

* *sugars* We tend to use coconut sugar because it's unrefined, non-GMO, and good for baking.

* *nuts and seeds* We stock whole or chopped raw nuts and seeds rather than their roasted or, worse, sugar- or salt-coated counterparts. We usually have sunflower seeds, chia seeds, walnut pieces, or sliced almonds because they can be added last minute to almost any snack.

* *supplement powders* We stock these mostly as smoothie boosters, such as vitamin C powder (for immunity), spirulina and wheatgrass (for protein and vitamins), maca powder (for energy and a libido boost!), and raw cocoa powder (in place of highly processed, conventional cocoa powders).

2. Medium-size baskets are ideal for the following items:

* *extra stock* Extra bags or boxes of pastas, grains, cereals, and baking items that haven't yet been opened and poured into airtight containers we'll organize in the baskets.

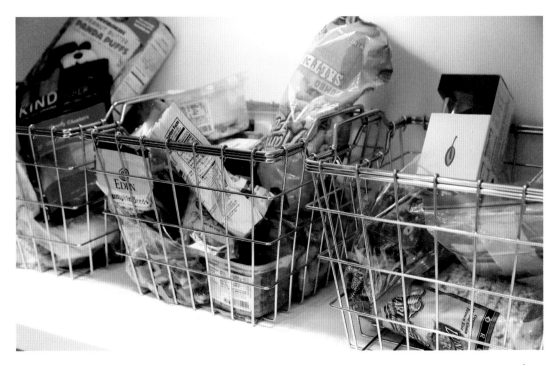

* *sauces and stocks* I try to choose smaller batch brands of bottled pasta sauces, and before buying, I always read labels to make sure there's no added sugar or a high-sodium count. The same goes for boxed vegetable and chicken stocks.

* *oils, vinegars, salad dressings, and condiments* I organized these together in their own basket. My rule of thumb when it comes to premade dressings: the fewer ingredients the better. I look for preservative-free, natural, simple blends. For condiments, I look for organic versions of ketchup, mustard, mayonnaise, and so on and stock those whenever possible.

* *breakfast basket* We have a basket filled with our specialty breakfast ingredients that we tend to pull out on a Saturday or Sunday. It has pancake and waffle mix, muffin mixes, boxed cereals, and maple syrup.

* *dry snacks* These include kids' snack bags of crackers, pretzels, popcorn, granola bars, trail mix, and so forth.

* *veggies* Bags of potatoes, onions, and garlic like a cool, dark space to preserve freshness and prevent sprouting.

* *beverage baskets* These are used to organize beverages, such as juices, natural sodas, sparkling water, and some of the kids' drinks.

* *boxed nut milks* While we do drink a little milk, we always have almond and sometimes cashew milk for cereals and smoothies. We choose the unsweetened versions. They are a great alternative to dairy, naturally low in fats, rich in omegas, and seriously delicious.

* *canned items* Look for low-sodium or no-salt-added canned tomatoes, soups, and legumes instead of the alternatives with preservatives and tons of sodium. Try to choose cans that say "BPA-free," which aren't lined with this suspicious chemical.

✳ *spices and salts* If you don't have a spice rack, a basket of spices is a great option. We use Himalayan salt, sea salt, or gray salt instead of conventional table salt, which is denatured and stripped of natural minerals.

Feeding a family can definitely be daunting. But now that I am a mom of three, I feel like I am just starting to hit my stride in the kitchen. I think what's most important is to try to keep things simple for your family and to make healthy eating easy and to help our children build good relationships with food. Food is such an integral part of our family lives and is always there at important events and gatherings. We should learn to love food, respect where it comes from, and enjoy the act of making it for our loved ones. I know that it takes time and rolling up

your sleeves, but there is something so rewarding about cooking for and feeding a good meal to the mouths you love. Maybe you've already got all this mastered—but if you are more like I was, start digging in (literally, to the foods that grow in dirt) and finding a few recipes that you enjoy making and your family enjoys eating. Give it your best, get your kids involved occasionally, and *bon appétit*!

TOP 10 takeaways

1. Create your own Superfamily Food Rules, and make sure they include eating meals together, striving to eat as healthily as you can, and communing with your family around food.

2. Meal plan, prep, mix and match—and reap all the rewards! The investment in time up front is a supermomma sanity saver in the end!

3. Have healthy grab-and-go snacks and meals that are easy to reach for and take on the road, wherever you are headed—to work, to the doctor's office, to the playground, you name it.

4. Have a few incredible one-pot meals under your belt. They are easy, healthy, nutritious, and with mason jars or other storage containers, they can travel!

5. Chef it up—spend a little extra time and effort on meals at home. Your taste buds and your family will thank you.

6. Learn to budget, bulk shop, and style your pantry. These strategies save money and time in the long run.

7. Whenever possible, buy seasonal, local, and organic fruits and vegetables; stop by your local farmers' market; or join a community-supported agriculture (CSA) farm.

8. Go meatless occasionally.

9. Institute a no-picky-eaters policy, set a good example, and expose your kids to a variety of healthy foods as early as possible. Give them opportunities to establish a healthy relationship with food and cooking.

10. Grow something, even if it's small—start with a few windowsill herbs, and graduate to a twelve-by-twelve-foot garden if and when you are ready!

feeding a family
my inspiration

ANGELA LIDDON @ohsheglows, OhSheGlows.com. Even if you aren't vegan, you'll love Angela's recipes! So satisfying and delicious.

CATHERINE MCCORD @weelicious, Weelicious.com. Weelicious is my go-to source for easy and healthy recipes for the entire family. Kid and husband approved!

CLAIRE THOMAS @kitchykitchen, TheKitchyKitchen.com. Claire's recipes aren't only delicious, but they are pretty, too! Great for healthy desserts and fun dishes.

DANA SLATKIN @dana.slatkin, DanaSlatkin.com. Dana has taught me almost everything I know! Love her cooking classes. She's all about balance . . . and not depriving yourself of a cookie every once in a while.

ELISSA GOODMAN @elissagoodman, ElissaGoodman.com. Soup detox guru! Love, love, love her easy salad dressing recipes.

ELLA WOODWARD @deliciouslyella, DeliciouslyElla.com. We try going meatless a few times a week at our house. Even my kids love Ella's plant-based recipes.

KELLY LEVEQUE @bewellbykelly, BeWellByKelly.com. This momma got me back in a bikini after having baby Grey. Her Fab 4 and Be Well smoothies and recipes are fantastic.

LAUREL GALLUCCI @sweetlaurelbakery, SweetLaurel.com. All Laurel's recipes are grain- and dairy-free and contain no refined sugars—aka totally guilt-free! Perfect for families with any food intolerances.

MARIE SABA @mariesaba, CocinaMarie.com. Attention all mommas with picky eaters: Marie Saba's food art ideas are a lifesaver to get your kids to eat their veggies!

PAMELA SALZMAN @pamelasalzman, PamelaSalzman.com. This woman has taught me soooo much in the kitchen. I love her healthy side dishes and desserts.

For more Feeding a Family inspiration, plus shopping and sourcing tips, visit MollySims.com.

ch/2

entertaining in style

W

hat makes a great party? According to my husband: good food, good people, good drinks, and good music. And he is right—these are the absolute essentials! But I also believe that *the devil is in the details* when it comes to entertaining. Whether you're planning a superfab fete or a budget birthday bash, the basics of food, drink, and fun are key. But if you're like me, and you appreciate stylish flatware and a printed menu *as much* as the basics, then I've also got you covered in this chapter. And these days, with my growing family, I'm a veritable entertaining machine. In my free time, if I'm not celebrating with family, hosting (or having) a baby shower, throwing a dinner party, or planning a kid-friendly backyard barbecue, then I'm probably asleep. Besides, who doesn't love entertaining at home? *You don't have to go anywhere.* See how that works!

With the help of my home entertaining experts, I've developed a pretty reliable formula, which I'm going to share with you in this chapter, for creating events that look and feel effortless. Keep in mind as you are reading this chapter, that entertaining is personal, so feel free to take the advice from this chapter that works for you, and pass over what doesn't. Entertaining should be an extension of the way you live your everyday life. The best events are always the ones that have been lovingly prepared with

personal touches. Serve dishes that make your mouth water, play music that moves you, and most important, remember that your guests are much more likely to remember good company and good conversation than a chic centerpiece (although if you invite me to your party, I promise I will 100 percent remember your lovingly prepared floral centerpiece). Follow your heart, and a few rules, and make the event your own. And follow my home entertaining mantra, which I refer to as the three S's: *simple, stylish, and stress-free.*

my *entertaining* experts

STEFANIE COVE Stefanie has taught me just about everything I know about entertaining. She's helped me plan my wedding, multiple showers, and more. She is smart, stylish, and always keeps her cool. (StefanieCove.com, @stefcoveco)

ANNIE BELANGER + BENTON WEINSTOCK OF A2B TABLE These are two event stylists who know how to set a mean table. Their tablescapes give me goose bumps and literally take my breath away. (a2btable.com, @a2btable)

DJ MICHELLE PESCE She is the go-to DJ for the coolest Hollywood parties, and she also spun at our wedding. Michelle understands just how much music can make or break an event. (NonaEntertainment.com, @djmichellepesce)

MIMI BROWN Mimi was a red carpet fashion stylist and now brings her chic aesthetic to event styling. She works on everything from small, intimate soirees to big-branded bashes. (MimiBrownStudio.com, @mimibrownstudio)

SIMONE LEBLANC Creator of superchic hostess gifts for any person on your list or any occasion. (SimoneLeBlanc.com, @simoneleblanc)

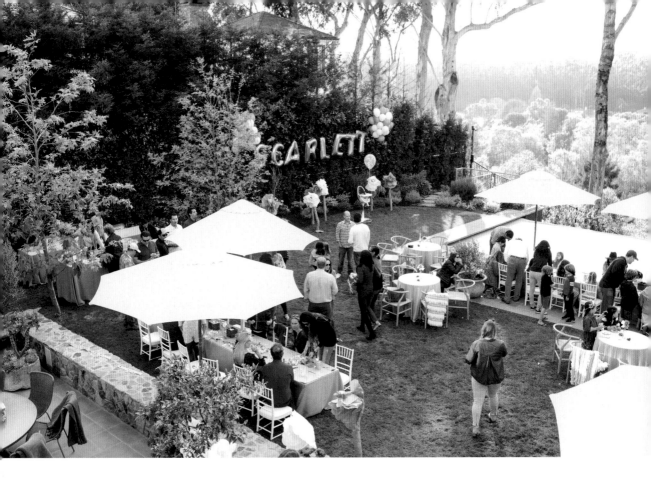

HOUSE PARTY, PLEASE

A house just simply isn't a home until you've thrown a party in it. With three kids, lots of friends and neighbors we love, a big backyard, and a true affection for fine wine, we welcome visitors and want our home to be a comfortable gathering place. When we first moved into our current Los Angeles home, a big house party was immediately put on the Sims Family Agenda. When you move into a new home, you need to christen it with the footsteps, voices, and laughter of those you love. I just felt our new house wouldn't be a home until bellies had been filled, drinks had been served, a few had been spilled, and hopefully someone had slept in our guest room or on the couch!

Let's begin by covering the basics. Whether big or small, it's important to consider the following to ensure an event will be smooth, successful, and chic:

1. **THEME** When party planning, I always start with a theme. (I do the same for home design!) This is nonnegotiable. A theme helps direct nearly all my decisions, from the colors, styling, and menu to activities, music, and more. Scarlett's first birthday was a co-ed soiree in our backyard. The theme: Cupcakes and Rosé. The "rosé" served as inspiration not only for the adult drinks but also for the color palette and decoration. It was all pinks, rose gold, cream, and white. We set up a DIY cupcake decorating table for the munchkins, and we "planted" big, beautiful tissue-paper roses all over the backyard. If I don't begin to plan an event by setting a theme, I'm down the Pinterest rabbit hole, and that's a scary, scary place to be.

2. **STYLING** Once you've decided on a theme, you can begin to think about the overall vibe that you want to create for your guests, through styling. Remember what I said about details? That's what styling is

supermodel *styling* touches

a printed menu When hosting a dinner party, I like to always have a simple printed menu. You can design a menu on Paperless Post and print it yourself, or there are a variety of artists on Etsy who will create and print custom menus for you. For more casual events, a menu written on a standing chalkboard is a great option too.

flowers No party is complete without flowers. You just have to have them.

flea market finds Event stylists love using found items with patina as party decor. Some of my favorites are vintage mirrored trays for displaying liquor or as a table centerpiece for candles and flowers, lived-in linen tablecloths, and old picture frames, in which you can put menus or small signage.

"mix and match" glass bottles Save wine bottles and colored-glass water bottles (think emerald-green Perrier bottles) that you'd otherwise recycle, and transform them into gorgeous bud vases or taper candleholders. This is a Mimi Brown favorite. Also, when I was a kid, my mom and I would hunt flea markets for milk-glass bottles which are always pretty with floral arrangements.

style in odd numbers Try a candle, a floral arrangement, and a found object as a centerpiece on your table. Or five candles of various heights, but not four. It just works; don't ask why!

subtle lighting Especially for an evening event, go to town with candles, market lights, tea lights, and lanterns. I love tea lights in simple paper lunch bags to line a walkway—it's an old favorite. There are so many subtle ways to use lighting to enhance an event: Taper candles at a sit-down dinner, tiki torches for a barbecue, scented candles in the guest bathrooms/powder room. And I go crazy for lanterns lit at dusk. Beautiful on the table, around the edge of a pool, and sprinkled in the garden.

signage For bigger events, it's a great idea to have signage that denotes where things are— the bathroom, the bar, and so on. For a birthday party, I love a big, bold birthday sign that makes a statement.

balloons! Always balloons! Parties of all kinds require balloons, whether to create a focal point, make a custom sign, or just add happiness, festivity, and whimsy.

linens Linens can be rented, or alternatively, you can find affordable and unique options for table coverings at fabric stores. Vintage fabrics can also be used as tablecloths, laid on the grass in the backyard for seating, and more.

about—the little touches that ultimately add up to a seriously chic soiree. When styling an event, I want things to look organic but turned up a notch. Not too fussy.

3. **BUDGET** Determine your party must-haves, and start there. Spend money where it counts. While details are important, don't break the bank to provide an experience for your guests that you can't afford. If you are investing in something that you can use over and over again (like beverage dispensers or table linens), choose items that are versatile and of good quality, so you can use them year after year. If it's something that is more disposable, think twice. I not-so-secretly love a good deal. Some of my favorite budget finds are a set of gorgeous nickel-plated trays I bought from the Dollar Tree that are lightweight and can be washed and stored easily, and they look superfancy. Annie and Benton also once bought stunning colored wineglasses in burgundy and blue from the Dollar Tree! You would never have guessed. Style is not about the size of your wallet. It's about developing your eye for a great buy.

4. **GUEST LIST** You can plan the party of a lifetime, but if the people you invite are boring, your party will be too! So the first order of business is to invite great people, keeping in mind how the guests you choose to invite will interact. Occasionally mix it up too. Don't invite the same people over and over. Throw in a wild card. And I don't mean your drunkle who will wear the lampshade on his head.

love/invite
your neighbor

If you are about to host a Fourth of July backyard reggae fest with a steel drum band, your cousin on vocals, and guests who will be parked all up and down your street, invite your next-door neighbors. Unless your neighbors are total weirdos with Christmas lights up year-round and aluminum foil curtains in the windows—then maybe not. But assuming your neighbors are semi-normal, *it's polite and right to always invite!*

5. **INVITATIONS** Invitations can be 100 percent free, or they can cost you a near down payment on a house (custom letterpress gorgeousness!). While some parties are casual and a simple email invite will do, others merit a more formal invitation. The invitation makes the first impression and begins setting the tone for your soiree. Whether it's a big-budget splurge, or something clean and classic or funny and thoughtful, the invitation counts.

* *luxe options* Letterpress on luxury paper will always be beautiful. Artists on Etsy provide these services as do design houses and specialty printers. We used letterpress for our wedding invitations and birth announcements. And yes, they are definitely a splurge, but they are also beautiful keepsakes.

* *luxe-for-less options* Graphic designers can create a custom design for your invitation (find one on Etsy, Fiverr.com, or by searching the web). They hand over the design, and you can save by managing the printing process yourself and going to

everyday *supermomma* tip

For significant life events, like weddings, baptisms, and birth announcements, I generally always do something more formal rather than digital. For these special occasions, I suggest an elegant printed invitation that you and your loved ones can hold on to and treasure. I highly recommend Jennifer Parsons from Tiny Pine Press!

a local printer. Alternatively, many designers are full-service and will also print the products for you at a price.

* **chic but totally budget-friendly options**
While there is nothing quite like the feel of good cardstock in your hand, the sad truth is that most guests end up tossing the invite. The good news is that digital invites have come a long, long way, and they are now incredibly stylish. My personal favorite? Paperless Post. I love the experience of receiving these invites—it's like opening an actual old-school envelope. So clever! Paperless Post also partners with leading fashion designers and up-and-coming artists to create amazing designs and invites that can be

stefanie cove's invite *etiquette*

rsvp, babes. **Don't forget to put the "RSVP by" date on the invite. This way, when you are planning budgets and crunching numbers, your guests will have a deadline to get back to you.**

announce attire. **Guests like to know how to dress for an event, so specify the attire on the invitation: Black tie. Cocktail. Ugly Christmas sweater. PJ party. It's up to you!**

set a timeline. **Send out invites with at least four weeks' notice. Six weeks is really best. If you are running late on getting out the invite, don't hesitate to send an informal "Save the Date" email. Keep in mind that calendars get especially busy during the summer and around the holidays, so send sooner rather than later at those times of year.**

return to sender. **For paper invitations, have a return address stamp made. This will save *a lot* of time for RSVP cards. It's also easy, elegant, and efficient for sending out postparty/gift thank-you notes.**

speaking of that "rsvp by" date . . . **If you are a receiver of an invitation, please do not neglect to respond by the requested date, and do not, I repeat, *do not*, respond late.**

totally customized. Not to mention the site helps you keep track of your RSVPs, and nothing gets lost in the mail. Guests love it too, because they can immediately add events to their calendars and refer back to the email if they need to for details.

6. **FOOD** Food is important at any event, large or small. Obviously. Even if you are on the tightest budget, it's better to serve pizza on your nicest platters than to have your guests starve. However casual or formal the event, I love to come up with a theme for food because it helps with fun, inspired menu planning. Always make sure to have options for both vegetarians and carnivores, and ask your guests about dietary restrictions before planning your menu.

7. **BEVERAGES** Your guests are going to come thirsty! Most everyone appreciates a drink pretty much the second they walk in the door. You can have a tightly curated selection of beverages or an open-bar bonanza. The choice is yours. Here are some important things to consider:

Beverage Breakdown:

* *bartender or diy bar* If it's a large event, think thirty-five or more, you really might want to consider hiring a bartender for the evening. For smaller events, or if that's not in the budget, set up a user-friendly DIY bar (or a few depending on the headcount), so it's easy for guests to help themselves. (Later in the chapter I detail how to stock the perfect DIY bar.)

* *The "signature cocktail"* Always have a signature bevvie. We've done one on theme for every event we've hosted—our wedding, birthday parties, backyard barbecues. It's fun and festive and adds a little personality to the party. I like to set up big glass jugs on tables with the name of the cocktail and the ingredients so that guests can help themselves to our signature sippers. (A few we've done: Harvest Moon: dry sake, fresh lime, and cucumber; Partridge in a Pear Tree: tequila, pear juice, fresh lemon, vanilla bean, and honey; Momma's Medicine: reposado tequila, hibiscus tea, fresh lemon, and fresh ginger. Look for a few recipes later in the chapter.)

* *mocktails and nonalcoholic drinks* Be considerate of all your guests, and include interesting, nonalcoholic beverages for those who don't drink or are the designated drivers. Have drinks for kids on hand too if little ones are coming.

* *avoiding bottlenecks at the bar* Always position the bar in a central location where it won't clog up traffic and create congestion. If it's a hosted bar with a server, always have the right bartender to guest ratio: one bartender per every fifty guests.

* *how much to buy?* I always calculate two beverages per person during the first hour of a party, and one beverage per person for each additional hour. Now multiply that by your total number of guests. Keep in mind that there are about four glasses per bottle of wine and five per bottle of champagne.

With weddings or big birthday parties, people have been up for a really long time. Put a bar near the dance floor and offer an energy drink option. Those are my two requests! If you don't want the party to fall flat—definitely do that.

—DJ MICHELLE PESCE

8. **SEATING** Your guests need to be comfortable! If they aren't, they will leave. Seating is not optional. It's something that must be thought of in advance. Here's how to do it right:

Seating Setup

* *create a variety of seating clusters.* Make sure that seating encourages conversation and connection, and is comfortable.

* *have kid-size seating if there are kids.* This is especially important if children are going to eat or do crafts. I share a few more specific ideas later!

* *for weddings and bridal showers, think smaller.* Opt for eight-person round tables, and position the tables closer together so that guests can turn and chat with those at the table behind them. Giant round tables lack intimacy and inhibit conversation.

* *create an at-home feel.* Rectangular farm tables are chic and give the feeling of an intimate, at-home dinner. Simple garlands, casual florals, and greens complement them well.

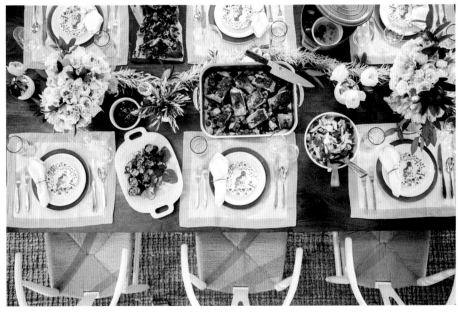

* *go modular*. Don't be afraid to pull modular seating (such as ottomans, benches, etc.) out of your home and utilize them for backyard events.

* *lie low*. Rugs or blankets laid out with oversize pillows make for easy seating for kids and toddlers. If outside, lay all this out and create some shade with an umbrella. Camping tents can work in a pinch and DIY tepees are fun too.

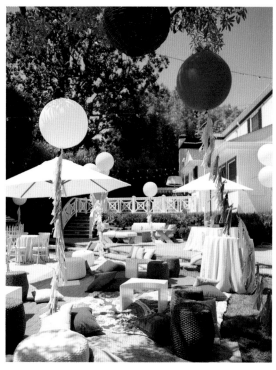

* *make a tight space work*. If you are in a smaller apartment, invest in some lightweight folding chairs you can store in a closet or hang on the back of a closet door so that you can still create comfortable seating for guests.

* *be considerate of older guests*. Think about where to position them for their comfort (closer to bathrooms and away from tricky walking paths).

Two things that are easy to forget when event planning: (1) You must have somewhere for guests to park and provide them with a good description of the parking setup if it's complicated. (2) Think about temperature. It has to be comfortable. Have heaters, blankets, and wraps for your guests if it's chilly, or fans, AC, shade, and cool drinks if it's hot and humid.

—STEFANIE COVE

9. **MUSIC** Do not underestimate the power of music. As DJ Michelle Pesce says, "It can make or break your event." Avoid leaving the creation of your playlist to the last minute and follow her other tips for creating the best musical environment:

* Most parties have a beginning, middle, peak, and then a slow-down at the end, and your music should follow this pattern. Create separate playlists for each stage of the party for seamless DIY DJing.

* Don't throw the biggest hits on during the first hour. You've got to build! Get the groove going and then turn up the party.

* Variety! Don't just play Top Forty. It won't feel like your event—it'll feel like listening to the radio. At the same time, don't play all the B-sides of obscure indie-rock bands that only you and your BFF know. Mix it up.

* If it's not your strength, ask someone else to DJ. Ask your supermusical supermodel friend to bring her favorite playlists to your party.

* An affordable professional alternative? Hire a DJ to create playlists for you and program your iPod for a guaranteed kick-a** night!

* Always do a sound check, whether you're hosting a big event or small. And don't do it five minutes before guests arrive.

* Sound: Not too loud, not too soft. Keep the type of event and the timing in mind.

* When in doubt, think about the general age of your guests and take them back in time. People love to be reminded of music from their youth and high-school and college years. It's generally a no-fail technique to making people get up and groove.

* And always remember . . . music is sooo personal. You cannot and will not please everyone, so at the end of the day, play what you love!

A great playlist is a must! I always make sure to prep it in advance and start the music while I'm setting up to help set the mood.

—JENNI KANYE

molly and dj michelle's
go-to music list

Here are some classic, tried and true tunes we love. Use these as a base for your set list, sprinkle in a few of-the-moment hits, and you are good to groove.

DAYTIME

"Here I Am," Al Green

"I Wish," Stevie Wonder

"Rock with You," Michael Jackson

"Modern Love," David Bowie

"Mr. Jones," Counting Crows

"Heart of Glass," Blondie

"Sympathy for the Devil," the Rolling Stones

"American Girl," Tom Petty and the Heartbreakers

"Give It Away," Red Hot Chili Peppers

"Holiday," Madonna

"Like I Love You," Justin Timberlake ft. Clipse

"Paper Planes," M.I.A.

"Sun Is Shining," Bob Marley

"Sweet Dreams (Are Made of This)," Eurythmics

"Where the Streets Have No Name," U2

"Jane Says," Jane's Addiction

"It's Still Rock and Roll to Me," Billy Joel

NIGHTTIME

"Doo Wop (That Thing)," Lauryn Hill

"Real Love" (remix), Mary J. Blige ft. The Notorious B.I.G.

"I Want You Back," the Jackson 5

"Crazy in Love," Beyoncé ft. Jay Z

"Who's That Girl," Eve

"We Found Love," Rihanna ft. Calvin Harris

"Poison," Bell Biv DeVoe

"Like a Prayer," Madonna

"Freedom '90," George Michael

"Sweet Child O' Mine," Guns N' Roses

"Brass Monkey," the Beastie Boys

"Dancing on My Own," Robyn

"Baby I'm a Star," Prince

"Don't Stop 'Til You Get Enough," Michael Jackson

"Good Life," Kanye West ft. T-Pain

"California Love," Dr. Dre and Tupac

When planning a celebration—you will make a million decisions. My advice to you? Make each one confidently, and then *move forward*. This applies to most aspects of life but is especially important when planning events. Picking a theme, colors, who to invite—these are all decisions. There are lots of beautiful ways to do an event, and no one way is ever the only way. Decide and don't look back.

my everyday supermodel go-to entertaining look:
When entertaining, it's important that you feel good and comfortable. Have a go-to look that you love and love on yourself. When Cindy Crawford entertains, nine times out of ten, she is barefoot and looks comfortable, casual, effortless, and in her element. For me? It's usually some flowy, floral dress, stylish flats, mascara, and a red lip—oh, and a glass of rosé in hand. Find yours.

my day-before *do-ahead* list

* Set the table, and add candles and decor pieces like flowers.
* Make any dishes that simply need to be heated up later.
* Cut up garnishes for cocktails and beverages.
* Program music playlists.
* Get excited, and get your guests excited about your event. Send them an email or give a call to let them know how much you are looking forward to them coming!

guest prep

Here are a few things you want to always keep in mind when friends or family are coming over for an event:

* **SOMETHING FRESH** Fresh flowers and fruit add personality and polish. Put out a bowl of fruit, fresh lemons or limes, pomegranates or apples—whatever is in season—and a simple arrangements of greens from the garden or a more floral flower arrangement. These simple steps can transform a space.

* **LET THERE BE LIGHTING** Turn off or dim bright overhead lighting. Turn on the lamps. If it's daytime and the weather is nice open all the shades, curtains, and windows.

* **BATHROOM BLISS** Create a little retreat in the bathroom, the kind you'd find in a fancy hotel. Put a candle and nice hand soap and hand lotion in the bathroom. For special guests and parties, we always put out the butler towels. They feel extravagant without actually being extravagant. We order them on Amazon. They are elegant, cushiony, and soft—and feel much nicer than drying your hands on a damp, used towel. And of course, make sure you have enough toilet paper and that an extra roll is visible for guests to see and replace if need be. And I am sorry to be so specific here, but let's keep it real: also have an elegant plunger accessible/visible just in case a guest needs it. *Please don't make them ask.*

CELEBRATIONS FOR EVERY OCCASION

Here's a peek into the special gatherings we've hosted over the past few years in our home. Use what we did for ideas and inspiration!

1. Chic Backyard Birthday BBQ
2. Casual Get-Together at Home
3. Intimate Dinner with Friends
4. Kids' Party Time!
5. Elegant Holiday Fetes

chic backyard *birthday* bbq

THEME 1 & 40 (I turned forty. Brooks turned one.)

GUEST LIST Neighbors, friends, and family members—a mix of all ages

INVITATIONS Because it was Brooks's first birthday, it had to be a printed invitation for me to save (aw, so cute).

STYLING Casual, fun-in-the-sun themed BBQ with balloons, a face painter, a kid zone, and lots of traditional BBQ fare in small bites

MUSIC Everything from Counting Crows (Scott's favorite) to reggae to some country and of course Jack Johnson's *Curious George* sound track (Brooks's favorite).

SAMPLE MENU

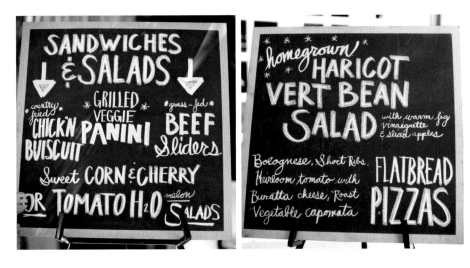

When it comes to entertaining, what we do a lot is we like to give people choices. I like buffet because it's easy to set up, it's not formal, you can wander around . . . sit, stand, talk, go back for more. It's just easy. People can bring something and contribute if they want to.

—CINDY CRAWFORD

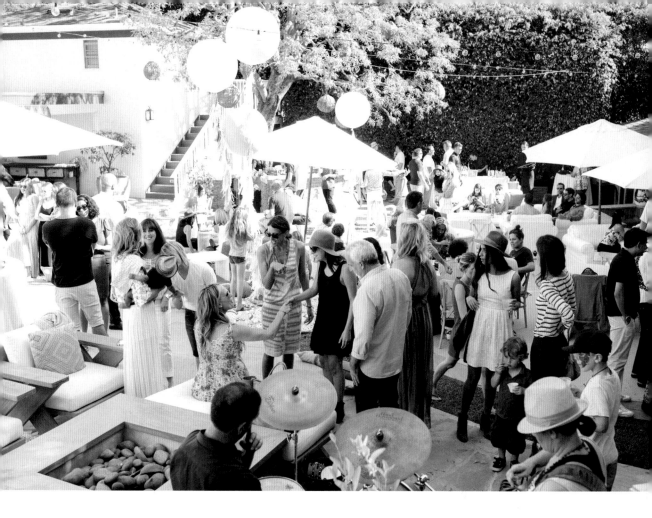

tradition
with a twist

Chef Gavan Murphy, a friend and my go-to barbecue expert, says, "Classic, comfort food items like burgers and hot dogs are always popular at a barbeque, but what people really love is a little surprise for their taste buds. Go for burgers, but maybe do bison burgers, and along with the traditional ketchup and mustard, offer guests a selection of chutneys and sauces."

DIY BAR

The DIY bar is a definite do! We love this concept. When it's done right, it's a win–win for both guests and hosts. It frees up the hosts to mingle and lets guests make fun drinks to their exact taste. It's not necessary to have every mixer and every type of alcohol on hand, but you must have the basics and a well-curated selection of interesting mixers. And don't forget to set it all up and display it with style. The bar is always a perfect place for chic styling—and a DIY bar is no different. Here are my suggestions:

✳ **SELECTION OF SPIRITS** An easy formula is to have at least one dark spirit and one light. Think vodka or gin for the light. And a rum, whiskey, or tequila for the dark.

✳ **SELECTION OF MIXERS** Always club soda. And depending on your spirits, add tonic, cranberry juice, and a light and dark cola. I generally avoid generic colas and bottled juices and instead like to offer more interesting, natural sodas and fresh, seasonal juices. Trader Joe's seasonally sells a delicious tangerine juice that kicks OJ's a** as a mixer. I also love to have healthy mixer options for my crew, like fresh-pressed vegetable juices, such as a cucumber or green juice. And cactus or aloe water is fun and refreshing too.

✳ **FRESH GARNISHES** Be sure to have the traditional lemons, limes, olives, and mint, but consider a few out of the ordinary additions. Edible petals and micro-flowers look so pretty when sprinkled in a cocktail and can often be purchased at specialty retailers. Rose petals, borage blossoms, and violets all work if you have them in your backyard.

Jalapeños are a great kick to add to drinks too. Or experiment with some of the herbal drink pairings recommended below. Get creative!

✳ PLENTY OF ICE Don't run out of ice! Ice. Ice. And more ice—whatever the party. For a smaller party—make gorgeous, floral ice cubes ahead of time. The day before, fill your ice trays with water, drop in a small floret or a petal, and freeze overnight. They are so pretty.

HERBAL DRINK PAIRINGS: *cheat sheet*

rosemary Warm, peppery, and piney, rosemary is great when blended with vodka and citrus-based drinks.

basil Sweet with a subtle pepper undertone, basil is the perfect complement to gin—and, of course, vodka.

mint Cool, refreshing, mild, and sometimes lemony, mint has a menthol note and blends extremely well with rum. (Mojitos, anyone?)

tarragon Slightly bittersweet and aromatic, with a hint of pine and licorice, tarragon suits both vodka- and gin-based bevs.

wine time

When it comes to wine, I am no sommelier, but I won't pretend not to absolutely love this Dionysian beverage. Below are a few of my all-time classic favorites in a variety of budgets.

favorite whites

Cakebread Cellars chardonnay

Kim Crawford New Zealand
 sauvignon blanc

2013 Dog Point Vineyard Section 94
 sauvignon blanc

Au Bon Climat chardonnay

favorite reds

2014 Bedrock Zinfandel Old Vine
 Vineyard

2012 Eyrie Vineyards pinot noir

Flowers Sonoma Coast Pinot noir

Joseph Drouhin Burgundy

favorite rosés

Whispering Angel

Miraval

2015 Château Riotor

Wolford Estates Estate Rosé 2016

favorite bubbles by budget

Pricey: Veuve Clicquot Brut Rosé

Midrange: Schramsberg Brut Rosé and Schramsberg Blanc de Noirs, Billecart-Salmon Brut Réserve, Perrier-Jouët Belle Epoque Brut

Budget-Friendly: Roederer Estate Brut

everyday *supermodel* spiked slushie

Imagine the most refreshing, icy beverage on a hot, sunny summer afternoon . . . and it's spiked for your sanity! Now these will take you back to your childhood slushie-drinking days, but with a kick. They have become so popular and for good reason. Give mine a try, and if you need me, I'll be in the backyard poolside wearing a floppy hat, oversize sunglasses, and sipping my slushie, Zsa Zsa Gabor–style.

yield: 2 servings

INGREDIENTS

1 (750 ml) bottle rosé (choose your favorite!)

4 ounces Belvoir elderflower and rose lemonade or whatever lemonade perks your fancy

Lavender sprigs, for garnish

DIRECTIONS

Pour the rosé into ice trays and let freeze for at least 8 hours or up to overnight.

Place the rosé cubes, a handful of ice cubes, and the lemonade in a blender and blend until the ice cubes are at your preferred consistency. Pour into glasses, garnish each with a lavender sprig, and serve immediately.

AN ELEGANT *aperitif*

An aperitif is a light, low-alcohol beverage you serve during the day or before dinner to wet the palate. One of our absolute favorites to serve at house parties, because it's so chic and simple, is Lillet on the rocks. According to Stefanie Cove, "Lillet on the rocks is the best daytime party drink. It's perfect for spring and summer, a picnic, or anything outdoors. It's made from Bordeaux grapes from France and it's delicious, a bit unexpected, and always a conversation starter. If you want a rosé feel, but something more surprising, you'll love this. It looks especially lovely with a floral garnish." For a fall or winter aperitif wine, I love the Sommavite Brunello di Montalcino, a floral, fruity, leathery red Italian wine from Tuscany that truly excites the palate like an aperitif should!

general *party* tips

* Designate a place to put guests' bags and coats.

* Have to-go boxes available for guests to take home leftovers.

* Ask your chattiest guests to arrive early.

* Share hosting responsibilities with your circle of friends. Don't be afraid to ask for help.

* If the party is outside, think about temperature and sun! If it's warm, make sure there is adequate shade and have sunscreen available for kids. Spread around blankets or Pashminas if there is a breeze.

casual *get-together* at home

THEME Movie Night or Game Night

GUEST LIST A small group of neighbors and friends

INVITATIONS Text message, phone call, or email. Anything goes here.

STYLING Generally, cleaning the floors of smooshed cereal and puppy pads. Always included are flowers or some freshly cut foliage or branches from the garden in an oversize vase.

MUSIC Definitely tailored to the crowd since it's a small, intimate group. Think modern and upbeat but not too loud.

SAMPLE MENU We order in! Usually family-style foods like Chinese, Italian, or sushi. If I'm feeling extra sassy, I'll mix up a signature drink.

I'm all about being as relaxed as my guests, which means keeping it as simple as possible. My formula for a good night in with a few friends: light the candles, pull out the wine, order takeout, and cue up the Netflix. Done and done.

—JESSICA ALBA

appetizer

No Fail Nachos
corn tortilla chips, shredded cheese
black beans, roma tomatoes
red onion, radishes, avocado, jalapeno
& cilantro

main course

Grilled Fish Tacos
with lime cabbage slaw

Grilled Chicken Tacos
with roasted tomatillo salsa

cocktail

Skinny Moscow Mule
vodka, ginger beer, green tea
fresh ginger, & lime

game night

"no fail" nachos

Even though I said you don't have to cook for a relaxed, casual get-together, sometimes I like to make an easy, delicious appetizer to get the taste buds going. Then we order in. Nachos are a great way to feed a crowd during a casual get-together before dinner is served. I have never met a plate of nachos I didn't like. Honestly, have you?

yield: *4 to 6 servings*

INGREDIENTS

6 cups corn tortilla chips
2 cups shredded mozzarella or
 cheddar cheese
1 (16-ounce) can black beans,
 rinsed and drained
4 roma tomatoes, cored, seeded,
 and diced
½ to ¾ cup diced red onion
6 radishes, trimmed and sliced
1 large avocado, pitted, peeled,
 and diced
1 jalapeño, thinly sliced
½ cup chopped fresh cilantro

DIRECTIONS

Preheat the broiler. Arrange the chips in one layer on a baking sheet. Sprinkle the chips with the cheese, evenly spoon the beans on top, and broil until the cheese melts, 1 to 2 minutes. Remove from the oven and scatter the tomatoes, onion, radishes, avocado, jalapeño, and cilantro over the nachos. Serve hot.

You don't have to cook at all when having friends over for a casual dinner. Order in, but serve it all up on your grandmother's china platters, your marble cheese board or aged cutting boards, and in your favorite serving bowls! Throw away the take-out boxes, and arrange everything beautifully. And then if you really want to feel like you are "making" something for your guests, serve up a pitcher of a special signature cocktail or an easy appetizer to serve when mingling before dinner.

molly's skinny moscow mule

Served in copper mugs, this version of the classic vodka cocktail has been lightened up with green tea, diet ginger beer, and grated fresh ginger to make it the perfect fit for everyday supermodels. We've served this at a bunch of backyard barbecues and it's always a hit with the ladies and gents. To really lighten it up, replace the ginger beer with sparkling or soda water. Also, subtracting the vodka for preggos and tee-totalers doesn't make it any less delish!

yield: *4 servings*

INGREDIENTS

- 2 cups chilled diet ginger beer (I like Bundaberg) or diet ginger ale
- 1 cup vodka
- 1 cup chilled green tea
- ½ cup fresh lime juice
- 1 teaspoon grated peeled fresh ginger
- 4 slices peeled fresh ginger
- 4 thin lime slices

DIRECTIONS

Stir together the ginger beer, vodka, tea, lime juice, and grated ginger in a pitcher. Fill copper mugs or glasses with ice and pour the vodka mixture over it. Garnish with ginger and lime slices and serve.

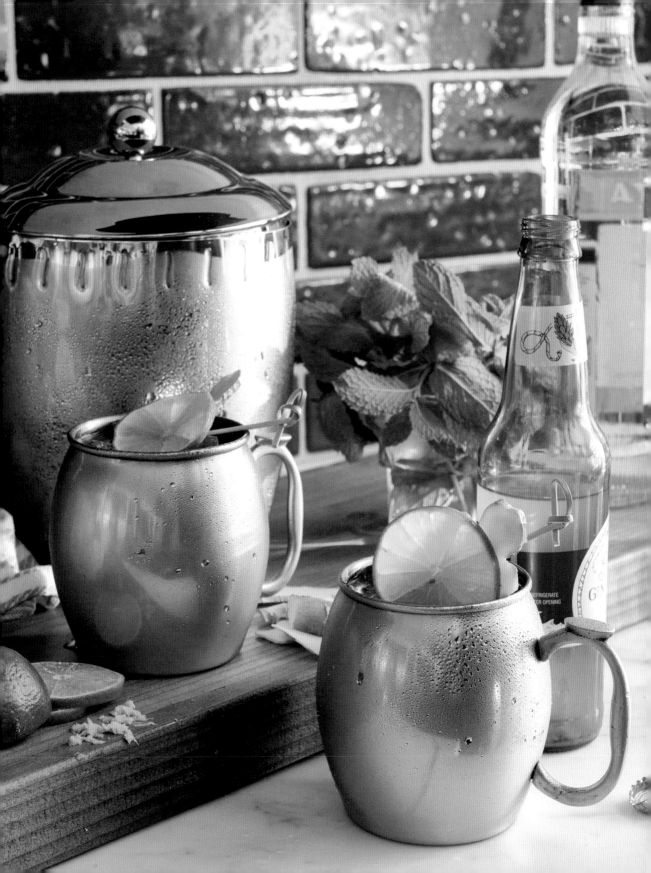

cindy crawford's *casamigos* margarita

Cindy has always made the best margaritas in town, and that was even before her hubby owned a tequila company! This recipe of hers is the perfect balance of spicy and sweet, with subtle citrus and herbal notes.

yield: *4 servings*

INGREDIENTS

4 ounces fresh lime juice

2 ounces orange-infused syrup

8 ounces Casamigos blanco tequila

8 cucumber slices, for muddling

Handful of fresh cilantro leaves

Sugar, chopped fresh cilantro, ½ slice of grapefruit, and salt, for rimming the glasses

4 slices cucumber, for garnish

4 slices serrano, for garnish

DIRECTIONS

Pour the lime juice and orange syrup into a shaker, then add the tequila. (Make sure to add the tequila last just in case you mess up! It's always better not to have to dump the most expensive ingredient.)

Muddle together the cucumber and cilantro leaves and add to the shaker. Add ice and shake vigorously for 8 to 10 seconds to chill.

Pour the sugar-cilantro-salt mixture onto a plate. Rim the rocks glasses with the grapefruit, then dip in the glass rims to evenly coat. Strain the margaritas into the rimmed glasses. Add fresh ice (fresh ice prevents the cocktail from diluting quickly). Garnish each glass with cucumber and serrano and serve.

chocolate bar buffet

I've adopted this chic and easy dessert "recipe" from my friend Mimi Brown. There is honestly nothing simpler on earth, but I promise it's just as satisfying as any dessert that takes five hours to make.

INGREDIENTS

Select a variety of artisanal chocolate bars, blocks of chocolate, and some good ol'-fashioned favorites (think Snickers and Skor bars)

DIRECTIONS

Freeze the chocolate bars in advance for a few hours. Remove from the freezer and break them apart into chunks and slivers. To serve, display the pieces on a marble cheese board or wooden cutting board. It's simple, but guests go crazy for this. It's decadent and a major dessert shortcut!

pamela salzman's no-churn gelato

This is a serious treat for your tongue. It has the creamy texture of Italian gelato but without all the sugar and cream. Plus, you don't need an ice cream maker to churn out this smooth and delicious treat, only a food processor. It's the perfect dessert for serving at a summer soiree when strawberries are at their ripest. The best part is, you can use almost any fruit that's in season.

yield: 1 quart

INGREDIENTS

2 pounds strawberries, hulled and cut into ½-inch pieces

3 tablespoons freshly squeezed orange juice

½ to ⅔ cup sugar or honey (not vegan) or a half-honey/half-sugar mix

¼ cup unsweetened whole-milk Greek yogurt or coconut yogurt

DIRECTIONS

In a large bowl, toss the strawberries with the orange juice. Pour the mixture onto a rimmed baking sheet and spread out evenly in one layer. Place in the freezer and freeze until solid, about 2 hours.

Break up the frozen berries so you can fit the pieces into a food processor fitted with the steel blade. Add the sugar and yogurt and puree for 4 to 5 minutes, stopping a few times to scrape down the sides. If the mixture is not turning creamy, allow it to sit in the food processor for a few minutes and then try blending again. Scrape into small dessert bowls and serve.

Store leftovers in an airtight container in the freezer. It will eventually freeze solid, so to achieve a creamy consistency again, you'll have to thaw it for a few minutes and then break it up into pieces and reblend in the food processor.

balsamic baked pears

These pears look superfancy, like you must have secretly graduated from an exclusive French culinary academy, and did I mention they're incredibly delicious and fill the house with the most intoxicating smell?

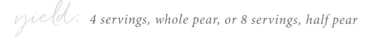 *yield:* *4 servings, whole pear, or 8 servings, half pear*

INGREDIENTS

4 Bosc or Anjou pears, halved
 and cored
5 tablespoons balsamic vinegar

1 cup honey
8 ounces goat cheese, crumbled
Pepper

DIRECTIONS

Preheat the oven to 400°F. Line a baking sheet with parchment paper.

Arrange a single layer of pear halves on the prepared baking sheet and bake for 20 to 30 minutes. Remove from the oven, drizzle with the vinegar, and return to the oven to bake for another 5 minutes.

Transfer the pears to a serving platter and drizzle with honey. Sprinkle the goat cheese evenly over the tops, and finish with a few grinds of pepper. Superyummy!

everyday supermomma entertaining tip

At a mixed-aged get-together at home, always remember that kids tend to finish eating first and adults always linger at the table. I advise having a self-sufficient activity planned for the kids for when they finish dinner so that the parents can continue being adults. The key is to have this activity prepared in advance so you don't have to scurry to find something and interrupt your fun! My husband has a huge selection of movies on hand, so we'll have a few out and ready for the kids to choose from. I also always set up a kids' table with paper, books, pens, and pencils for drawing and coloring. That way something is already prepared, and they can go nuts while we grown-ups buy ourselves a little extra time at the table.

intimate dinner with friends

THEME I often base themes around the season, a special reason for the dinner (such as a congrats on a friend's promotion or pregnancy), or a type of cuisine (Tex-Mex, Pan Pacific, Italian with a twist).

Recently, we had girlfriends over for a fall "harvest holiday" dinner with Simone LeBlanc. Before dinner, Simone set up a chic wrapping table where we learned to make custom wreaths and decorate gift boxes in her oh-so-chic way.

GUEST LIST Ten to twelve people tops. And I try to pull from a diversity of my friends. A dinner party is a great time to introduce new friends to older friends since the more intimate environment makes it comfortable and easier to introduce new people.

INVITATIONS A simple email usually does the trick. If you want to go more formal, for a holiday or other celebrations, then an elegant digital invite will do.

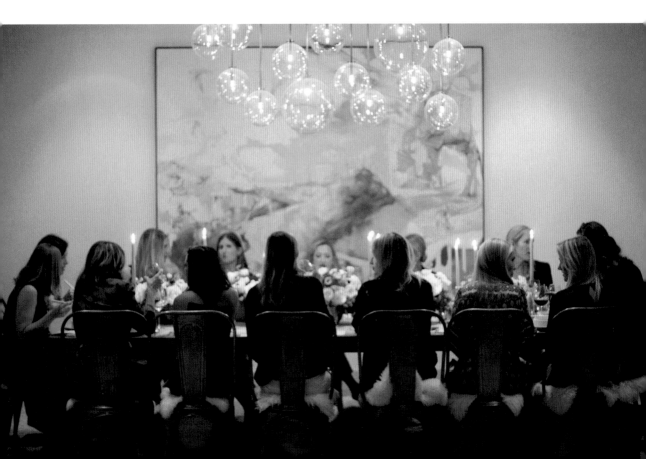

STYLING The dinner table is the focus. Always a tablescape and a printed menu (for more on seasonal tablescapes, see page 118). We also have lanterns lit and scattered in the front garden and in the backyard seating area for romance and ambience. Live arrangements of flowers or greens in the intimate gathering spots of the house can be simple and straight from the garden or yard or something more elaborate.

MUSIC A mix of classics like the *Great American Songbook*, Ella Fitzgerald, and Frank Sinatra and modern masters like Ray LaMontagne, John Legend, and Adele. The key is to keep it as background, not blasting.

SAMPLE MENU

October 19, 2016

First

A Dim Sum Trio
Shrimp, Green Vegetable and
Mushroom Dumplings

Entree

Tokyo Shiro Ramen Noodles
Served with or without poached Jidori Chicken Roulade
Japanese Vegetables, Organic Egg and Wakame
Vegan option available Upon Request

To Finish

Lots of Sweet Treats; Save Room!

I always prefer to serve family style for a dinner party because it creates conversation and a less formal atmosphere. I also like to serve on bamboo plates and use bamboo flatware, making cleanup very easy.

—RACHEL ZOE

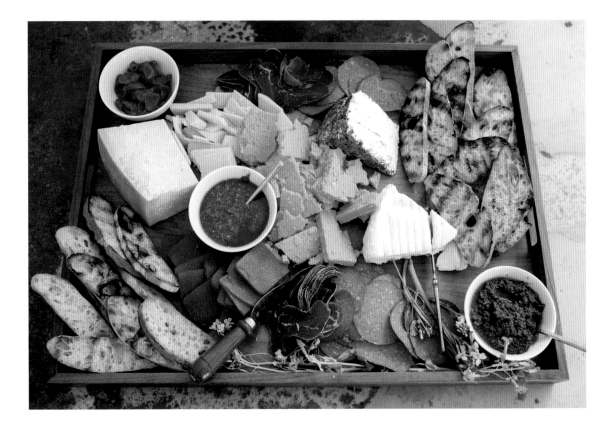

platter UP

Building the perfect charcuterie platter is a no-brainer for fuss-free entertaining. These work for any kind of dinner party, big or small, fancy or casual. I always have one prepared when guests arrive. Guests love to nibble and nosh while drinking wine, in anticipation of the delicious meal to follow. I love creating beautifully balanced and presented platters. Follow this formula and you will be making party platters in your sleep:

the perfect platter:

✳ Satisfy all senses by including something salty, something sweet, something bitter, and something savory.

everyday *supermomma* secret

If you are not overly confident in the kitchen, that's okay. I try to focus on working smarter, *not harder*. High-quality food and ingredients impress on their own, so you don't have to. Have you seen the watermelon radish? It's like the Gisele of radishes. Slice it and serve it in a simple green salad, and tongues and eyes will wag. Chioggia beets? A total kaleidoscope of color and interest for your guests' dinner plate and palate. Throw those in a roasted veggie medley, with a little olive oil, salt, and pepper and you are good as gold! Create simple dishes around extraordinary ingredients and you can't go wrong. It's a little bit of a sneaky shortcut, but it works every time.

* Include a range of meats—at least one that is soft and mild, like prosciutto, and one that is firm and stronger flavored, like salami.
* Include a range of cheeses—at least one that is soft and mild, like brie, and a stronger choice, like Gouda.
* Have a bit of soft bread and something crunchier, like crostini or crackers to complement the different textured meats and cheeses.
* For something sweet, include grapes, fresh or dried berries, and a dollop of local honey, which goes beautifully with certain cheeses, like goat.
* For something acidic, include dill pickles or cornichons—or even pickled jalapeños.
* For something nutty, include salted, toasted, or raw almonds, cashews, or pistachios.

serving Tips Serve on a large wooden breadboard and garnish with fresh herbs or flower petals.

kids' *party* time!

THEME We've had some really fun birthday parties for the kids over the years, and the themes are usually inspired by their favorite characters or toys of the moment. Here are a few we've had: Batman Birthday Bash, Curious George, and LEGOs (for Brooks) and Cupcakes and Rosé and the Magical Unicorn Party (for Scarlett). Nicola Vruwink from Poni is our go-to girl to help get creative!

GUEST LIST Family, friends, neighbors, classmates, and parents

INVITATIONS Paperless Post. This is an informal and easy option that allows us to track the guests.

STYLING Always a giant, vibrant Happy Birthday sign; colorful balloons everywhere like crazy—big and small—and on-theme decor. I also love floral garlands on the tables at kids' birthday parties and lots of casual seating with rugs and pillows.

MUSIC I've hired friends who are musicians, like my friend Melissa Green (who also has a superfun sing-along album, *Sing Loud!*, you should check out!), to bring a guitar and play songs that kids and adults enjoy, like the Beatles, Jack Johnson, and Maroon 5.

SAMPLE MENU Bite-size nibbles and healthy, hearty foods kids love. And always Popsicles if it's a backyard, summer shindig.

FUN ACTIVITIES We always have craft tables/activities at our kids' parties. They take a little bit of prep work to set up, but they are so cool for kids. Usually, the crafts are on theme with the party. For Scarlett's Magical Unicorn party, we made pretty, little unicorn headbands and ribbony wishing wands. But a craft table can be as simple as butcher paper and crayons laid out on a picnic table for children to color and create together.

supermomma kids' party tips:

* Make sure to have kid-size seating around. Get creative. Stools and sturdy buckets can double as kids' chairs in a pinch, and ottomans can be easily moved from inside the house to outside.
* Throw down some rugs, blankets, and pillows for a quick and casual

kids' or adult seating area. Bales of hay
with blankets work too, as does setting up
little tents or tepees in the backyard for
shade.

* Put kids' drinks in stainless-steel buckets
within reach of the little shorties. While
they still have to ask parents' permission
to have one, this way they can at least help
themselves.

* Serve adult food too. This is one of my
husband's pet peeves! Please don't make
us eat one more chicken finger at a kids'
party!

* Today, you have to be really careful about what you serve. Avoid all
the major allergens just to be safe.

party styling Tip Always have a place for a great photo op. Have some-
thing big at the entrance or in the backyard that's a focal point of fun. My go-to is
a big sign with the birthday girl's or boy's name in balloons. And paper garlands or
pendant flags. Lots of garlands! And I have to admit, while I usually keep it really
simple, this year we went a little over the top and, yes, actually got a pony that we
dressed as a unicorn for Scarlett's second birthday. It was so cute and the pictures
are beyond adorable. All worth it!

everyday *supermomma* secret

Another great idea for backyard parties
with toddlers is to set up a play center. Use
modular toddler fencing to create a little
toddler "zoo" where they can sit, play, and
roll around safely inside. Lay blankets and
rugs on the grass, arrange pillows for comfy seating, and set up the area with a
few toys. This is great for parents with young children, because they are confined
and aren't running all over the place, so you can easily watch them. It helps set the
parents at ease and baby-proofs at least one, specific area.

we all *scream* for popsicles!

My kids and their friends are crazy for Popsicles. For any backyard birthday with the babes, I love to offer them as treats. And they just scream fun, yum, and summa-summa-summatime! I love to make healthier versions with layers of real, pureed fruit and just a little ice cream. Your superkiddos are going to go bonkers for them (and you will too!). Just watch out for brain freeze. I went on a bit of a Popsicle bender recently and discovered Tovolo Groovy Pop Molds, which are my new favorite (though you have to be a bit patient to get them to come loose from the mold). There are so many flavor combinations you could try for a birthday party. My suggestion is that you make a few bases in flavors that you and your family enjoy and then play around with different combos. They can be a little messy and drippy. An easy solution is to poke the Popsicle stick through a cupcake wrapper and slide up the wrapper to the base of the Popsicle to catch drips. Here are our superfamily faves:

three-layer *luscious* lickers: mango, raspberry + cream

yield: 6 Popsicles

INGREDIENTS

MANGO LAYER
1 (12-ounce) bag frozen mango
 chunks
1½ cups limeade

RASPBERRY LAYER
1 (12-ounce) bag frozen
 raspberries
1½ cups lemonade
2 tablespoons dark maple syrup

CREAM LAYER
3 cups honey nonfat Greek
 yogurt (if using plain, add
 honey to taste)
¼ cup skim milk (you may need
 more, you may need less; the
 mixture should be pourable,
 but not too thin)

Put the mango and limeade in a blender and blend until smooth. Fill one-third of the molds with this mixture and place in the freezer for 20 minutes. Rinse out your

blender and proceed to blend the raspberry layer. Fill the second third of the molds with this mixture and return to the freezer for another 20 minutes.

In a small bowl, mix together the yogurt and milk. Fill the remaining space in the molds with this mixture and return to the freezer for a final 20 minutes.

These base layers are also absolutely delicious on their own as a single flavor. For a twist on the cream base, add some pieces of chopped fruit (fresh or frozen) into the mix.

molly's michelada *(adult!)* popsicle

Don't let the kids have all the Popsicle fun. Here's a delicious if not-so-nutritious spiked Popsicle that big boys and girls love.

yield: 6 Popsicles

INGREDIENTS

2 cups diced tomatoes

Juice of 1 lemon

Juice of 1 lime

Dash of Tapatío or your favorite hot
sauce

1 teaspoon Bragg liquid aminos

Dash of celery salt

Pint glass of your favorite beer

DIRECTIONS

Place all the ingredients except the beer in a blender and blend until smooth. Pour into 6 Popsicle molds and place in the freezer for 2 to 3 hours.

Once frozen, dip a Popsicle in the pint glass full of beer and drink up! The mix of flavors is *delicious*!

elegant *holiday* fetes

Holiday gatherings or intimate dinners are an ideal excuse for creating gorgeous, elaborate tablescapes. Who doesn't appreciate a beautifully decorated holiday table set for family and friends? Annie and Benton of a2b table are the best at whipping up a beautiful tableau for your table, and I've learned so much from them about how to create a memorable setting.

THE TABLE TABLEAU

This supermomma *loves a tablescape*. It is one of my all-time favorite things to do when entertaining an intimate crowd. And I get really, really into it. Why? It's fun, imaginative, and truly transports your guests for the evening. I believe there is an art to tablescaping. Is that an actual verb? Hmm, well . . . it is now! Follow these tips to create the perfect table tableau:

* **THEME AND COLOR PALETTE** A theme inspired by the season or a specific holiday is usually my go-to. But you can be as creative as you want to be! I'm often inspired by the type of cuisine we are serving and use that as a jumping-off point for the tablescape. If we are serving Asian food, perhaps I'll go with a subtle chinoiserie theme. If it's Tex-Mex, maybe mini-cacti, succulents, or calla lilies make an appearance. We have a huge painting in our dining room and the colors of it inspired the whole tablescape for a recent dinner we had. And while I love color, I do generally (although not always) keep to a more monochromatic look for simplicity's sake; I tend to stick with flowers and details mostly in the same color family. It's less risky and always elegant.

* **YOUR "WARES"** This refers to your dinnerware, glassware, and flatware. We usually go with white plating because it's easiest, but also have a set of gray, which I love to use for a moodier setting. For our

wedding, we rented mix-and-match vintage floral plates, which were so gorgeous for the garden setting. I have a set of brass flatware that we use often, and you'll never go wrong with silver (if you can bother with it), although we usually don't and rely instead on our day-to-day stainless steel! Glassware? It depends on how formal or informal we want to be, but as for Annie and Benton (and I!), we all *love* colored wineglasses for a touch of serious style. Choose a color depending on the season, and they don't have to be expensive! You can often find pretty little numbers at your local dollar or home-discount store. Frankly—you can always find fun, funky, and affordable glassware at secondhand stores and flea markets.

* **LINENS** These include the tablecloth and napkins, runner, and placemats or chargers. For linens, if you have a white linen tablecloth and a warm or cool neutral (such as oatmeal or gray) and a dark fabric (such as a deep navy), you can never go wrong. One of those can serve nearly any event. Annie and Benton recommend hitting up a fabric shop and finding inspiration there. (Since they have to create tablescapes for clients, they often get an entire theme from a piece of fabric.) Sometimes a fun piece of fabric can become your tablecloth, and it's generally very affordable. If investing in chargers, I think simple, clear glass, metal, or white ceramic chargers are the most versatile.

* **CENTERPIECE(S)** I promise you, here is where you can be creative. Go with a classic floral arrangement if the table is round. Currently, I am obsessed with the romantic look of flowers in whimsically shaped

everyday *supermomma* secret

When planning a dinner or party, everything does not always go smoothly. You will have to be on your toes. For one dinner party I hosted, we'd ordered two linens for the table. They arrived and were not wide enough for the table. I had to take an existing linen I already owned and tape it to the new linens to create one very wide linen that would actually fit the table and hit the floor. Table linens (like curtains) should always hit the floor, you know! It was a little hairy, but in the end, it looked gorgeous and no one knew the difference.

For a last-minute detail, I love to add a little something at each place setting to make the tablescape feel extra personal—whether it be sprigs of fresh herbs on each napkin, or a homemade gift that guests can take home with them. In the fall, I gravitate toward homemade cranberry sauce or a pumpkin scrub, and in the spring I like to take advantage of my garden and pull together fragrant floral bundles.

—JENNI KANYE

(nothing over the top) bowls or urns. My girlfriend Mimi Brown, who does flowers often for Gwyneth and Goop parties, loves a few pretty florals strewn in small to medium glass jars and vases down the center of the table. You obviously can never go wrong with flowers! But—if they are not in the budget, no biggie! Simple greens can look just as fresh and pretty. Keep in mind, centerpieces and table decor should be low enough to see over (or high enough to see below!). Otherwise, guests won't be able to socialize across the table—or worse—your hard work will be taken off and placed on the floor (I've been there!).

* **CANDLES + TABLE JEWELRY** Most often, we use a mix of candles and candlesticks. I love white tea lights in votives mixed with taller votives. They go with everything, glam things up, add sparkle—and are the perfect height and size for tables of any shape or size. Tall taper candles in a rich color can be very chic too. Recently we've done all gray, all navy, and all crimson. They add a layer of intrigue and sophistication to the table. I often also sprinkle the table with a few shiny objects: a brass or silver bowl, or a mirrored tray can add a touch of elegance and help reflect the candlelight. Here is when "table jewelry" really ups the ante when going for glamour and sophistication.

* **MENU AND SEATING** If I've planned a more formal gathering, I'll place a printed menu on the plate and a place card for the name. For formal events, I find that determining the seating in advance takes the guesswork out of things for the guest and makes things more comfortable and streamlined. For a more casual dinner, a handwritten menu on a chalkboard is fun—and "seat yourself" works perfectly.

* **SEASONAL DESIGN DETAILS** I love to include special decorative touches that really speak to the season or specific event. For example,

if it's springtime, we'll feature soft pastel colors, cubed vases of wheatgrass on the table with dyed Easter eggs buried inside. For our last Christmas holiday, we eschewed the traditional red-and-green trend and set the table in all white but incorporated iconography characteristic of the season. We placed white frosted-glass pine-tree-shaped votive holders all down the center of the table. It was stunning! Here's where glass hurricane lamps with bases come in superhandy. They make perfect centerpieces for showcasing seasonal details. For the fall one year, we filled them with spray-painted rose gold leaves. Think flowers in spring, citrus fruits in the summer, and so on. . . .

tablescaping ideas
from annie and benton

Create different heights with arrangements, votives, candles, and other details.

Always order the long-burning, dripless candles that burn 8 to 10 hours, and remember, it's best to avoid scented candles for the tablescape as they interfere with the food and flavors.

Spray paint is your friend! Save various glassware, wine bottles, jars, or little pots and spray-paint them in your theme color. Spray-paint vegetables, like pumpkins or gourds, all white or all black for a sophisticated and spooky Halloween tablescape. (We did one like this that I loved!) Dried leaves, stones, and sticks found at a park or in the garden are also beautiful when sprayed a copper, silver, rose gold, or pearl.

Tie helium balloons with fishing wire or thin twine to arrangements, vases, vintage bottles, or even stones—and place the weighted pieces down the center of the table, in a long, straight line. The weighted balloons add height and drama to your tablescape.

Want to add some extra glamour (and comfort) to your seating? Faux-fur pieces placed on dining seats do the trick.

seasonal looks

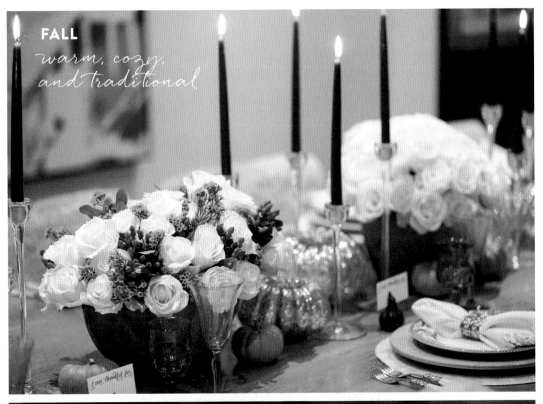

FALL
*warm, cozy,
and traditional*

❄ **WINTER**
*whimsical, white
wonderland*

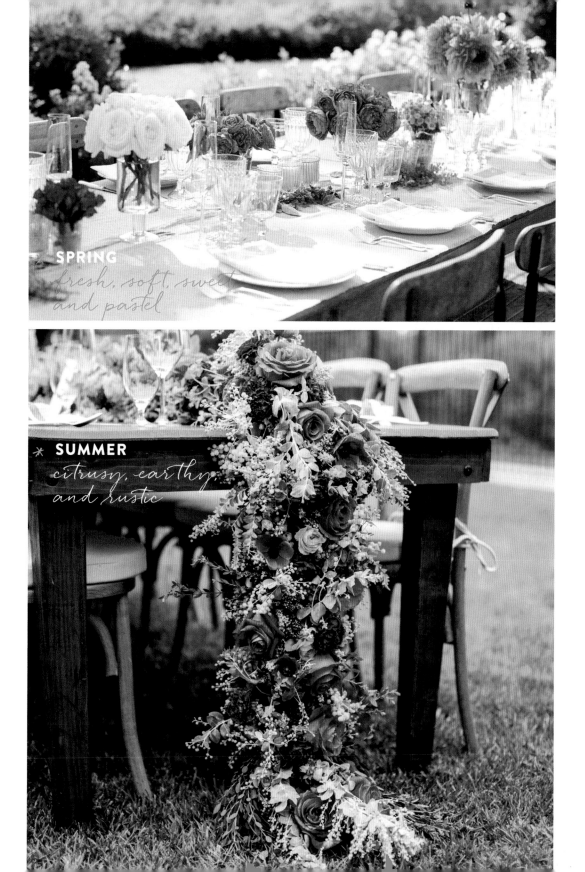

SPRING
*fresh, soft, sweet
and pastel*

❋ SUMMER
*citrusy, earthy,
and rustic*

THE *art* OF GIFTING

The holidays are not only a time of entertaining, but also a time for giving (and probably for *forgiving,* too!). When you are in search of the perfect gift, think outside the "bottle of wine" box. Here are a few of my favorites that don't take a lot of effort but show you spent a little more time in consideration of your hosts.

* **PAMPERING YOUR PEOPLE** Think decadent hand cream, nourishing facial mask, organic linen spray, herbal soaps, or loose-leaf tea. Something that says "spa-ahhhh" all over it is usually a big hit. Even for the guys—trust me! Just because they won't buy it for themselves doesn't mean they won't be slathering on that luxe eye cream with their pinky fingers every night before bed.
* **BURN NOTICE** A luxury candle is always chic and feels special. I haven't met a candle I've been given as a gift that didn't personally light my fire.
* **CUSTOMIZED STATIONERY** One can never have enough stationery. Paper goods have an elegance, richness, and intimacy that other gifts don't share. If there isn't time to have a monogram whipped up (which I get—there probably isn't), it's still an item that is always appreciated and endlessly practical.
* **HOMEMADE OR HOMEGROWN GOODIES** Everyone loves something

The thing about entertaining is that it gets intimidating for people. The reason you get together is to socialize, not to have the best meal of your life. Keep it simple and remember the food is only secondary. It's about getting together, spending time together. If the hosts are stressed, it just isn't as much fun for anyone. Relax, enjoy yourself and so will others.

—CINDY CRAWFORD

homemade or homegrown. Do you make a mean banana bread? What about a mint jelly or apricot chutney that puts all others to shame? Do you have a juicy lemon tree that keeps on giving? Or the best pomegranates known to man? Wrap up your homemade or homegrown goods in some butcher paper and ribbon, or pack them in a sweet little basket with some decorative tissue and ribbon—and share your bounty with your hosts.

* **BOOK SMART** Maybe you haven't turned on your oven since 1999. But you are in the know when it comes to bestsellers or indie favorites. Gift the page-turning thriller that everyone's talking about, a timeless coffee-table tome, an uplifting book of inspirational quotes, or the of-the-moment comedienne's hilarious memoir.

* **SOMETHING FOR THEIR KIDS (OR FURRY KID)** A treat for the kids is always a good thing, but a word to the wise: if there are multiple children, it's best to get the same thing for each child or something that they can all share (not that these share-challenged ankle biters will necessarily share). Ask ahead if their furry friends have any allergies or special favorite treats. My dogs will eat *anything*, but I know a lot of dogs are allergic to chicken, so double check!

* **ANYTHING IN A PRETTY PACKAGE!** People go crazy for nicely wrapped packages. Beautiful soaps, exotic condiments—you name it.

Entertaining is something that I have learned to master. It wasn't something I was always good at—or even enjoyed for that matter. After years of attending events, taking notes, and having so many of my own celebrations, I've truly come into my own with regard to entertaining in style—and finally, in comfort. Whether you are Martha Stewart remastered or you are just getting your entertaining sea legs, remember, there are endless resources out there and nuggets of advice. But the best advice of all is to just go for it! And always follow my entertaining mantra: *Keep it simple, stylish, and stress-free.* You'll never go wrong!

TOP 10 takeaways

1. Master your fete fundamentals. Once you do, you'll be party planning like the professionals.

2. Build your "entertaining wardrobe" by gradually collecting essentials piece by piece over time, focusing on classics, and mixing in vintage pieces, versatile decor, and trendsetting accessories.

3. Take your party to the next level with tricks of the trade: have a theme, a focal point, fresh flowers, and candles, candles, candles!

4. Know what you can do ahead and get it done. That way you'll have more time for fun and engaging with your guests.

5. Always have a signature cocktail either premixed or available at the bar. It's fun, festive, and adds a personal touch. And don't run out, please!

6. Have a go-to meal that you can always prepare, including a dessert. Master the art of the charcuterie platter and there won't be anyone you can't impress in a pinch.

7. People love traditional foods with a twist. Don't be afraid to try something a little unique, and always go for small bites when it comes to appetizers.

8. When planning a kids' party, serve kids' cuisine as well as adult food. Please don't forget about the big people!

9. Tablescape it up and honor the art of gifting when it comes to the holidays. Never arrive at a house party without a gift in tow!

10. When entertaining at home, relax, be yourself, take off your shoes if you like (like Cindy!), and let goooo. After all, that's what it's really all about. *Enjoy.*

entertaining in style
my inspiration

AMANDA SAIONTZ GLUCK (@fashionablehostess, FashionableHostess.com. Amanda can literally turn any occasion into a chic soiree. Her tablescapes and details are to die for!

ANNIE BELANGER & BENTON WEINSTOCK @a2btable, a2btable.com. My tablescape gurus! Annie and Benton have such a great eye. Their mix of high/low makes creating a tablescape *so* simple.

EDEN PASSANTE @sugarandcharm, SugarAndCharm.com. Amazing recipes for any theme of party!

JENNI KAYNE @jennikayne, RipAndTan.JenniKayne.com. The ultimate. Jenni doesn't just throw an event, she creates an atmosphere.

JESSICA VARGAS @littlesparkscookies, LittleSparksCookies.com. It's not a party without cookies! Jess provides decoration ideas for any occasion! They may not look as good as hers . . . but it doesn't hurt to try!

LEILA LEWIS & ALLY STREELMAN @inspiredbythis, InspiredByThis.com. These ladies give some major entertaining inspiration . . . especially for weddings!

SIMONE LEBLANC @simoneleblanc, SimoneLeBlanc.com. The gifting pro. Her boxes are my go-to for any birthday, anniversary, hostess gift, etc. She proves that even the littlest touches make the difference.

LAUREN CONRAD @laurenconrad, LaurenConrad.com. She has simply beautiful feminine style that is great for baby showers and summer soirees.

ABBY LARSON @stylemepretty, StyleMePretty.com. This is the best wedding planning site out there, but so many of the ideas shared here are great for all kinds of events.

LAUREN SAYLOR @afabulousfete, AFabulousFete.com. Great inspiration for calligraphy, invitations, and menus. You can order designs right from her site.

NICOLA VRUWINK @nicolavruwink, HelloPoni.com. I love using Nicola for all our parties to help us create the perfect themed decor! She's honestly the craft queen. Anything you have in mind, she'll create it.

For more Entertaining in Style inspiration, plus shopping and sourcing tips, visit MollySims.com.

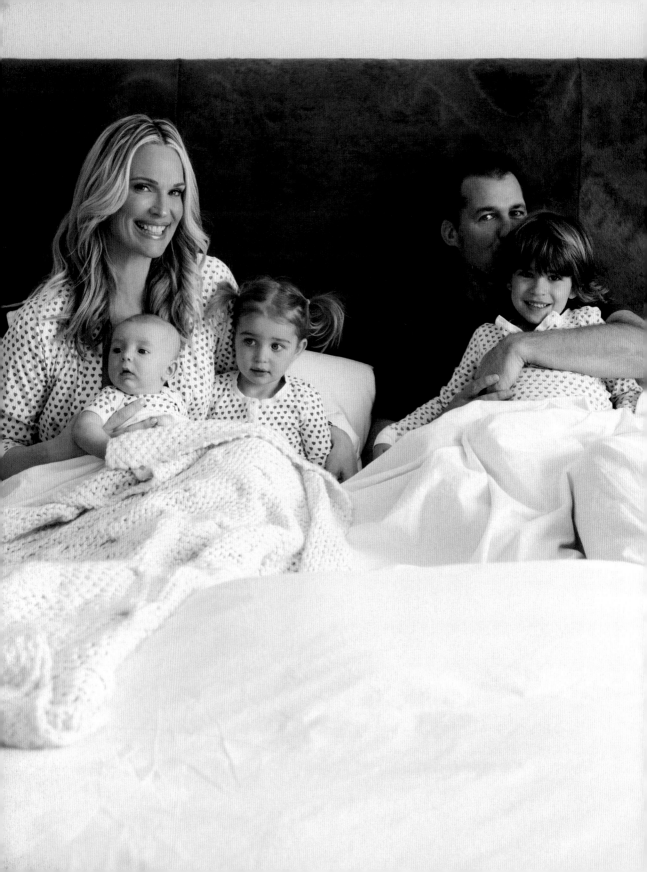

ch/3

happy, healthy home

Y our home should be *your place*. It should be your escape from all the craziness of the world. Like Dorothy said when she clicked her sparkly red slippers (slippers Scarlett would love!): "There's no place like home." There simply isn't. My home and my family are my sanctuary. They are my magic. They are my *everything*. As I've said before, our home is the heartbeat of our family, and it's probably yours, too. In our home, we aim to cultivate comfort and positive energy in all the ways we can. Happiness and harmony at home can be cultivated in the *physical environment*: is our home clean, organized, cozy, and comfortable? But it is also about the *emotional environment*: are we respecting one another, following a family code of conduct, and supporting one another emotionally? A happy, healthy home has as much to do with the way a home is physically set up to meet a family's needs as it is about the energy and attitudes inside its four walls. For example, a good night's sleep has as much to do with clean, comfy sheets as it does with the attitude we bring to our bed when we lay down our head.

I feel so blessed to have my wonderful family, and it is my goal to cultivate harmony and unity in our home in every way possible. Anyone who thinks family unity happens without effort and commitment is mistaken. While Scott and I can't always control what happens *outside* our home, we try our best to create peace *inside* it, in whatever ways we can. That means keeping things organized, connecting as a family, sharing simple pleasures, and doing our best to honor one another. In this chapter, I share my strategies for making our home a sanctuary and cultivating family wellness.

Because in today's fast-paced world, we are more stressed than ever. So are our children. We seem to have increasingly less time for what really matters, and important things slip through the cracks. We need to take a step back and remind ourselves of *what is truly important*. In this chapter, I concentrate on solutions and strategies for streamlining and creating mental and physical harmony at home. Yes, it can be done! I also let you in on how our family functions in more personal ways,

including some of the promises we make to one another and the way we strive to interact. Some of this advice may speak to you and some of it may not, and that's okay. Keep in mind as you are reading that families are all unique and different and magical and complicated.

When talking about taking an active role in the health of our home, where do I start? Believe it or not, for me, it's always with *cleaning*. Yes, I can put Mr. Clean to shame. Why do I start here? Because for me, cleaning up on the outside leads to cleaning up the inside. When your physical space is set up to serve you and your family, you will not believe how much easier things go—there is way more harmony and flow not only in the physical space but also in the emotional space!

my happy, healthy home *heroines*

CLEA SHEARER AND JOANNA TEPLIN OF THE HOME EDIT These women are two extraordinary professional home organizers, and I am obsessed with their blog, *The Home Edit*. I hired them to turn traditionally ignored places in my home into stylish, functional Instagram-worthy spaces. (TheHomeEdit.com, @thehomeedit)

DR. ROBIN BERMAN The absolute best psychiatrist/therapist/supermomma I have ever seen, especially when it comes to family dynamics and parenting. Her book, *Permission to Parent*, is my all-time favorite. Get it. (PermissionToParent.net)

JILL SPIVACK A psychotherapist and pediatric sleep consultant. I've relied on Jill's trained and sound advice since I had my first child. I've taken countless parenting classes from her and continue to seek her advice in private sessions. Thank. You. Jill.

I truly believe that when we are free of clutter, we function so much better as families. We fight less because we can find things and aren't blaming others. There is literally less "crap" to fight over. When we declutter our homes, life opens up. Trust me. There is just more time and space. Living with less actually means *living with more*. In order to live life more fully and deeply, we must make room. Letting go of things you don't need makes room for the things you do. It creates a vacuum for the good stuff. Marie Kondo's revolutionary bestseller *The Life-Changing Magic of Tidying Up* has sold millions of copies for a reason—we are all drowning under the weight of too much stuff. If you haven't heard of Marie's book, it's because you are *actually living under a rock*. See? Too much stuff!

Her philosophy made so much sense to me as a mom. Those of you with kids know just how much stuff you accumulate over time. You think you need this stuff, but you really, *really* don't. Kondo's book encourages us to ask ourselves, honestly, whether the objects in our lives spark joy. If they don't, we need to say good-bye to them. I am 100 percent on board with the Kondo approach. The things I keep in my home are what I value most—the things that truly bring joy to my family and the things we need. Everything else is honestly just filler and distraction. Do you hear me, supermommas? If you're a clutter bug, your kids are going to pick up on that, and they will likely imitate your behavior. Instead, teach your kids by example— cherish your favorite things, honor the things in your home that you really need and that serve you, and kick the rest of it to the curb! Get your children involved. Have them go through their books and toys that they don't use anymore and donate

everyday supermomma secret

Decluttering, cleaning, organizing—to many of us, these activities sound tedious and exhausting. But the big secret is, all the time you spend organizing on the front end will save so much time in the long run because you will be able to find things when you need them—and so will your husband and kids. This seriously reduces how often the hubs or the kids ask, *Mom have you seen my ____?????*

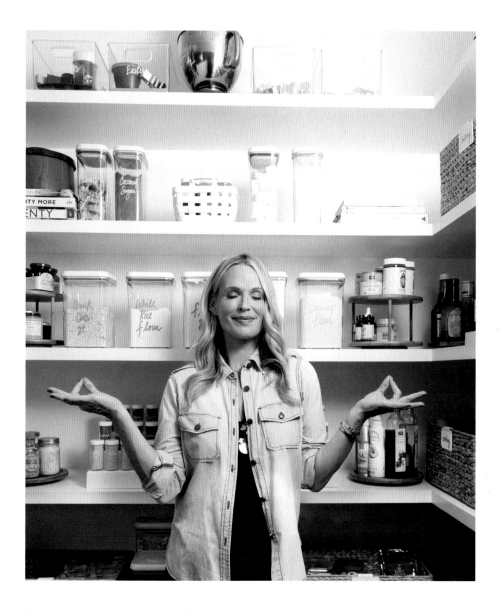

them to a local charity or sell them at a garage sale (and watch them smile when they make a few bucks!).

While getting rid of items and the decision making involved can be tremendously challenging, I personally love what follows: the act of actually organizing what is left. I love to make spaces streamlined, functional, and easy to use. Organization doesn't have to look or feel clinical. As a matter of fact, organized spaces can be superchic and totally integrated with the rest of the house. We're going to show you how!

the *dish* on decluttering

Organization is kind of like weight loss. Once you get your space organized, you suddenly feel lighter, like you have more energy for other stuff. But if you don't have a plan to keep the weight off—or to keep things organized—it's easy to backslide. I may be an obsessive cleaner by nature, but I still need a plan to keep things on track. Clea and Joanna, my ladies from the Home Edit, have spent countless hours helping me develop step-by-step strategies and systems for streamlining and organizing my home, which I am now going to share with you!

STEP 1: GET LIST BLISSED!

Start by making a room-by-room list of every single area in your house that needs to be organized. The first room on your list might be "Master Bedroom," and then under the room itself, list each unique area in the room that needs to be addressed. For example: dresser, nightstand drawers, walk-in closet, armoire, linen chest. This way, you will feel less overwhelmed by the idea of having to tackle the entire room at once, and you can break down what you tackle by specific task.

Once you've made a room-by-room list of everything in your house that needs to be organized, group your tasks for each room in one of four columns. Here's an example with the bedroom:

master bedroom

SMALL TASKS	MEDIUM TASKS	BIG TASKS	FAMILY TASKS
Nightstand	Dresser drawers	Armoire	Walk-in closet
Linen chest	Shoe racks		

If you plan to declutter the whole house, more power to you! Make a separate list like this for each room and part of the house. The larger tasks might require a weekend to complete, but for the smaller tasks on your list, set aside twenty to thirty minutes of free time for each. The best part about making lists is that when you finish a task, you get to cross it off and feel oh so gratified. You know exactly what I'm talking about, people! That's why you need to put even the smallest of tasks on your list.

You also want to highlight or put an asterisk next to the rooms or tasks that are a big priority in your household. For example, you might be able to put off cleaning

out the garage, but if you can't find anything to wear, then your master bedroom closet requires attention, stat! Another thing to keep in mind if organizing is truly a struggle for you: Don't begin with the hardest tasks first, such as sorting out sentimental items. Start with small tasks instead so that you will see progress more quickly. Those small victories will give you the motivation to move on to your bigger tasks that require more emotional or physical muscle.

STEP 2:
PULL EVERYTHING OUT

Once you've made your lists, choose the area and task to start with. Let's say you choose organizing your kitchen drawers and cabinets. Open every drawer and cabinet, pull out every plate, bowl, glass, mug, and utensil, and lay them all out on the counter. You've got to do this, because how else will you know if you have two identical whisks? By pulling everything out and seeing it all together, you will be able to see what you can get rid of, and you can come up with new ways of using things. For example, when everything is laid out together, you might realize that a set of place mats you have go well with a particular set of dishes or that a ceramic water pitcher you never use would work well as a vase.

STEP 3: EDIT, EDIT, EDIT

With every item that you pull out, ask yourself three questions: (1) **Do I love it?** (2) **Do I really need it?** (3) **Have I used it in the past year?** Honestly—that's it. If you *love* it—you need it. If it's the only pair of kitchen scissors you have, then of course you need it. And if you haven't used it in the past year, then maybe you don't *really* love it or need it. If you can't answer yes to at least one of these three questions, get rid of it.

STEP 4: CATEGORIZE

Once you've pulled everything out and edited out what you don't need, start to create categories by grouping like items together. In the kitchen, for example, your categories might be "Bakeware," "Serveware," "Fancy Dishes," "Everyday Dishes," and so on. Also, think about access—what you use on a daily basis versus what you use less often. Think about safety, too, if you have little ones, and where and how you'd like to store pieces that aren't kid-friendly. When items are stored by category, it saves on time looking for things.

STEP 5: CREATE A DESIGNATED "HOME" FOR YOUR ITEMS

Each of the categories you come up with should then have a designated "home" in whatever room you are organizing. If we continue with organizing our kitchen cabinets and drawers, we'll want to create one designated home or shelf for adult glasses and a separate home for kids' cups. Store everyday utensils in one drawer and good silverware in another. You get the idea. The goal is that when you take something out, you know right where it goes back. And not just you—but everyone else in your home too.

STEP 6: MAINTAIN!

Constant maintenance is key to keeping things orderly. Don't be lazy. If you take it out, put it back where it belongs. It's that simple. Don't let dirty (or clean) dishes pile up. Deal with things right away. Do the dishes directly after a meal. Unload the dishwasher as soon as dishes are clean.

The holding Tank If you simply cannot decide whether to keep or toss an item, put it in a "Holding Tank" storage container and hide it away in your attic or basement. If in six months to a year you haven't needed any of those stored items, then you know what to do! Ditch 'em! If an item was sorely missed, welcome it back. The same goes for your "Sentimental Bin." Keep those items that you never use but can't seem to part with in a separate bin in your storage area and reassess them at a later date.

stylish storage solutions

Who said organized spaces had to be boring? Once you've decluttered, grouped, and organized, it's okay to get a little fancy. When you put in the extra effort to make even utilitarian spaces look like a stylish part of your house, you are cultivating that outer harmony that leads to inner harmony that I've been talking about. Here are my favorite ways to organize in style:

* **USING UNIFORM NEUTRALS FOR MAIN PIECES** Invest in storage solutions that coordinate, calm the eye, and blend in with the overall aesthetic of your home. In general, your main organizing pieces should always be in neutrals. For example, use hangers and storage boxes of the same color (black, white, or natural) in your closet. Uniformity in color keeps the look calm and clean. If you then want to add a pop of color, jazz things up with brightly colored labels.

* **LABELING** Speaking of labels, I love them, and I use them in all my organized spaces. Using clear, easy-to-read labels make for a finished space. They can be handwritten or typed, but it's an extra touch that is as elegant as it is efficient.

* **MAKING THE MUNDANE BEAUTIFUL** Add special, organized touches to areas of your home that are usually ignored (your laundry room, mail sorting area, and pantry, for example!). It can really make a difference in the way your home looks—and how you feel in that space. You will feel more relaxed, and even the act of paying a bill or doing the laundry becomes more enjoyable, believe it or not.

MY STORAGE ESSENTIALS

* **BASKETS** Baskets are not only incredibly practical for storage, but they can also add an earthy beauty to your space. They come in all shapes and sizes, they're great in playrooms for storing kids' toys and stuffed animals, in closets for organizing towels and linens, and in the living room and bedroom for a chic way to store throw blankets and pillows. Baskets are also great in a pinch, like when you have to do a quick tidy for an unexpected guest. Unlike closet or under-the-bed storage, baskets are also mobile and temporary, which can be a plus. Wire oyster baskets are cool in the kitchen. Oversize woven seagrass

baskets are cool in cozy living spaces. More structured, small- to medium-size square baskets are great as organizing solutions in the laundry room, office, bathrooms, and pantry.

* **CORKBOARDS** I use corkboards in the office, in the hallway, and in the children's playroom not only for displaying the kids' art projects but also as a cool catchall for photos, thank-you cards, and anything else we might want to display in an organized way. That way it doesn't pile up around the house and we have it on view where all of us can enjoy.

* **LUCITE BOXES + CLEAR STACKABLE DRAWERS** I love these for the craft closet and for makeup organization. They work great in offices and on desks that don't have a lot of drawer storage.

SUPERMODULAR STORAGE

As you have gathered by now, I am obsessed with modular storage. I love cubbies, baskets, boxes, shelves, trays, you name it. And modular organization is great for kids! I learned this from the Montessori school philosophy on child development, taught to me by my dear friend Tara Rubin, Brooks's preschool teacher and currently the owner of the Nest preschool. The Montessori philosophy is that children should know where their things are and should be able to easily reach them,

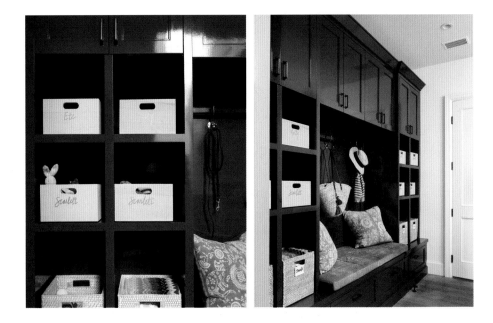

pull them out, play with them (books, LEGOs, tea sets—whatever) . . . and then put everything back on their own. This encourages independence, creative play, and taking responsibility for their things. So in Brooks's and Scarlett's bedrooms, I put rows of modular cubbies for their stuff. Brooks knows where his shoes go in his cubbies, where his trucks are, and where he can get his toothbrush and toothpaste. Scarlett, even though she is only two, is learning! Definitely a work in progress. But I love that they are learning to take care of their own stuff. Felt, square cubbies are especially great for kids because they are so lightweight.

home edit *philosophy*

I love to repurpose milk crates as stackable storage cubes for the garage, where I can tuck away certain sports equipment and seasonal items. As I've said, utility spaces don't have to look utilitarian. It's easier than you think to incorporate these spaces into the overall design and aesthetic of the house. Spaces we have a tendency to ignore, like the mudroom, the laundry room, and the garage, deserve a little design love too. Putting effort into making every space in the house look great gives me a sense of well-being and balance. You deserve to love and take pride in every last nook and cranny of your home. To give you a sense of what is possible with a little creativity, below are three examples of traditionally functional but not fashionable spaces that the Home Edit's Joanna and Clea helped me make over in our home. Check out how we did it:

1. **CRAFT CLOSET** Our craft closet is organized to the max (thanks to the Home Edit divas!) We use magnetic, plastic dividers on the closet doors to store pens, paper, and greeting cards. Another great organization hack is the use of clothing rods to hang our favorite versatile wrapping paper from. Clear, stackable Lucite trays store scissors, ribbon, glue, stamps, tape, and other odds and ends, while straw baskets keep gift boxes and gift bags safe.

2. **MUDROOM** In our mudroom, we have a grid of cubbies and modular storage baskets personalized for each family member. We keep the kids' shoes in their bins so that when we are running out the door, we can grab a pair quickly. Our pets have their own bins with leashes, toys, and other essentials. We also have a bin for the backyard, with towels, sunscreen, hats, swim goggles, and sunglasses. And we have a bin for sports equipment we use a lot in the backyard, like baseballs, baseball mitts, Frisbees, and so on.

3. **PANTRY** I showed you our pantry makeover in Chapter 1, but it's so amazing. I'm obviously obsessed. Feel free to drool along with me. We use tons of baskets and cubbylike storage here too.

keeping order is about respect Ultimately, organized living is actually a lot about respect. It's about respecting ourselves, our space, and our things—and others. What we do have, we treasure, we take care of, and we appreciate. To me, it's so important to teach our children not just the cost of things—but the *value* of them. Very different. It's important to teach your family to respect your home and their belongings. These are skills that not only will benefit the health of your home and family here and now but will also be excellent skills for your children as they grow into adults.

extra tips for an *organized* home

- ✳ **FIVE MINUTES A DAY KEEPS THE CLUTTER AWAY!** Once you've organized a space, devote five minutes a day to maintenance. Who doesn't have five minutes? Pick a shelf, a corner, a drawer, a surface—and spend five minutes on it. Throw things away; put items in the donate box. Those little moments of time that you would have otherwise wasted really add up!

- ✳ **ONE THING IN . . . ONE THING OUT.** When you add to your closet, always subtract. When you add to your kitchen cupboard, do the same. This is an excellent strategy for keeping "stuff" from getting out of hand.

- ✳ **SHRED FOR SAFETY AND SANITY!** Get and start using a paper shredder (unless you are a fan of identity theft). Shredders make organizing an office so much easier—and fun! It's weirdly satisfying to shred.

- ✳ **BEWARE THE DREADED JUNK DRAWER.** It's a slippery slope! One junk drawer can lead to two, which leads to three, and pretty soon you have an entire junk room! I say *one* junk drawer is okay; the Home Edit girls say *no way*. The point is, watch out for the downward spiral.

- ✳ **PRACTICE THE 80/20 RULE.**

THE 80/20 RULE

Ah . . . that dang drawer that just won't shut. The cabinet that won't close. The coat closet that is at 110 percent capacity. Does any of this sound familiar? When you organize a space, it's important not to have every closet, cabinet, and cubby filled to the brim. Negative space is important not only for keeping things organized but also for keeping the harmony. Practice the 80/20 rule: 80 percent full, 20 percent open space. If you fill everything to the brim, it's likely to spill over, get damaged, or be lost. If you follow the 80/20 rule, when you do acquire something new, there is room for it. It's like portion control for your storage space.

In 2006, I first read Christopher Gavigan's book *Healthy Child Healthy World*, and it opened my eyes to some of the possible dangers of chemicals in many common household products. Christopher later went on to found the Honest Company with my supermomma friend Jessica Alba. He talks about how small exposures to these chemicals may seem harmless, but the big issue is about cumulative effects due to chronic exposure. There are days when I literally catch my kids and dogs eating off the floor and the countertops, so today I do all I can to make sure that the products I use to clean my home are natural and nontoxic.

You can make your own safe, natural cleaning products that will clean everything from toilets to tiles, floors, and fixtures—from ingredients you already have around the house! And I'll show you how to do that. If that's a little too much effort for you, there are more and more safe, nontoxic cleaning products on the market to choose from (like the Honest Company's products). Making better choices and reducing your family's exposure to toxic chemicals begins with reading labels and becoming better informed across the board.

friendlier, greener cleaners

These guys below are tried and true when it comes to cleaning and greening. Stock up on them for a DIY green clean.

- ✳ **BAKING SODA** Baking soda is a nontoxic bicarbonate cleaning machine! It's great for scrubbing toilets and cleaning grout and is truly incredible for removing dirt. Not to mention, it kills microorganisms and is effective against yucky bacteria.
- ✳ **BORAX POWDER** This antibacterial bleaching agent is safe for the environment and has low toxicity.
- ✳ **HYDROGEN PEROXIDE** A natural stain remover, you can put peroxide directly on clothes or fabric stains and rinse off with cold water. It's also effective for disinfecting toothbrushes, retainers, and mouth guards. Sexy!
- ✳ **100% CASTILE SOAP** Made from all-natural plant oils, this cleanser is completely biodegradable and earth-friendly. The simple combo of hot water and castile soap makes for an all-purpose cleaner. A 1:1

ratio makes a great dish or hand soap. Or mix a little baking soda with some hot water and castile soap for a gentle tub, tile, and sink scrub. Castile soap is even gentle enough to wash fruits and veggies with, and it helps remove waxes and pesticides.

* **DISTILLED WHITE VINEGAR** Vinegar is not just for salads! I've always known that vinegar was good for cleaning, but I had no idea just how versatile of a product it was until recently. It's truly amazing for removing dirt and for polishing glass, and it's incredibly effective against bacteria and microorganisms too.

* **VODKA** Believe it or not, vodka is an excellent window cleaner and fixture cleaner. Spray it on and witness its streak-free powers! Because vodka kills germs, add it to a spray bottle, mix in a few drops of your favorite essential oil, and use as an air freshener or to freshen up your mattress or couch. But don't make yourself a martini at the same time—otherwise not much cleaning will likely get accomplished!

* **LEMON JUICE** Not just for lemonade! Lemon juice is highly acidic (even stronger than vinegar) and is therefore an effective killer of most bacteria. It's also a natural lightening agent and can be added to a variety of homemade household cleaning products, such as grout cleaners and laundry detergents.

* **CITRUS ESSENTIAL OILS** Lemon and grapefruit essential oils have antiseptic properties, and they smell so clean and fresh. They are great for adding to your homemade cleaning products in whatever scents are your favorites.

* **ELECTRIC DIFFUSERS OR ESSENTIAL OIL STICK DIFFUSERS** Instead of using the synthetic aerosol air fresheners or the chemical-laden ones that plug in, try an electric or ceramic diffuser ring placed around a lightbulb that uses essential oils to freshen the environment.

supermomma word to the wise While natural cleaners are effective in many cases, many of them are not registered by the Environmental Protection Agency as certified disinfectants. For example, vinegar and baking soda are not proven effective against salmonella or *E. coli*. So if you suspect that a surface has been contaminated, use one of the cleaning agents registered by the EPA, and always use in a well-ventilated room, wearing gloves, and with caution.

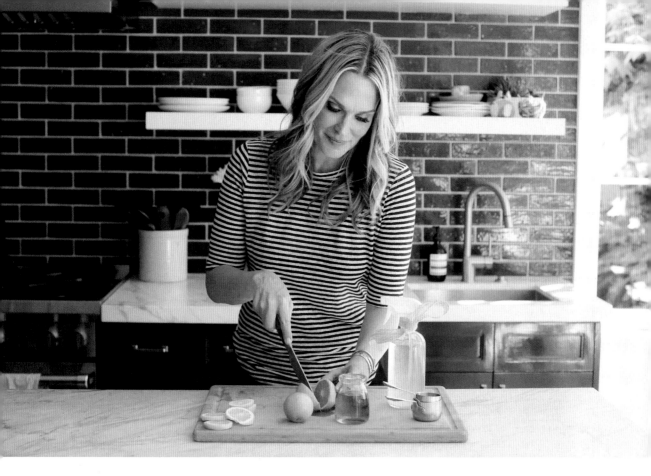

my *favorite* clean green diys

better than bleach!

While I know there is nothing like bleach to get your whites white, I generally avoid it when doing laundry because I don't want it anywhere near my children's skin. I also avoid using bleach in the kids' bathrooms and bathtubs because those are for momma-and-baby time. "Better Than Bleach" is a great alternative that you can use in most cleaning scenarios that would typically call for whitening and brightening. While I still will use bleach occasionally in my kitchen and bathroom when necessary, this is my choice for everyday kind of use.

yield: *About ½ gallon*

INGREDIENTS

¾ cup hydrogen peroxide

7 cups water

⅓ cup lemon juice

12 drops citrus essential oil
(lemon or grapefruit)

DIRECTIONS

Whisk together all the ingredients in a small clean pail, then transfer to a ½-gallon dark, glass bottle. Label and date.

all-purpose wood polish

When you have little ones crawling around on your floors, you start to think a lot about the safety of the wood cleaner you're using. Here's my to-go nontoxic recipe for wood floors and furniture.

yield: *About 1⅓ cups*

INGREDIENTS

1 cup olive oil

2 tablespoons white vinegar

Juice of ½ lemon

4 drops of your favorite essential oil (I love anything citrusy or lavender)

DIRECTIONS

Whisk all the ingredients together in a small bowl, then transfer to a spill-proof container. Use an old clean dish towel as an applicator. Label and date.

supermomma surface cleaner

This all-purpose surface cleaner is great for kitchens, bathrooms, and glass and tile surfaces, and it also works well on mildew, mineral deposits, and general grime. Steer clear of using it on stone or marble surfaces, since the vinegar is acidic and can eventually cause degradation or etching. (Trust me, I learned this the hard way.)

yield: About 3 cups

INGREDIENTS

1½ cups hot water

1½ cups distilled white vinegar

6 drops essential oil (I love lavender, mint, or neroli)

DIRECTIONS

Whisk together and store in a dark, glass bottle with a spray top. Label and date.

Tip Always label and date your DIY products. Nobody likes a mystery product in their cleaning cupboard.

other ways to go *green*

1. **TAKE THE LESS PLASTIC PLEDGE.** Plastic is not so fantastic because it's not biodegradable and it contains some suspicious chemicals. We try to use glass containers for storing food, stainless-steel bento boxes for the kids' lunches, and glass baby bottles (or BPA-free plastic baby bottles as an alternative when we're on the go).

2. **BANISH PAPER TOWELS.** We try hard to use cloths and rags for cleanup rather than grabbing paper towels. They're so wasteful. I turn old T-shirts into rags for a more earth-friendly means of cleaning up. I also try to use cloth instead of paper napkins when I can.

3. **SAY NO TO PAPER AND PLASTIC BAGS.** I opt for reusable tote bags for grocery shopping and canvas bags for the kids' lunches. I keep a stash in the car for emergencies.

4. **ELIMINATE THE CHEM-HEAVY DRYER SHEETS.** I line-dry clothes when I can (which saves on the electric bill too), and when I can't I use all-natural wool dryer balls.

5. **RECYCLE!** I know this kind of goes without saying, but it doesn't hurt as a reminder. It's never too early to teach your kids to recycle. Even little kids can get into it and will love learning to put glass, paper, plastic, and so on into designated colored bins. Have your children save them up, take them to your local recycling center—and let them cash them in. This not only teaches them the value of recycling but also that there is a little reward in it for them to. It's a win–win.

6. **CHOOSE ORGANIC FABRICS AND MATTRESSES.** When it comes to our linens, our children spend so much time sleeping on them, we definitely go with organic bedding and mattresses. It's better for the environment and for them.

SMALL LUXURIES + SIMPLE PLEASURES

When I lived in France for several years as a young model, I noticed that everything from appliances to toiletry items to food packaging seemed to be designed with elegance in mind. The French have a very casual yet thoughtful way of making their homes feel comfortable and still chic. There is something so simple, so refined, about French style. Nothing feels forced, and there is always a subtle sensuality in even the mundane. There is a calm amid the chaos! I call it "undone elegance" when something appears effortlessly beautiful, but you know it actually took some thought and, yes, *effort*.

Creating an elegant, tranquil home isn't about spending a lot of money. It's about surrounding yourself with things that cater to all the senses: touch, taste, smell, sound—and spirit. Here are a few French-inspired everyday tricks to try in your home for a bit more of *la bonne vie* (the good life).

1. **LINEN LOVE** If you are sleeping with me, you'll be sleeping on nice linens. When I bought my very first home, one of my splurges was on bedding. Think about how much time you spend in the bedroom. In an average lifetime, we spend about twenty-five years asleep! Maybe less if you are a new mom. All the more reason to treat yourself to buttery-soft Egyptian cotton sheets, because when you aren't nursing, sanitizing bottles, burping your baby, or doing other superhuman stuff—you are sleeping. In my guest bedrooms too, it's crisp white sheets and duvets. I want my family and friends to feel spoiled like they are in a five-star hotel when they visit. The higher the thread count, the better.

2. **FLOWER POWER** Is there anything better than a sparkly clean house with fresh flowers? I love to stop at our weekly farmers' market to pick up whatever blooms are in season. If I don't have time to do that, I'll grab something from the local market while I'm picking up groceries. Even fresh foliage, tree blossoms, or greens from the garden will do the trick: cherry blossom branches in winter, or curly willow branches year-round, arranged in a tall vase, or long-lasting, lush arrangements made with calla lily leaves, ferns, Queen Anne's lace, and the foliage from alstroemeria.

3. **SACHET ME AWAY** There is something so feminine and intimate about a scented sachet tucked in a drawer. Sachets remind me of the French countryside where everything is literally wine, sunshine, and roses. Sachets not only add subtle and delicious fragrance to your drawers and clothing, but they have a practical purpose: they deter little critters that can crawl around inside drawers and nibble on natural fibers, and they help absorb dampness.

4. **EVENING ROUTINE** *Bonsoir, super-maman.* While you might not be able to do it every night, consider establishing one night a week when,

after the *enfants terribles* are in bed, you turn off the TV, turn on tunes that set a mood (Serge Gainsbourg, anyone?), pour a glass of wine, and put your phone away. Read a book, call a friend, or cuddle up with your *amoureux*.

sweet *homemade* sachet

1. Start with a breathable cotton or linen drawstring pouch. Alternatively, you can use two squares of cotton fabric.

2. Mix your favorite dried herbs and flowers (think lavender, rosemary, and rose petals) in with dry rice. For a stronger fragrance, scent your blend with a few drops of essential oil (lavender, vanilla, and cinnamon are nice).

3. Fill your drawstring pouch, or carefully place your blend on one of the fabric squares, lay the other on top, and stitch together. And voila! Your drawers smell like Provence in spring.

You can also make larger pouches with cedar chips or rice scented with dried eucalyptus or pine essential oils. These are especially nice for closets, shelves, and drawers containing precious wool pieces or cashmere sweaters. So much better than awful chemical-laden mothballs, don't you think? Sachets also make great gifts, because who doesn't love something that is homemade, smells delicious, and protects your intimates!

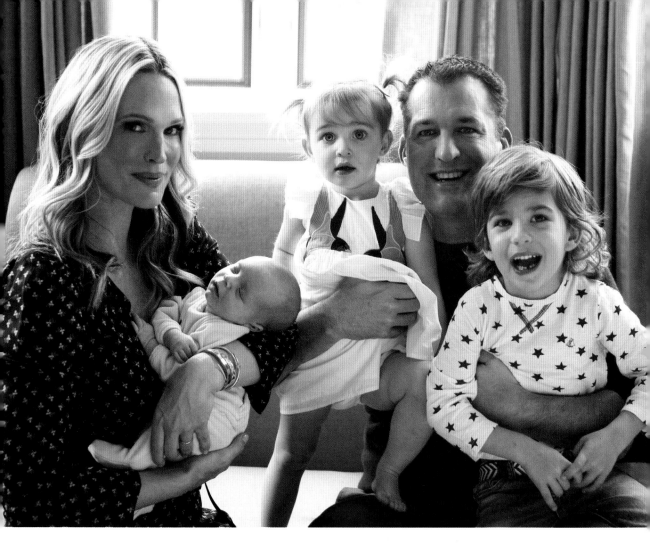

HAPPY AND HEALTHY ON THE INSIDE

So far, we've been talking about *external* ways to make your house a comfortable space, but let's dig deeper. Decluttering, cleaning, and greening your physical space are only one part of creating a happy, healthy home. True harmony at home is just as much about the way we treat one another, the priorities we establish as a family, the codes we follow, and the quality time we share. In this next section, I want to share our family strategies for cultivating a positive, supportive, internal environment at home.

code for our *abode*

Do you have a family code of conduct? Rules that you all live by? Rules aren't just for kids. In this day and age, we all need to be reminded to treat one another well. When life gets crazy, it can be easy to lose sight of how important this is, and our loved ones often end up bearing the emotional brunt. By establishing a family code of conduct that you and your partner agree on, you will be on the same page when the going gets tough. It's kind of like having a family bill of rights or a constitution! Our family code of conduct is 100 percent inspired by the well-known passage out of 1 Corinthians in the Bible. But regardless of your religion, a family code of conduct is essential for a harmonious home.

1. **LOVE IS PATIENT, LOVE IS KIND.** I am passionate and fiery, and sometimes I speak before I think—and say things I do not mean that are, well, mean. It's easy when we are upset to lash out and say things we regret. We talk with Scarlett and Brooks about not whining and crying but instead taking a deep breath and using their words. Learning and practicing patience with one another, and choosing kind words over cruel, is definitely a family rule we must remind one another to follow.

2. **LOVE DOES NOT ENVY OR BOAST.** In our family, we must constantly remind ourselves to focus on gratitude. It doesn't matter how much you have, it's easy to get caught up in what you *don't*. It's human nature. Therefore, we all make efforts not to compare ourselves to others or worry about who has what. We try to teach our kids to value what they have and to love sharing it with others. We want them to know they are blessed and to share what they have with others. We try to teach our kids to be humble, contribute to others' happiness, and pass that on!

3. **LOVE IS NOT PROUD.** This is a big one in our family—and one I struggle with, to be totally honest with you. Even when I am wrong and I know it, it's sometimes hard for me to say I'm sorry. I'm stubborn. Scarlett might have inherited my stubborn streak too, that cheeky little monkey! But the truth is, there is no room for pride in successful relationships. We must be able apologize and admit our mistakes and apologize when our loved ones want that from us. I'm working on it.

4. **LOVE IS NOT RUDE, IT IS NOT SELF-SEEKING.** We are family, which means we are a team. And there is "no *I* in *team*," as the saying goes. We have to work to remain open to the best outcome for all. We don't operate from the ego; we operate from the *heart*. We do things for one another because we love one another. Being a family means putting others first. We moms are pretty good at this. Sometimes too good! But the truth is— if we see our family members as extensions of ourselves, it's easy.

5. **LOVE IS NOT EASILY ANGERED.** Right now, Scarlett follows Brooks around everywhere, copies his every move, and just wants to be where he is at all times. Physically she wants to be right there next to him, practically on top of him, and that often means kicking or pinching him. While that is not right, we are teaching Brooks to ask her nicely to stop and not to totally freak out and have a meltdown every time. Deep breath, deep breath, count to ten, and let it gooo.

6. **LOVE REJOICES WITH THE TRUTH.** We need to be able to be honest with our partners. If something upsets us, hurts us, angers us—we cannot hold that in. We have to be brave and honest in our relationships. If Scott and I aren't honest with each other, what examples will our children have? I don't let the kids get away with fibs. Some kids love to fib, but for me, it's a no-no. We will sit down until they tell me the truth. *Did you sneak the bag of chocolate pretzels into your bed last night? Did you pinch your brother?* C'mon, now be honest. And that goes for Scott and me too.

7. **LOVE ALWAYS PROTECTS, ALWAYS TRUSTS, ALWAYS HOPES, ALWAYS PERSEVERES.** This one for me is majorly important. We show up for one another, dream big dreams for one another, and are there in times of triumph and uncertainty. When you choose to have a family and are blessed with children, it's a marathon, not a sprint.

8. **LOVE NEVER FAILS.** Love is rock solid, even on days when you feel like throwing in the towel because your kids are driving you nuts or the bills are piling up. Love falls down, but love always gets back up. Sometimes when I am upset with Brooks, he really doesn't like it. And I tell him that yes, Mommy is really, really disappointed. I tell him, *I will always, always, love YOU—but no, I don't love your BEHAVIOR right now.*

the *family* calendar = security + sanity!

I live and breathe by our family calendar. Without it, I am nothing. I would never remember Brooks's soccer practice, Scarlett's playdates, my meetings, or Scott's travel. I would go supermomma batsh*t crazy without it. It's not that I want to be rigid. It's the opposite actually. With the schedule written out and accessible to Scott and myself and our child-care providers, we can relax because it provides clarity and order. When we know what we are all doing, we also are able to keep our kids in the loop and that gives them a sense of security. Kids like to know what they are doing in advance. By being able to prepare your children for their day, they will have less resistance when it's time to get ready for basketball or ballet. Trust me on this one! In addition to everyday stuff, I think it's also important to include bigger-picture family goals on the monthly calendar. That way, as a family, we aren't just chasing the clock. We are also chasing dreams.

planning pointers

1. **CREATE A FAMILY CALENDAR.** Keep your family calendar online, or go with an old-school paper calendar hanging in your kitchen. Whichever you choose, *write it all down somewhere*. A family calendar is not about being rigid or strict—it's just about keeping things organized. When you're busy, if it's not all written in one place, it's easy to forget even the important things, like birthdays! Remember poor Molly Ringwald in *Sixteen Candles*?

2. **SCHEDULE IN FAMILY TIME.** Make sure you also schedule in quality time for the whole family, not just doctor's appointments, kids' sporting events, dinners, and meetings. This is especially important if you or your partner travel a lot. Pencil in "Movie Night at Home" on a Friday or "Pancakes and PJs" on a Saturday morning. And while all schedules require flexibility, make sure these little moments don't get pushed aside by obligations that don't really matter or aren't as important.

3. **RESERVE TIME FOR YOURSELF.** This one is really, really important for avoiding supermomma meltdowns. Because, heaven knows, we've all had 'em! Please schedule in time for yourself. Don't just say, "I'll do it if I have time." You've got to make time and reserve it for yourself. For the love of your family, get that facial, take that spin class, or that Coding for Dummies class (I don't know what you're into!). Maybe it's as simple as reserving twenty minutes in the bath with a good book and a glass of wine. *Schedule it in.*

4. **AVOID OVERSCHEDULING.** Listen to your kids. Do they seem exhausted and uninspired? Are they just flat-out doing too much? As Brooks's incredible early-education teacher, Tara Rubin of the school the Nest in Los Angeles, says, "Children need to learn how to entertain themselves sometimes, and they need to learn how to be bored." Often parents are so concerned with making sure their children are constantly entertained, they'll cart the kids around from one activity to the next. As Tara explains, "It's okay for kids to stay home or to just schedule one 'event' a day. Let children be children, encourage self-directed play, allow them real-life experiences, and incorporate

these experiences into your daily routine (grocery shopping, errands, cleaning), making them opportunities for fun real-life learning." A day doesn't always have to be perfectly planned out to be considered productive. Make sure that you and your kids have time to just *be* and maybe even to *be bored*.

5. **SET FAMILY GOALS.** In addition to day-to-day responsibilities, it's so important to have a big-picture family plan and shared goals. And I don't mean with your cell phone carrier! Sit down with your family and chat about your mutual and individual goals. They can be long term or short term. Things like annual vacations and holiday plans are important, but other unexpected goals might also come up. You might learn that your son has always wanted to go to guitar camp. Or that the hubs is desperate for a fly-fishing weekend with the boys. Or maybe supermomma desperately wants to take her kids to a show on Broadway. Whatever it is! When we know what our goals are because we've discussed them, we can work together to achieve them. The start of the year is the best time to sit down and talk together and write down your annual family plan.

We try to always make time for each other. Yes, sometimes it feels like work to "make" time, but it pays off! I've never regretted date night with my husband, or fun outings with the kids. These moments and memories are part of what makes us family.

—VANESSA LACHEY

my **10** tenets of *happiness*

Happiness. It's a subject that has been discussed and debated for ages by everyone from ancient philosophers like Socrates to contemporary spiritual leaders like the Dalai Lama. And recently, scientists and sociologists have jumped on board, conducting study after study in search of a way to quantify our happy days. And what research shows, time and time again, is that personal happiness has a lot to do with intentional behaviors—in other words, things that we can control! Happiness is highly influenced by our choices and voluntary behaviors. Here are a few well-documented ways to cultivate happiness in your home:

1. **WORK OUT FOR WELLNESS.** Exercise releases dopamine and oxy-tocin, chemicals that are the feel-good hormones. When you exercise, your body is rewarding you for doing something that it should be do-ing. Your body is telling you, yes, this is good. More please! Keep it comin'. I am a huge believer in the connection between fitness and hap-piness. Even in my last months of pregnancy, I still made it a priority to wake up and work out every single day, even if just for twenty minutes. I always, always felt better.

2. **BE A SOCIAL BUTTERFLY.** Don't let your inner hermit take over when things are tough. When we are depressed or down, we tend to want to hide out and retreat. Resist the urge! Instead, get out there and surround yourself with positive people. You know who they are. Just being around them makes you feel better. Also, pushing yourself to do for others can help you step outside your worries. Helping others always ends up in a total boomerang effect by boosting the way you feel about yourself!

3. **LIVE IN THE PRESENT.** "I'll be happy as soon as x or y happens" never works. You have to choose to be happy now. Choose to love yourself and your life and to focus on the present. When I begin to worry about the future, all I have to do is get in bed and read a book to my baby girl. It centers me and brings me back to what really matters. "Right here, right now, there is no other place I want to be." That Jesus Jones song anyone? No?

4. **SET ACHIEVABLE GOALS.** Always be working for something. Setting and achieving realistic goals creates an incredible positive cycle. When something works out and you achieve a goal, it feels amazing. And even when things don't work out and you face a setback, you will feel better knowing you gave your all.

5. **THINK POSITIVE THOUGHTS.** Expect the best. Hope for the best. Work for the best. Shoot for the stars. We put up a sign in Brooks's bed-room that says GOOD MORNING, WORLD because that's how we want to encourage him to start his day, with positivity. Wake up and welcome what is in store!

6. **ACCEPT WHAT CANNOT BE CHANGED.** This sounds like a twelve-step program. But the reality is, we don't have control over certain

things in our lives. We've got to let go of the idea that we can control everything. There are sad things in this world. Try your best. But acknowledge what can't be changed, and accept it.

7. **TREAT OTHERS WELL.** The better you treat those around you, the better you will feel about yourself. It's just true.

8. **BE GRATEFUL.** Grateful people are happier people. They focus on what they have, not what they don't. Whatever you choose to focus on will expand. So focus on the good stuff.

9. **KEEP LEARNING.** Did you know that, like exercise, learning stimulates endorphins? When you exercise your brain, it rewards you. Learning boosts self-awareness and confidence. So pick up a book. Go to a lecture. Listen to a podcast. Boost your brain activity *and* your attitude.

10. **DO FOR OTHERS.** As human beings, we are social animals and we are wired to help one another. It feels good! I always feel better when I step outside of myself and do things for others—I actually get a kind of high. Research shows that the act of helping others produces all those good-vibe hormones too. Whenever possible, teach your children to care for others as well. If they love animals, but you don't have a dog, volunteer with them at the local SPCA to walk dogs. When you find something you can do together as a family, it's even better. During the holidays, we gather the children's gently used toys and a few new ones, and we take them to a local shelter together so that they can be used and enjoyed by a new family.

superfamily fun!

Family ties are extremely important to Scott and me, and we make an extra effort to establish strong bonds—through fun! Here are a few ways that we work to create ties that bind:

1. **CREATING FAMILY TRADITIONS** Traditions bring us, both the immediate family and the extended family, closer together, and they signal our commitment to one other. I get that extended family time in par-

ticular can be tough. People don't always get along. But it's still important to bring everyone together once in a while. Your family members can learn to get along a few times a year! Research shows that yearly family traditions provide a sense of security, routine, and consistency for all family members, but for kids especially. Children remember these special experiences much more than the toys and gifts. Include your kids in the planning and decision making when it comes to family traditions. For every holiday, the kids and I make sugar cookies—for Thanksgiving, Halloween, Easter, you name it. And at Christmastime every year, we adopt a family through the Baby2Baby charity. We buy them all gifts, and together, as a family, we deliver them in person. It's so special for all the kids.

2. **SEEING RELATIVES + ATTENDING REUNIONS** Although our children's cousins don't live in California, it's important to me that we make the time to physically get together and see one another. At least once

a year, our family—or my brother's family—makes the cross-country trek. Usually we just stay at each other's houses, spend time together in the backyard, see movies, and go to the beach. We keep it simple. I feel so lucky that my children get to grow up with similar-age cousins. It just makes life for them that much richer—and for me, it warms my heart. We also do video calls to say hello, wish happy birthdays, or just to check in. That helps too! If you aren't from a big family, you can still create a sense of extended family and community. Best friends can be "aunties" and "uncles" and their kids can be adopted cousins. Find your family wherever they are!

3. **CELEBRATING** Everyday superfamilies just wanna have fun! We make a big deal of birthdays in our house, and we celebrate significant moments, like an excellent report card or a game-winning soccer goal. When Brooks finished his first year of preschool, we celebrated with

a special dinner that he chose, and he got to stay up past bedtime and watch his favorite movies. Oh, yeah! It's important to celebrate special moments and milestones in our lives. And not just with the kids but also as adults. Every year, rain or shine, Scott surprises me with a special, secret weekend away to celebrate our anniversary. It's not only the recognition of another year passed together, but a celebration of our partnership, our commitment, and our love. And this was his idea . . . I know, I'm very lucky. He is total babe, incredible father, and *everyday superhubby.*

4. **EXERCISING TOGETHER** I've mentioned the connection between happiness and exercise. A healthy body leads to a healthy and happy mind. And it can be a ton of fun to get active together as a family! We live near some beautiful hikes in the Santa Monica Mountains, so we love to hike together on a Saturday afternoon. Exercising as a family is a win–win when you're too busy to work out!

5. **PLANNING A STAYCATION** Some of us only get a week or two off a year, and that's just not enough time for relaxation and total free-time fun with the whole family. Not everyone has the time or the money to take a family vacation when they need one. But you can cultivate that feeling of vacation in a just a day or over a weekend. Do something different! Devote a day to fun. Turn off the cell phones and turn up the music. Set up a bunch of tents in the backyard. Blow up some balloons. Make Popsicles. Play some Beyoncé. Invite your friends over. Invite your kids' friends over. Wear big hats and sun-glasses, and serve rosé for the adults and pink lemonade for the kids! If you have a pool, blow up a bunch of ridiculous floats, and let the kids play around on them. Set up a Slip 'N Slide—whatever it takes. The point is to P-L-A-Y!

photographing your family!

Documenting the everyday and special occasions is so much easier in the modern age. We've got high-quality camera phones and even video cameras wherever we go. With ease, we can record and play back our lives. However, I do still love the tradition of setting up more formal photos for special occasions, such as the holidays, summer vacation, big family gatherings, and the annual family photo or during a pregnancy and after the birth of a new baby. The photos can be candid or more formal, but the point is, they are precisely captured. It's so touching to look back on these years and these events and have a collection of images that tell our family story.

We have a family photographer, Gia Canali, whom I've used for many special events, beginning with our wedding and my first pregnancy, to the children's birthday parties, annual holiday cards, and special photo sessions. She sets up beautiful shots and knows just the right backgrounds to pick, so I thought I'd ask her for her tips on how to set up and create perfect family photos at every occasion.

WHEN AND WHAT TO *photograph?*

Some parents love to document the turning of each year of their children's lives, especially when they are so little and each year brings so many changes. Others like to photograph stages and skills—like when a child first crawls, sits up, or starts walking. Lots and lots of families choose to take family photos for the holidays, which can be sent in e-cards or through the mail. A more recent trend is to document day-to-day life: an afternoon in the backyard, a day at the beach, a get-together with visiting out-of-town relatives.

how to set up your own, diy photo shoot:

1. **COME UP WITH A PHOTO CONCEPT FOR KIDS.** Start with a simple idea. Activity-based ideas are always good, such as building LEGOs or playing with bubble wands. If you can get outside, even better!

2. **CHOOSE THE LOCATION AND YOUR "SET."** Consider the environment—you want something that is fairly plain and without a lot of distracting detail in the background or foreground so that your family is the focus. And you don't want to pick an area with too narrow a scope. Kids move around a lot, so you need to make sure that you have a pretty large, clean frame and background—otherwise, forget it! What's most important when doing your own setup is to scout the location first, and if shooting at home, to build your set in advance. Do it when the kids are napping and always test out the frame. You really don't want to be doing the setup while they are waiting—wasting their precious little attention spans! Some of our favorite locations include:

 * *The beach* It is great because it's simple, classic, generally has numerous angles with clean backgrounds, and the frame is nice and big! No matter how much your kid runs around, you almost always have a usable frame. If you don't have a beach nearby, an open park, grassy meadow, or lakefront works well too.

 * *The bed* Believe it or not, another very workable location is often the bed. I personally love using our bed at home for a DIY photo shoot. Put on a set of white sheets and comforter or

all-neutral linens, and clear off any stray items on surfaces that may sneak into the frame, such as phones, glasses of water, the newspaper, or the alarm clock on the nightstand.

* *The floor* Yep! You heard me right. A big fluffy rug and some neutral pillows on the floor always photograph well, and it's perfect for newborns. It can be beautiful and ethereal. To create even more of a set, hang a blanket against the wall as a backdrop, like we did in one of our shoots with Brooks and Scarlett. Simple white string lights or a garland can also add a festive, fun touch.

3. **DECIDE ON STYLING/PROPS.** Think classic toys. Some of our favorite props include:

* *stuffed toys* A fun photo is to put the baby or toddler in the center of a light-colored rug or on the bed and surround her with all her favorite plush, stuffed animals or, more simply, with her favorite one! And you didn't have to buy a thing.

* *balloons* There is something endlessly fun and free spirited about a little one holding balloons. You can buy them in any color, they are affordable, and they make for classic photos.

* *kites* If shooting at the park, the beach, on the bluffs, or in an open space, bring along kites—they're an excellent activity for children and will keep them occupied for a good amount of time, and while they play, you can snap, snap, snap away!

* *bubbles* For an outdoor shoot, bubbles look so pretty and whimsical, and children absolutely love them. I do too!

* *"messy props" caveat* Just keep in mind that messy props are always . . . messy. If you really want that adorable photo of your baby eating a rainbow sprinkle ice cream sundae, then save that photo for the last shot . . . and be prepared to pack *three pairs of the same outfit*!

4. **THINK ABOUT WARDROBE.** Speaking of outfits, simple is always better, especially when doing shoots that you will be using for a holiday card. Avoid logos and busy patterns. Coordinate children and family members in like or complementary colors. All white or white mixed with denim or khaki never fails. You want your family to stand out, *not* the sports team logo or the superhero T-shirt.

5. **PICK THE BEST TIME OF DAY.** Photographers' favorite time of day is just before sunset—the golden, or magic, hour. But I also say that the best time is when your kids are happy. So if that is in the early morning, that's when you'll be the most productive and get the best shots. Don't underestimate how much time this can take, btw.

6. **CREATE A SHOT LIST.** Do as photographers do. Make a list of what shots you want to get, and prioritize your list, placing the

most important shots at the beginning and the less important toward the end. Plan a mix of both posed and candid shots. When working with children, be conservative with your list—you don't want to get overly ambitious here! After you've done one or two shoots, you will have a better idea of how many shots you can reasonably get in a two-hour shoot.

7. **BE PATIENT.** This is key to being in charge of your own shoot. Parents really must have positive energy. Embrace what is happening. You might want your little one to do something a certain way—but that is not necessarily going to happen. But if you go with the flow, you just might be surprised by what funny or sweet moment that you managed to capture. And know that it's fine to reschedule. Sometimes kids just aren't feeling it. As Gia says (and as we've done before), "Sometimes it's better to win on another day than fight really hard and lose on the day you've scheduled!"

everyday *supermomma* secret

I absolutely adore photo walls in the home. I am very nostalgic. I really enjoy being reminded of all the stages of my children's growth. Their little faces change so much, and they grow up so fast. On large walls in our home, like at the top of the stairs, we love to create and display our most special family photos. We use simple white, black, or light wood frames and white matting. We make oversize photos and space them just a few inches apart. It's one of my favorite parts of the house. It's a lot of effort to select the photos and have them printed and framed and hung, but it's so worth it. I can't walk past the wall without smiling, laughing—and sometimes even tearing up.

interview with *parenting expert* jill spivack

Jill runs several parenting classes in Los Angeles, and I often see her in her private practice for specific advice relevant to parenting and family. She is truly a treasure and her book *The Sleepeasy Solution* was my bible when my first baby went through sleep training. Her number-one goal is to help parents raise their children with love, consciousness, and clarity. Very chic.

Why is discipline important?

The word "discipline" actually means "to teach." We need to prepare our children to deal with a world that sometimes says no, and sometimes is frustrating or disappointing, where things don't always go their way and they don't always get what they want. We are raising our children to leave us one day, hopefully with a good set of tools for dealing with feelings. If children realize that with some intense emotion they can get what they want, they will escalate their behaviors and become more and more difficult. As a result, what started out being easier for parents will ultimately create constant battles over even the most ordinary requests. What's worse, if parents don't create a safe place to learn to deal with hard feelings, children will have to learn out in the world by social rejection or getting into trouble with teachers or other adults. A child feels more safe and loved when they are given boundaries around their behaviors. When kids are given too much power, they feel afraid that the powerful people in their lives aren't protecting them.

When is discipline too stifling and hard on the kids?

Parents often associate discipline with punishment. But they are quite different. Discipline is setting logical, loving, but firm and consistent boundaries and delivering them with empathy. Punishment (yelling, physical punishment, or taking away objects or rights that have nothing to do with the offense) is hurtful, illogical, and counterproductive, only creating fear in kids as opposed to teaching them how to be in the world.

What are some of the most important strategies for nourishing independence and building self-confidence?

Value children. Listen to children. Set appropriate boundaries and expectations. Teach problem-solving skills. Praise effort. Encourage children to help.

our parenting *principles*

Parenting is, hands down, the toughest job in the world. Both Scott and I know that being an engaged parent is no small task and that there is no one right way to do it. But after three kids (and making many mistakes and learning along the way), we have discovered a few things that work for our family, *most* of the time. These are by no means the last word on parenting; the fact is, parenting is such an individualized thing that what works for one family will not necessarily work for another. Even so, I wanted to share a few ideas with you in hopes that what helped us might help your family too.

1. **SEEK OUT ADVICE FROM OTHER PARENTS.** To begin, a lot of the parenting concepts that work for us I was initially exposed to in parenting programs. When I was pregnant with my first child, I was scared out of my mind. My solution was to find out what other parents, educators, and caretakers did by joining parenting programs. With each one of my children, I have attended Mommy and Me classes. I went to a group run by Jill Spivack, and she addressed topics relevant to first-time moms. We talked about sleep, marriage, the transition to parenthood, work and identity changes, and play for the little baby. These classes and the relationships I developed with other moms honestly served as my touchstone to sanity. Jill also has Second-Time Mom groups, which address subjects like sibling rivalry and balancing a family, as well as Advanced Mom groups, which are for parents only and cover behavior and development topics as our children get older. Search around and you are sure to find a group or classes that are right for you. For divorced parents, there are excellent co-parenting classes available, which help parents get on the same page. Your county or state may also offer free parenting programs, and I know

that many branches of the YMCA offer a wealth of parent-and-child classes for their members, such as Mommy and Me Sing and Sign or Little Hands Arts and Crafts.

Don't just take my word for it. Research done by the Institute of Health Sciences at Oxford University found that group parenting programs give us confidence as parents and also have a significant positive impact on the mental health of mommas. Supportive parenting programs have been shown to reduce depression and anxiety in new mothers and to improve self-esteem and spousal relationships. It's great to have the research to back it up, but I also know this to be true because *I feel it with every bone in my body.* The support of these groups and other moms has been a huge comfort and continues to help alleviate my fears, anxieties, and concerns as I grow and mature into motherhood.

2. **YOU ARE THE CAPTAIN OF THE SHIP.** This is pretty much a direct quote from Robin Berman's seminal book *Permission to Parent.* You are the boss, and don't you forget it. As parents, you are the heads of the household, and you are the ones running things. Not your kids. Yes, they are so cute that we don't always want to step in and be strict and discipline. Yes, they can sometimes act out or be manipulative and it seems easier to give in because you are tired or just don't have it in you. But you cannot let them walk all over you. Being firm with your children does not mean you are not being loving. Being firm is actually being loving, because you are saying no in their best interest. Children need a parent, not another friend. My kids know they have to sit their tushies down at the table when it's time to eat, and they know that if they don't, they will get in trouble. They know that when Scott or I say no, it means no. It doesn't mean they always behave, supermommas! But it does mean that when they misbehave or don't listen, they may expect consequences, because we are consistent. And that is what is important. I promise, our kids still think we're fun!

3. **LET KIDS BE BORED.** Tara Rubin, Brooks's preschool teacher, and I talk about this. Study after study tells us that our kids are overscheduled and families are overrun with to-do lists. I have definitely been guilty of overscheduling myself and my kids. This is a challenge for many families. You want to give your kids all the opportunities in the

world, from music lessons to arts, sports, and education—but what's the right balance? Well, we must realize that when we make all our kids' decisions for them, and when kids are overburdened with programmed activities, it affects their creativity and cognition. As Tara says, "Children need things to do—but not *all* the time." Also, we shouldn't always decide for our children which activities they'll engage in. She further explains, "Children need to think about what they want to do on their own. They've got to use their own brains. When they come up with their own ideas and activities, it encourages independent thought, gives them a sense of independence, self-reliance, and in turn, *confidence*." Isn't that what every parent wants for their children?

4. **EMPOWER THEM TO CHOOSE.** Give young children limited choices and only choices that work for you. This still empowers children to make their own choices, but they are choices you are okay with. Little ones do not do as well with open-ended questions. And frankly, as a parent, you never know what you are going to get when you leave something open-ended for your kid. So instead of asking, "What would you like for breakfast?" ask, "Would you like cereal, pancakes, or eggs and toast?" That way your child has control over her choice, but clearly strawberry ice cream and cheddar bunnies are not options. Everyone is happy! This strategy works well for discipline too. Scott and I might say, "You can (1) calm down, sit in your room, and think about what you've done; or (2) apologize to your sister right now and give her a hug; or (3) keep doing what you are doing, *but then you won't be able to watch* Curious George *tonight*. What would you like to do?"

Kids don't really listen to what you say, but they listen to what you do.
Kids are watching, especially young children, and they really are learning
by example. They see how you treat people, and they see how you handle stress.
And they do what you do.

—CINDY CRAWFORD

5. **MODEL GOOD BEHAVIOR.** Children learn from observing their parents and caretakers. If you want your children to do something, they need to see you do it too. It's not rocket science. "Do as I say, not as I do" does not work for modern parenting. For example, the more digital screen time you have (with your phone, iPad, TV, etc.), the more they will want that too. Children are incredibly impressionable at every stage; this goes for infancy and toddlerhood, and continues in adolescence. No parent is perfect, and that's not what you should strive for. But Scott and I definitely look more closely at what we are doing when we are around our children, and we try our best to be positive examples.

6. **HOLD OFF ON "HELICOPTERING."** This is especially tough for Type A moms. Yes, you have to be there for your kids. Yes, you want to care for and watch over them. But don't go Goldie Hawn overboard on them, especially when you have the financial or emotional resources to spoil and overprotect. Your kids need your love and support, but let them try things for themselves. Let them fail. Children actually need to experi-

interview with *parenting expert* dr. robin berman

I met Dr. Robin Berman through Reese Witherspoon. She is a brilliant psychiatrist, supermomma, and the author of *Permission to Parent*, my all-time favorite book on parenting. She is truly a shepherd of little souls. Here are some key insights from Robin on raising children with love, and creating a family life where there is calm.

Parenting, where to begin?

When it comes to raising our children, we should "begin with the end in mind," as Stephen Covey says. What kind of human beings do we want to raise? We should ask ourselves, "When I launch my son or daughter, what is my highest intention for my child?" Being a person with integrity and compassion will serve that child far better in life than any academic or sports achievements. Not that those aren't important, but awards and honors are most meaningful when built on a foundational base of being a kind, considerate, and compassionate human being.

On consistency and the "nonnegotiables."

Time to get dressed. Eat dinner. Bath time. Bedtime. These are *nonnegotiable decisions. They are not up for debate*. They should not be daily battles. Consistency in a child's daily routine prevents your home from erupting into chaos and creates a peaceful environment. In a frenzied household, children lack the calm, healthy, and quieter rhythms that allow them to tackle the more erratic beat of the outside world. Not to mention that power struggles in the home suck the joy out of parenting and the parent/child relationship for you. Keeping daily routines consistent, like bedtime with stories, fosters healing rhythms that allow the ordinary day to become sacred.

On loving language and measured tone.

We learn our worth by the way we are treated by our parents. Parents who homeschool their children in love can use the power of mindful words. Loving language and a respectful tone adds a layer of beauty to our homes, one which is almost tangible. Language matters, because a parent's voice becomes the voice in their children's heads. Our goal, as parents, is to plant seeds of love; love builds self-esteem, while shaming or humiliating a child—"Bad girl! You should be ashamed of yourself."—erodes self-confidence. Mindful language invites insight and learning. "You made a mistake; we all do. What did you learn from it? What would you do differently next time?" Know too that raising your voice may control your child for that instant, but not for the long term. Kids raised in fear do not feel safe. Often, they learn to hide their true feelings. By grounding your home in love and respect, home can be a safe harbor, a peaceful place that encourages children to flourish and become confident and loving adults.

Home is the school of love.

Parents spend so much time promoting sports or piano lessons, or drilling math facts, but where is the Kumon for teaching feelings? Home is the school of love. It's where we learn to manage our emotions, where we begin to understand our self-worth. If we don't learn this at home, it's far more difficult to learn these skills as adults. We have to actively model what we want our children to learn. If we want our children to be measured, then we have to teach ourselves not to fly off the handle. If we want our children to be honest, then we have to ditch the white lies and learn to be impeccable with our word. Parenting is an opportunity to raise ourselves so we can better raise our children. Children add so much joy to our homes; they remind us to play, to be present, to grow our best selves, and most of all they allow us to experience an epic love.

It does not get chicer than that.

ence forms of disappointment and discomfort in order to learn to cope for themselves. It is part of life. How can they if we do everything for them? If you clean your kids' room for them every day, they will never learn to do it themselves. Let's give our children enough space that they may learn essential life skills on their own. Our children will be who they are going to be, and we shouldn't try to change that. But they do need guidance to be the best version of themselves.

7. **AVOID LABELING.** Labeling our children, whether negatively or even sometimes positively, is generally not very helpful. It might seem like we are just being descriptive or factual about our children; however, we need to be very careful how we choose to define our children early on, because the truth is, we don't truly know who our children are yet or what they'll become! Why should we tell them who they are and what they are going to be? By stating assumptions, we are getting in the way of possibility and could be creating a self-fulfilling prophecy or unconsciously shaping their self-image in a negative way. We should avoid saying, "She's *this* or *that*." This is especially true when speaking directly to our children. It's best to let go of our judgments, stay open, and keep away from labels so that our children can grow and bloom without being tethered to negative predictions.

8. **WHISPER IN THEIR EAR.** As French writer Anatole France said, "Nine-tenths of education is encouragement." This I believe! While excessive praise for every little thing can be damaging to a child, being an

engaged, active, and encouraging parent lets your children know that you are there—and that you care. You can be an engaged, active, and encouraging parent whether your children score a goal or don't, whether they get an A or a D, and whether they do as they are told or misbehave. That way it's not always just good job/bad job. It's recognition of their hard work. And it's about engaging with the child and asking, What went wrong and how can we do better next time? Don't ever let your

children forget that they have a cheerleader in their corner. By whispering in their ear, letting them know that you see their hard work and progress, or that you are there to help them through a lower point, they will be better for it. My parents always whispered in my ear. They instilled confidence in me from the time I was small that I could achieve any dream. They encouraged me when I succeeded and also when I failed. Both success and failure provided us as parents and as children opportunities to learn and grow. That kind of belief and support goes an incredibly long way when it comes to your kids' confidence and ultimately to their future success in life

A happy, healthy home is something that all of us strive for. It's as much about how we care for our home as how we care for *one another* inside of it. To me, it is as much about how our home functions as how it feels. It's as much about cleanliness, safety, comfort, and organization as it is about connectedness, fun, relaxation, and respect. A happy, healthy home and the relationships we build inside aren't about perfection. (Believe me, there are days when I say, "I give up!") But rather, it's about striving for a little more harmony in our lives. It is always a work in progress. When you are lucky enough to build a family with someone you love—whether it's just two of you or ten—it's something that deserves to be cared for and cherished. Cultivating a healthy physical and emotional environment that nurtures and feeds our bodies and souls will truly help your family feel purpose and soar together.

happy,
healthy home

TOP 10 takeaways

1. Embrace minimalism, people! Start today. Declutter, organize, and simplify your life. You won't believe how good it feels.

2. Clean up and green up your home to the best of your ability. Choose healthier, nontoxic cleaning products or even make your own. Get rid of the worst offenders, and add some green plants to further purify the air.

3. Find joy in the small luxuries at home. You don't have to be rich to live richly and deeply. Cultivate everyday pleasures that bring you joy and nurture your spirit and your family's.

4. Establish your own Superfamily Code of Conduct. These will be rules that you all live by.

5. Have a family calendar and work from it, being sure not to overload and overschedule!

6. Happiness is a choice. Choose to be happy whenever you can, and live in the present. Appreciate the things that you have, appreciate one another, and make gratitude a part of your daily family rituals.

7. Exercise. It's crucial to your health and well-being—mental, physical, and spiritual. Stay on top of your family's health, and get active together!

8. Establish traditions. They can be big or small, but it's important to have them and to maintain them. They tie us together.

9. You are the captain of the ship. Lead with love, not with fear, and whisper in your children's ear. Let them know you love them, that we aren't perfect, but we can always try to do our best.

10. Take a holistic approach to family wellness. Apply healthy principles to both the physical space of your home and the emotional space; tend to your family relationships and your commitment to honoring and helping one another.

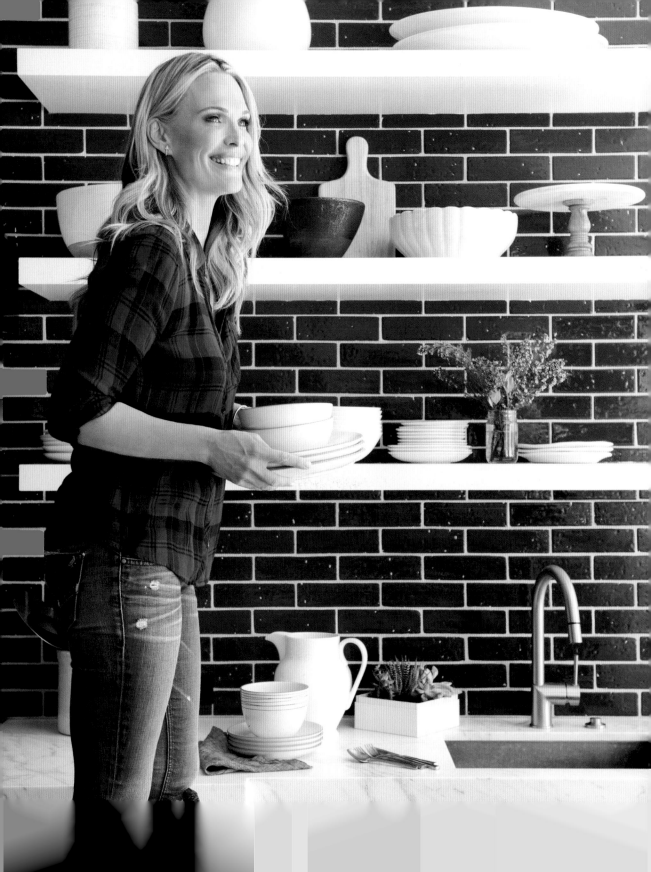

happy, healthy home
my inspiration

GWYNETH PALTROW @gwynethpaltrow, @goop, Goop.com. GOOP is my go-to for all things superchic for the home. From recommendations for detoxing your abode and your life to tips on home organization and more, I can't get enough!

CLEA SHEARER & JOANNA TEPLIN @thehomeedit, TheHomeEdit.com. They are obviously part of my gurus in this chapter. Love, love, love these girls. Their Instagram and blog are full of inspiration!

JOY CHO @ohjoy, OhJoy.com. Calling all color obsessed! Joy Cho's aesthetic is all about the bright and bold. She's a great source for any DIY for the kids, too!

TAYLOR STERLING @glitterguide, TheGlitterGuide.com. For those who like the simple elegance. I love Taylor's approach to adding wellness into the home through peaceful colors, fresh florals, and cozy textures.

ELSIE LARSON & EMMA CHAPMAN @abeautifulmess, ABeautifulMess.com. For someone who enjoys a little DIY, Elsie and Emma are a great resource. Their style is fun and all about embracing imperfection through enjoying the small things in life.

JEN JONES @iheartorganizing, IHeartOrganizing.com. Another great organization inspiration site! Jen is all about saving space and doing it in a creative and budget-friendly way. Her blog is fantastic!

LAURA SAVILLE, JOANIE WHITMAN, PAT LAND & ALICIA VOORHIES @thesoftlanding, TheSoftLanding.com. Three sisters and their mother, these women give great tips on how to create a safe, natural home. Find lots of DIY natural remedies and more.

For more Happy, Healthy Home inspiration, plus shopping and sourcing tips, visit MollySims.com.

ch/4
design & decor

As much as I love fashion, interior design is my true passion. You could call it an obsession, but a healthy one. My love affair with design goes back to when I was in my twenties, living in Paris early in my modeling career. Nothing compares to that city when it comes to a street school for style, and Paris had a tremendous influence on my approach to design. I fell in love with the Parisian attention to detail, their love for both the simple and the ornate, the grandeur of the city's historic buildings and the quaint cafes and boutiques nestled along charming walking streets. At twenty-seven, I left Paris and moved to New York to pursue other career opportunities. Many of my model friends were spending their hard-earned money on Hermès handbags, but I was saving for a house.

The first house I bought was in Wainscott, New York, in the Hamptons. It was a three-bedroom, traditional Hamptons home. Nothing fancy, but absolutely perfect. I did very little to it, apart from painting the walls and filling it with comfortable and casual furniture from Crate & Barrel and a few flea markets. Lots of slipcovers, beachy stripes, natural woods, sisal rugs, and big, comfy pillows. I also installed an incredible giant faux-coral chandelier over the dining room table. To this day, I still think it's amazing! Since then, with every new city that I've moved to, I've taken the opportunity to indulge my love for design by decorating my apartment or house. Today, I'm up to at least seven total design projects, so I've got a fair bit of design experience under my belt. Some were apartments, a few were houses that only needed minor face-lifts when I moved in, a few were remodels, and one was a house that Scott and I built from the ground up! And I have learned that quality decor and design do not have to break the bank. Good design can be found everywhere these days, from exclusive showrooms to independent boutiques to big-box furniture stores to flea markets! I've also learned over the years that it's okay to make mistakes—I've made many of them in my homes. Decorating is about trial and error, and learning what you like and what works for you and your family. So don't be intimidated!

Decorating a home is about marrying the functional with the beautiful, the practical with the personal. My home is my sanctuary and it houses my most precious belongings: my husband and my babies. I want it to be cozy, warm, and inviting; I want it to be stylish; and I also want it to work for us as a family—and with three kids *under five*, not to mention our three dogs, that's a tall order. Similarly, you want to make your space work for you! So roll up your sleeves and get ready to get your hands dirty. In this chapter, I consult with my design and decor gurus and share some design fundamentals in addition to my favorite tips and tricks. Whether you are a young professional sprucing up your first apartment, or you have a big family and are knee-deep in laundry and big design dreams, we'll explore tips and tricks for making any house a home.

my *divas* of design & decor

DAN SCOTTI Dan is a Manhattan-based architect and interior designer who can do no wrong. In recent years, he has been my honorary professor of design. He has helped us build two homes from studs to ceiling—and our friendship survived! He's amazing. (DanScottiDesign.com, @danscottidesign)

KISHANI PERERA Kishani is the first interior designer I ever worked with. She made my pied-à-terre dreams come true when we designed my first Manhattan apartment in an authentic Parisian style, and she also helped me design the home I used to own in the Hollywood Hills. I've learned so much from her about sourcing, scoring vintage, and styling a space on a serious budget. (KishaniPerera .com, @kishaniperera)

TRIP HAENISCH Trip is an L.A.-based interior designer who is famous for clean, contemporary, original interiors. Trip designed our vacation home in Mexico, and he has taught me to take chances and to think outside the box when it comes to design. (TripHaenisch.com, @triphaenischinteriors)

TIFFANY HARRIS Tiffany is the chicest of the chic, an interior designer and home stylist who designed our playroom, my children's bedrooms, and their nurseries. She has such a special, warm touch, and as a mother of three, she knows how to meet the practical needs of a growing family without sacrificing style. (TiffanyHarris.com, @tiffanyharrisdesign)

Whether you've just moved into a new house and are starting with a blank canvas, or you've been living in your home for a while and every room looks like the "before" picture on a home renovation show, the prospect of decorating an entire house (or even just a room) can be daunting. But don't stress! Here are the strategies I start with for major design inspo:

* **CONSULT THE MASTERS.** When I'm decorating a new home, the first thing I always do is turn to classic and contemporary design

The everyday home . . . is a perfectly imperfect space you love. It's the heartbeat of your family, and within its four walls, you host your closest friends, feed your family, cultivate your style, and snuggle with your loved ones. It is a place you cherish and care for—because it cares for you back—and it's the home you've always dreamed of, where memories are made and magic happens. It's not perfect, but it's all yours.

icons for inspiration! These are the creative geniuses whose pioneering looks and vibes inspire me. Their work also typifies timeless design and stands the test of time. I thumb through the work of designers like David Hicks or Michael S. Smith and totally style-stalk newer designers making waves in the design world, such as Emily Henderson and Amber Lewis from Amber Interiors. There are so many amazing home stylists and designers who have taken social media by storm, making design accessible for everyone. (For sources of endless inspiration, see my list of favorite designers on page 181.)

✳ **REVIEW DESIGN MAGAZINES AND POPULAR WEBSITES.** These can be a tremendous source of ideas. As far as magazines go, I've read *Elle Decor* from day one, and the original *Domino* magazine was the best, and now it's back! *World of Interiors* and *Architectural Digest* are designer favorites and great for high-end ideas, and *Dwell* is great for contemporary style and affordable inspiration. My favorite blogs and websites include ApartmentTherapy.com, MyDomaine.com, Lonny .com, Houzz.com, and DesignSponge.com. And there are tons more out there. Go explore!

✳ **PAY ATTENTION TO PUBLIC SPACES.** Restaurants. Retail stores. Lounges in international airport terminals. The industrial and functional materials used in these spaces can inspire cool new ideas. And when you are a family with children, it's smart to pay attention here. These businesses are likely to use materials that are durable and work well in high-traffic zones. I'm always snapping photos while I'm out and about and saving them in a design folder on my phone. Try it!

✳ **PEEP OTHER PEOPLE'S HOUSES.** Yes, I'm a nosy neighbor. When I see gorgeous pieces or functional design ideas in my friends' and neighbors' homes, I always ask them how they did it. Friends and neighbors are an endless source of design wisdom.

everyday *supermomma* secret

Design inspo can honestly come from l-i-t-e-r-a-l-l-y anywhere. For my sweet Scarlett's bedroom, it came from a cardboard box. A cardboard box, people, did you hear that? I loved the paper-bag brown color of it mixed with the hot pink, rose gold, and ivory text that was printed on it. I gave that box to my designer, Tiffany Harris, and said, "I want it to look like this. Go nuts."

DESIGN SCHOOL 101

Once you've immersed yourself in the looks and styles that inspire you, it's time to study up a bit. Whatever your personal style or taste, these main elements of design will always come into play and need to be carefully considered. So take note before you get started:

1. **THEME** Loosely identifying an overall design vision or theme for your home will give you a strong foundation. Design guru Trip Haenisch recommends letting your location and surroundings inspire your theme. Are you by the beach, near mountains, or in the big city? Perhaps you want your design theme to be French Country Meets the Coast, or Mountain Cabin Meets Americana, or Midcentury Modern Meets Manhattan. Design theme inspiration can also come from the structure of the house itself, from a single photo in a magazine, or from a single piece of furniture you already own and love.

2. **FORM + FUNCTION** If you have a growing family, you should probably prioritize form and function first. Design should be just as much about functionality as style. If something looks pretty but isn't functional, it creates a lot of unnecessary stress. Your family couch, your kitchen

sink, the tile and grout you choose—all these things are going to get a lot of use and abuse. So think carefully about both form and function when making choices. I *love* a crisp white bedspread, but our bed is blessed with kids and dogs, and that just wasn't going to work no matter how much I wanted it. So we went with a beautiful gray bedspread, and I put my white linens to use in the guest bedroom!

3. **SIZE + SCALE + SYMMETRY** It's important to choose furnishings that fit your space. Rooms with high ceilings do better with more substantial pieces that ground the space, whereas low ceilings merit lower profile furnishings to make a room appear larger. When deciding on placement for furniture, art, and accessories, symmetry is also something that needs to be finessed. All my bedrooms feature matching bedside lamps on each nightstand, and our front sitting room is also arranged with total symmetry in mind. Our brains love symmetry because it creates a sense of order and calm.

4. **COLOR PALETTE** Determining your foundation colors and your accent colors is key. It's like makeup: when the skin/foundation doesn't look good, nothing else will. Neutral foundation colors like white/cream, beige, and shades of gray tend to work best for floors, ceilings, walls, and countertops. Once you have your neutral foundation, you can play and introduce color with accents in your furniture, draperies, and accessories. In our house, we have light wood floors; light carpets and rugs; and walls in shades of white, light stone, and ecru. For accents, we chose a rich, deep charcoal-navy for our kitchen cabinets and bedroom doors.

5. **DEPTH + DIMENSION** This is really about making sure that your spaces aren't flat. Often, this is achieved by incorporating different textures, finishes, metals, and tones to create rhythm and movement in a space. If everything in a room is the same color and texture, it will read flat. For depth and dimension, think a neutral linen sofa, a sheepskin throw, a patterned pillow, a glass coffee table, an oversize Persian rug, and a leather side chair. All different textures, but all working together to add layers and depth.

6. **REPETITION** Repeat after me: repetition creates harmony in a home. When you repeat similar elements in various spots throughout a room—or an entire home—it will create a sense of cohesion. Whether this means repeating shades of an accent color, a repeating pattern, or a repeating material (chrome, marble, glass) or other detail, repetition helps encourage flow and harmony in a space. I also believe that a house should tell a single story. Unless you want to live in the Madonna Inn, rooms should be connected, even if they are different.

7. **INVESTMENT** This is an absolute fundamental! Think of your interior design choices as contributing to the equity of your home. It doesn't make sense to spend a ton of money on an expensive, exotic table lamp and then cheap out on the flooring. You should invest the bulk of your budget in installations like floors, countertops, cabinets, and built-ins. Make smart, solid decisions and think of your home as an appreciable asset.

8. **SUSTAINABILITY** Whenever possible, think earth-friendly design. From low-flow plumbing features, to reclaimed and Forest Stewardship Council–certified woods, to low VOC (volatile organic compound) carpets and paints, there are simply too many high-quality, sustainable options out there to ignore. It's our responsibility as custodians of our planet to consider sustainability when designing our spaces.

9. **SOUL** A house is not a home unless it has soul. But you have to live in a space for a while for its soul to emerge. When we first moved into our dream house in Los Angeles, everything was beautiful, freshly painted, sparkling, and new, but something was missing. *You could feel it.* I just knew the house was the right one for us—but I knew we'd have to live

in the space to make it *truly ours.* Once we had lived in the space for a few months, and I layered in some personal pieces, pinned the kids' art to the bulletin boards, hung family photos on the walls, piled cozy blankets into baskets, and added a few special accessories, the spirit of the house came alive! These are the elements that truly make your house *your home.*

on working with a *designer*

I am a collaborative person and I like to share ideas. I have worked with a designer on all of my bigger projects because I truly believe the final project turns out better that way. A good designer will help you grow your taste and will take your ideas and make them better. And sometimes a designer can even save you money on certain pieces that they get a designer discount on. Even if you don't want to shell out for a traditional interior designer, there is good news: there are a growing number of digital design firms out there that can help you design a room or an entire home at an affordable price.

my homes over the years

Below are a few themes I've explored in the homes I've designed over the years. This list should give you a little peek into my diverse taste and design evolution and should also help give you a sense of how to develop a design theme for your home:

1. **PARISIAN-INSPIRED PIED-À-TERRE** I had just moved into this New York apartment after living in Paris, and I wanted to be surrounded by the familiar. So I identified my theme—a feminine Parisian abode—and got to work. My designer, Kishani Perera, and I chose a palette of soft grays, off-white, and dusty rose with pale woods, vintage furnishings, and feminine fabrics. All the furniture—tables, chairs, art, armoires, light fixtures, even my sleigh bed—was sourced from French flea markets (mostly from Clignancourt) and shipped over. My home became an escape from the hectic streets of New York where I could sink into the sexy, old-world comfort of vintage Paris.

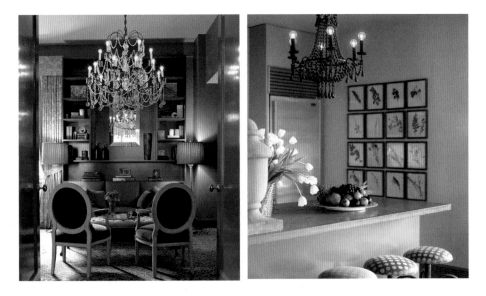

2. **SPANISH RANCH IN THE HILLS** From New York, I packed up my entire life and traveled cross-country to the West Coast for the television series *Las Vegas*, and I bought a Spanish-style ranch house in the Hollywood Hills. I worked again with Kishani Perera to decorate and

renovate the house on a serious budget with a lot of DIYs. Even with our tight budget, it was a beautiful space, with classic architecture, and it ended up looking great!

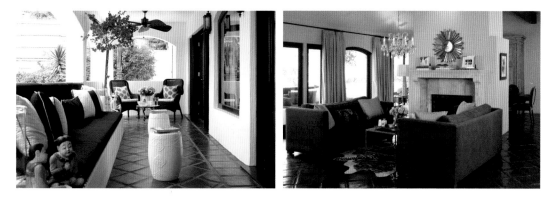

3. **BEVERLY HILLS BOHO-COLONIAL** When I first moved in with Scott, he had been living in a traditional home that was a little too Pottery Barn for my liking. There was also—wait for it—a red leather bathroom. We redecorated the space to reflect our new life together and transformed it into a more stylish colonial with bohemian touches.

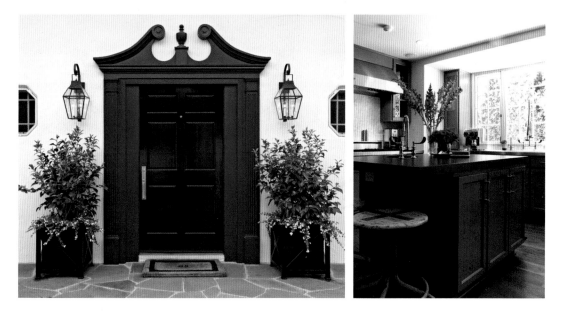

4. **CONTEMPORARY MEETS TRADITIONAL HAMPTONS** When Scott and I got married and decided to start our family, we knew we wanted to have a family home in the Hamptons. So we sold the house I'd bought in the Hamptons when I was single. This is when we met Hamptons-based designer Dan Scotti, who designed our next family home. It's classic East Coast but designed with lots of modern, mid-century touches for a comfortable of-the-moment, lived-in look.

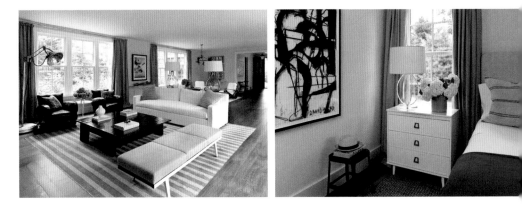

5. **BEACHY, MODERN MEXICO** We currently share a vacation home in Mexico with another family. When we bought the place, we had to totally gut it and replace all the floors because of water damage from a series of storms. The result was a colorful fun-in-the-sun, casual but

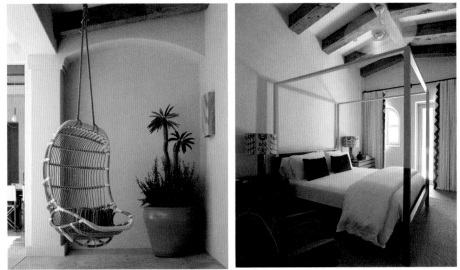

stylish space designed by the über-talented Trip Haenisch. The color scheme and decor take cues from the white sand, the turquoise sea, and the bright blue sky surrounding the house. Our Mexico house is all about bringing the outdoors in and restoring calm to our harried souls. And because it's a beach pad, it's extremely sun-, sand-, and kid-friendly.

my childhood home My childhood home in Kentucky was over one hundred years old, with these beautiful, perfectly beat-up wood floors that my momma would polish once a month. And it had these incredibly high ceilings that, as a kid, always seemed so out of reach. I can remember playing with my brother while my momma and daddy sat in chairs on the porch. This kind of lazy but loving family afternoon spent at the home you love still inspires me to this day.

where do i start?

THE MOOD BOARD

After I've done my research, I always create a mood board. A lot of designers do this too! One option is to make a physical board on which you pin color swatches, fabric samples, and pictures of furniture and accessories to see it all together. I also love using Canva.com to create my mood board from images I upload to the Canva website. It's a great way to take your ideas and inspiration and move them into something visual, workable, and more concrete. Pinterest deserves its own shout-out. Is there anything on the planet better for design inspiration? I love to browse everything from DIY projects to color palettes and design tricks. If you don't have an account, sign up immediately. It's easy to create a collage or mood board there too for every room in your house.

let's talk budget, *baby*

Once you've got your mood board, it's important to get a handle on the budget you have to work with. Regardless of how big or small your budget, you need to know where to splurge, where to save, where to invest, and what to skimp on. Here are some tips for being financially savvy when designing your home:

* **INVEST IN YOUR INSTALLATIONS.** As I've mentioned, when renovating a home, you should plan to spend the most money on the pieces *that have to be installed.* This is straight from the brain of architect and designer Dan Scotti. If you can splurge, splurge here. Installations are anything that is built-in—floors, countertops, cabinets, shelving, and so on. These are things that will *add real value to your home.* Also keep in mind that your labor and installation costs are often going to be the same whether the material you're using is cheap or expensive. Labor is labor. Generally speaking, never compromise on something that has to be installed. If you need to pull back in places, do that on household items that are not permanent and can be switched out easily at a later time. Light fixtures, linens, rugs, furniture—all that stuff is easily upgradeable.

* **BE AN OPPORTUNIST.** A great way to save money is to use what you already have. New is not always better. When Scott and I got engaged, and I moved into his house in Beverly Hills, we began to redesign the space (including the red leather bathroom). I repurposed almost every single piece of furniture that I owned from my Hollywood Hills house. We recovered couches and chairs. We reinstalled lighting from my old house, which I'd been able to take along. With some easy updates, my old stuff looked great in the new space. And guess what? When we moved again, I repurposed nearly every single piece of furniture we had from the Beverly Hills house and used it in the house we live in now. The couch that had been in Scott's office, believe it or not, was recovered with a lighter fabric, and it's now stylish and sleek in our front sitting room. Frugality in my family is serious business!

* **CONSIDER REPRODUCTIONS AND KNOCKOFFS.** Honestly, sometimes you cannot even tell the difference between "lust" and "less." There are tons of talented craftsmen out there who will

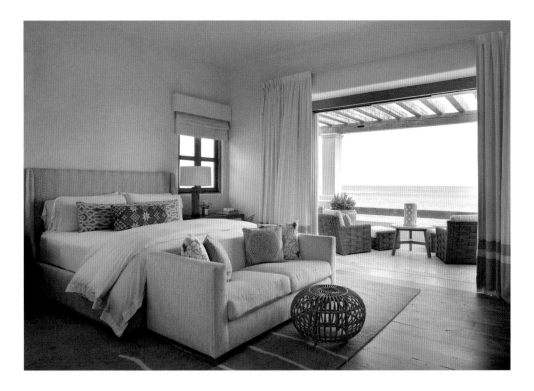

reproduce something from a picture. A professional designer will have a list of go-to people who do great woodwork, custom couches, and lighting in your area. But if you are not working with a designer, you can absolutely find these people yourself, vet them, and have them bid on your project. It's worth the effort, because a good reproduction can cost half the price. Craigslist and eBay are great sources for this kind of stuff. I have had several reproduction light fixtures made for our current home in Los Angeles, most notably the one in Scarlett's bedroom. The original comes with a totally crazy price tag (seven digits!), so we had one made for a fraction of the price. Definitely one of my prouder design moments.

✳ **SCORE BUDGET DECOR.** If you have the patience, you can save tons of money by scouting out gently used furniture, and sometimes even good vintage and antiques, at estate sales, garage sales, swap meets, and flea markets and on eBay and Craigslist.

choosing your *palette*

NEUTRALS DONE RIGHT!

As I've mentioned, when designing a room or a home, I always begin with a neutral foundation. Some rooms in my home might remain totally neutral, without splashes of color, while others I might layer in bolder, brighter tones. Regardless, the foundation from room to room is most often the same. When neutrals are done right, the result can be extremely sophisticated, stylish, and layered. Let's take a look at how to accomplish this.

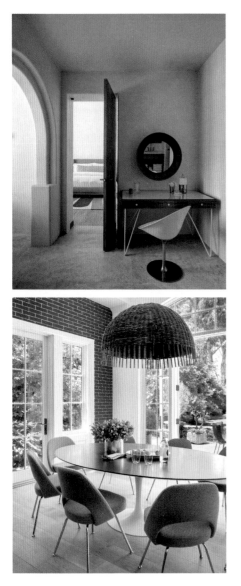

ALL NEUTRAL

I often love rooms that are all-over neutral, particularly bathrooms and bedrooms. An all-neutral room done well creates a serene, harmonious effect. But it's easy for a totally neutral room to look, well, bland and boring. Here are a few tips for avoiding this pitfall, and for nailing the all-over neutral:

* Layer in different shades of your chosen neutral tones for dimension and subtle contrast.
* Use subtle patterns—think tone on tone or pale stripes—to create movement in the space.
* Use a diversity of textures in the room. Think a linen couch, nubby blanket, faux-chinchilla pillow, leather side chair, and sisal rug. Different textures, like patterns, also help create dimension and subtle contrast.
* When working with all neutrals, using high-quality materials can make a difference. Invest in a few quality neutral pieces that really make a statement.
* Mix contemporary and vintage styles for a more custom look and to keep things interesting.

✳ Add subtle eye-catching details that reflect light, such as chrome or brass hardware or a crystal lamp.

NEUTRALS WITH COLOR

Trip Haenisch believes that you shouldn't be afraid to use color but that too much of it can be overwhelming. And I agree. He finds that starting with a neutral base gives you the openness you need so that color can relax into the space rather than strangle it. Here's what Trip recommends: "As a general rule, for your bigger pieces, like oversize couches, countertops, flooring, and walls in the main part of the house, start with neutrals—whites, cream, beiges, oatmeal, and light grays." When you do bring in color, he says, "the contrast enriches the entire space and brings both the neutral and the color to life. Without color, a house just doesn't have the same soul."

Splashes of color in a vintage textile, an oversize piece of art, an interesting lampshade, or a chandelier look that much more stylish and chic when set off by a neutral backdrop. In our Mexico house, Trip used white walls, light cabinets, and birch flooring as the establishing neutrals. And then his use of color was so satisfying, especially in our kitchen! He introduced four barstools in primary colors along the bar/kitchen island. I didn't think I would ever use primary colors in styling, but I love, love, love it!

Also, the foundation colors of each bedroom and bathroom are light and neutral, but in each bedroom, he chooses one color and works with various hues to give it so much personality and life. They are the perfect complement to the sun-drenched rooms. The walls in the bedrooms are painted with these soft washes of color, like watercolor. And the way he worked the colors into the geometric patterns of stripes in the curtains and then repeated again in the bathroom tiles—I mean, heaven.

ONE NEUTRAL ZONE THREE WAYS

Check out just how easy it is to transform a space with color when you have a neutral base! Your styling options are limitless. My interior designer crush, Tiffany Harris, and I changed up my basic outdoor living room into three totally unique looks using extremely affordable textiles and decor from a few discount home stores. We started with the same neutral base and then for each unique look layered in pattern and color. Try this with a space in your house that you think you'd like to update often, whether for a specific season (summer or the holidays) or simply for a change of pace without investing a lot.

1. *new neutral*

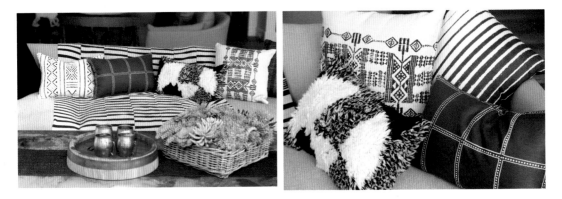

2. *california coastal*

3. *global bohemian*

supermodel styling Tip Notice that in the California Coastal look there isn't a seashell in sight. You can evoke the cool, calm, coastal vibe without being too on the nose or kitschy. Keep in mind that a little goes a long way with themed decor!

CLEVER WAYS TO USE COLOR

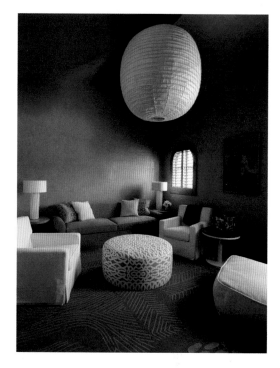

* **WORK WITHIN A TIGHT COLOR PALETTE.** Rather than choosing a rainbow of color, pick one or two main colors that complement your space. If one of your colors is blue, choose to mix various shades of blue in that color family, perhaps layering in denim, indigo, and sky like we did in our house in Mexico.

* **USE COLOR REPETITION.** This is an excellent strategy for creating a cohesive home and smooth transitions from room to room, especially if you can see into one room from another! And you can change up the ratio of color used. For example, in one room you might pick up color in a bold red painting over the couch, and then in another, you might repeat that red in a much smaller percentage, featured simply in a pillow or a vase.

* **CONSIDER COLOR TEMPERATURES.** Cool colors are considered calming (blues, greens, purples), while warm colors (yellows, reds, oranges) are energizing. Keep this in mind when choosing a color palette for your space. The dominant color tends to set the emotional tone of the space. In one of our bedrooms in Mexico, we used light neutral woods and whites, set off by yellow tones. The effect is a happy, bright, sun-drenched space.

* **RULES ARE MADE TO BE BROKEN.** There is a design rule that says that darker colors should be used toward the bottom of a room, getting lighter as you work your way up. This mirrors nature if you think about it. However, I will say that this rule can be very effectively

turned on its head. For example, if you want to create a sense of intimacy or to shrink a large space, go dark, very dark, on the walls or ceiling! The bedroom of our Los Angeles home has these gorgeous, superhigh ceilings, but we wanted to make the space feel cozier, so we painted the ceiling a rich shade of charcoal.

* **WHEN IN DOUBT . . .** If you are at a loss for how to work color into your house, pick one accent color for each room. I've been doing this since I was twenty-seven and living in my first Hamptons home (I had a *coral* room, a *sage green* room, and a *sky-blue* room), and it still works.

I want people to immediately enjoy and feel comfortable in our home. I don't want our guests to worry: Do I have to take my shoes off or do I need a coaster? We are a no-coaster household. And that even translates to what I wear when our guests come over. I want to be the most casually dressed person—I'm always barefoot and wearing jeans or a sundress.

—CINDY CRAWFORD

that *luxe + lived-in* look

I don't like anything to look or feel too precious or too perfect. *Kind of like how second-day bed-head hair is the best.* The same goes for home decor—it shouldn't look intimidatingly perfect. There's nothing I love more than a beautiful old house with chipping walls and soft, silky over-washed linens. Think of the faded grandeur of farmhouses and estates you see in Europe. I love this. We all respond to the authenticity, charm, and character of such places and spaces. When something is a little worn and weathered, there is love in it. It carries history and heart. Here's how to achieve a lived-in look in your home (when you don't live in a grand European estate):

* **WOOD FLOORING** Beautiful hardwood floors actually look better with age, as their edges and corners lighten from wear, and they acquire lines and scuffs for character. Weathered floors tell a story.

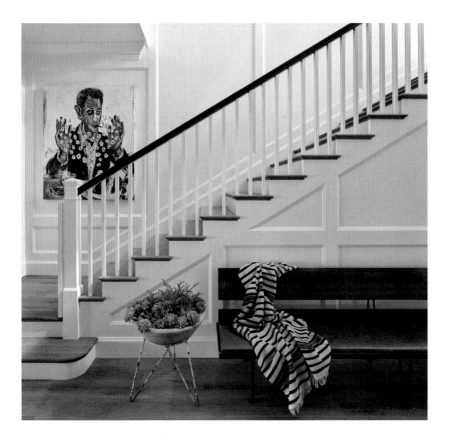

* **CARRARA OR CALACATTA MARBLE IN THE KITCHEN OR BATHROOM** It's pricey, but marble is always clean, classic, and screams elegance. It also improves with age—picture the stone counter in an old French bakery. This type of marble picks up little rings and marks, but it looks beautiful and feels authentic. These imperfections are what make a house a home.

* **COPPER, BRASS, CHROME, AND NICKEL** I love using these classic materials for the hardware in my home (faucets, cabinet knobs, doorknobs, etc.). These metals are strong and durable, and they develop a beautiful patina with use over time.

* **RUBIO OIL FOR STAINING WOOD** This is a go-to for designer Dan Scotti. We used Rubio oil on the floors of our current home to give them a softer finish. Rubio oil is VOC-free, made of mostly natural oils, and comes in over forty shades.

* **SANDING** You can lightly sand pieces of furniture on edges and corners that would naturally wear with time. Then leave the finish

raw or work in an antique wax to seal the wood for an even more aged finish.

* **WALLS** Soft color washes, like we did on some of the walls in our Mexico abode, give a soft-focus effect and look like they were painted forever ago, but are still fresh.

let's *talk* about paint, baby

I love fresh white walls mixed with light neutrals (shades of off-white and greiges) that are punctuated with glossy interior doors and cabinets in rich shades. It's kind of my signature. Friends love this look and have copied it too. It's a formula that I believe stands the test of time and still makes a statement.

HOW TO GET WHITE RIGHT

Selecting white paint is a b*tch. Honestly. All whites are not created equal, and depending on the room it's in, the amount of light it gets, what the walls reflect (Green backyard outside? Dark wood floors?), white can have subtle undertones of green,

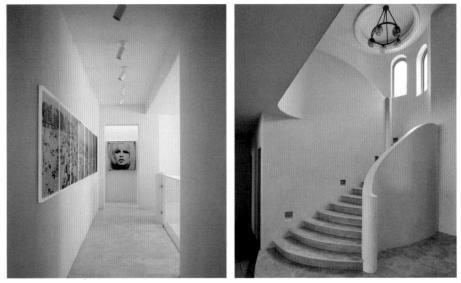

don't *forget* to have fun!

That's right, supermodels and supermommas! It's meant to be fun. Everything in your home does not have to be sophisticated and grown-up and serious. Make sure there are pieces in your house that make you smile or even laugh. Enjoy and embrace your space with playful elements, like the following in our home:

We put a giant black-tile thunderbolt at the bottom of our pool in Mexico and then named our place "Casa Thunder." That's right.

In our kids' playroom, I had a bright, bold neon sign custom made that says HAPPY MESS.

We have an aluminum and cork photo board on the wall in our kitchen across from the pantry pinned with photos of all our friends and family as a daily reminder of what is really important in life.

We also have a giant cork board in the upstairs landing featuring all the kids' "Picassos," which I cherish! Framed kids' art projects can make for the coolest contemporary wall art. They're so full of color, life, and happiness.

In our living room, we have an oversize framed photo of Jim Belushi making what is basically a funny face. The kids love to point at it and ask us, "Who's that guy?!"

Colorful textiles can breathe joy into a space. We have Suzani textiles and other vibrant fabrics that are stylish and whimsical integrated throughout the house. We even used a Mexican Otomi fabric on a lampshade in one of the bedrooms in Mexico.

Smaller spaces, like powder rooms, are a great place to take risks. They are usually their own little space—so have fun in there. Choose a funky wallpaper, piece of art, or exotic tile.

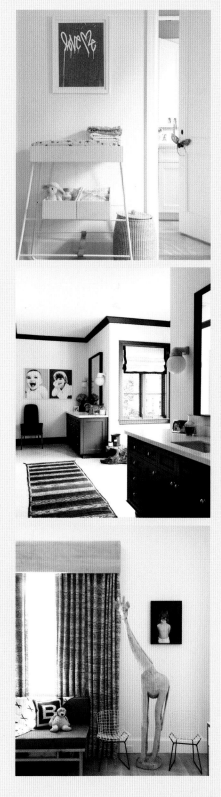

gray, pink, orange, red, yellow . . . and the list goes on. The only way to know for sure how a white paint will look is to buy small samples of several whites and paint fairly large swatches of each color on the walls. Look at the colors at various times of day and with the lights both on and off in the room. Trust me: you will be so surprised how different each of the colors read. In our Hamptons house, we mixed a soft, custom white for all the walls. We spent the extra time doing that because we knew we wanted it perfect. Most of my walls are matte, but I'll admit that matte doesn't always work so well with a toddler's greasy fingers. Semi-satin finish might be the way to go.

OUR FAVORITE WHITES

I surveyed my designers on their favorite white paints for walls, and here were a few of their top picks:

- ✳ **BENJAMIN MOORE DECORATOR'S WHITE** It's a classic and decorators do truly use it often because it's bright and clean, without being cold and clinical.
- ✳ **BENJAMIN MOORE WHITE 01** We used this on some of the walls in our current Hamptons house. It's a very neutral white and ever so slightly warm.
- ✳ **DUNN-EDWARDS SWISS COFFEE** This is a really warm, creamy white.
- ✳ **BEHR SNOW FALL** Supercrisp, this white is perfect for a modern home with lots of art.
- ✳ **VALSPAR HONEYMILK** It looks just like it sounds. It has that perfect bit of creaminess to keep things fresh but softens walls and still warms up a room.
- ✳ **FARROW & BALL POINTING** This is actually a very clean ivory, not too yellow or creamy, and still very fresh and beautiful in most spaces, modern and traditional.
- ✳ **BENJAMIN MOORE WHITE DOVE** This is also a very neutral white, not too yellow or pink or blue. It's beautiful.

all-white tip When you want the all-white look to get a richer, more refined and defined space, choose a few slightly different whites to set off the space. My designer Dan Scotti does this in all his homes. Often the ceiling, walls, and moldings will all be white—but in slightly different shades and grades. This adds more dimension to the room and very subtly, but effectively, enriches the entire space.

A KID-FRIENDLY TIP FOR WALLS

Matte paint is difficult with kids . . . a semi-gloss or an eggshell is a lot more for-giving.

Baseboards generally should be semi-gloss or glossy. They get dusty and dirty and need to be able to be cleaned. Matte walls are very cool looking, but they get dirty. Really dirty. And if you have grubby little kid hands, or wheelie kid toys that occasionally bump up against walls, or dogs, you are going to constantly be clean-ing the walls. I had to negotiate with designer Dan on this. He loves the matte look. He also doesn't have children. I made a compromise, and I do have matte paint in our dining room downstairs. But in the kids' rooms and other high-traffic areas, it's all about the eggshell.

what about wallpaper?

Wallpaper is having a moment. But choose wisely—some styles are definitely a trend. Remember, it's not lipstick. It doesn't just wipe off. In my Hollywood Hills home, I set up an office downstairs and chose a moody, exotic floral. It was just what I needed at the time as my work-from-home business was starting to take off, and I craved something inspiring and ad-venturous. But I did get tired of it. It was a little too much for an office space. Something that I loved, and never got tired of, was the natural seagrass wallpaper that we installed in the den of the first house I shared with Scott. Actually, we used it a lot in that house. For the walls and ceilings in our sunken den, the guest bathroom, and our upstairs master bedroom, we hung seagrass wallpaper that gave each space an earthy, cozy vibe.

Here are some wallpaper ideas that are trending (but aren't too trendy):

* **FRUIT, FLORA, AND FAUNA** Jungle prints, ferns, tropical fruits, birds, banana leaves (à la the Beverly Hills Hotel).

- ✳ **TRADITIONAL PATTERNS AND MICRO-PATTERNS** Tweeds, herringbone, and superfine stripes.
- ✳ **WALLPAPER THAT TELLS A STORY** Toile, chinoiserie, and mural-style wallpaper. This is a truly original way to make a statement, and these wallpapers come in both bold tones and neutrals.
- ✳ **ETHNIC-INSPIRED WALLPAPERS** Moroccan-, Asian-, and African-inspired motifs give a bohemian vibe to a space.
- ✳ **GEOMETRIC PATTERNS** These can be found in very subtle tones like pastels and sometimes metallic. They look very cool in modern homes, even on just an accent wall or area.

faux-wallpaper diy If you want to go really easy and low maintenance, try wall decals that give the effect of wallpaper without the hassle. We put up adorable, fun black Batman decals on the white walls in Brooks's bathroom. And when he's not into Batman anymore? We'll just peel them off and abracadabra . . . white walls again! This would be really fun to do in a smaller space, on a feature wall, or anywhere you aren't afraid to have a little fun. It's that easy.

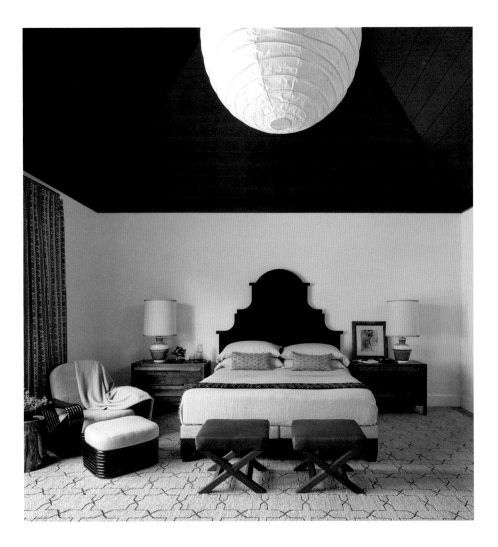

a *note* on ceilings!

I'm not actually going to go on much about ceilings . . . however, I do have one really big tip: *don't forget about them!* Install an interesting chandelier or light fixture, hang a plant or mobile from the ceiling (like we did in Scarlett's room), or paint the ceiling a dramatic shade for a cozier, intimate effect (like we did in our bedroom). The ceiling is your design friend, so pay attention to it.

floors

The floor is the foundation we stand on—where our toddlers take their first steps and where our old dogs rest their bones. Floors get a lot of use and perhaps the most wear and tear of anything in our homes. So flooring needs to be equal parts function, fashion, and feeling. In most of my spaces, I follow a simple flooring formula that works best for our family: wood flooring in living spaces (including the kitchen, living room, dining room, and kids' playroom), tile in the bathrooms, and low-profile carpeting in bedrooms (although we do have wood flooring and rugs in the kids' rooms). Something new we're experimenting with is sisal carpeting in our home offices. Since we've got rolling desk chairs and these tend to be high-traffic zones, the idea is that sisal is extremely durable, yet still cool looking and not too office-y. And as I discuss on page 235, in addition to the flooring we install . . . I love to generously layer with rugs!

Everyday Superfamily Flooring Tips:

* **WOOD FLOORING** Wood flooring in light, natural tones is great for family homes because it looks almost as good when you get a scratch. While darker floors can be beautiful and offer a polished, formal look, they will show scratches and dirt and require a lot more maintenance. According to Dan, they are better in a space that won't get too much traffic or abuse.

* **SUSTAINABLE FLOORING** Great options include cork, bamboo, recycled cement, reclaimed wood, and engineered wood. These are eco-friendly and easy to maintain, and cork and bamboo provide thermal and acoustic insulation. Some of these surfaces have the same warranty as traditional hard wood, or close to it. According to Kishani Perera, "Engineered woods are a great, less expensive alternative to real wood, and they look nearly identical. While real reclaimed wood can set you back anywhere from forty to one hundred dollars per square foot, now you can get the engineered version for four dollars a square foot. The disadvantage with engineered wood is that you can't refinish it. But it's definitely a close look for less."

- * **CARPETING** I have kids and pets, which can be tough on carpets. So I choose to forgo plush carpeting in the bedrooms and instead got an economical, durable, low-VOC commercial-grade carpet. I have them cleaned often and sometimes replaced.
- * **TILES** In bathrooms, I am a fan of oversize Carrara marble tiles. Faux-marble porcelain tiles can give a similar elegant effect for less, and they are very functional. In general, grout tends to drive me crazy and can get really dirty with lots of family foot traffic. If you have pets and kids, tell the installer to do very fine grout. The effect is more sophisticated, calming, and clean! Ceramic, wood-grain floor tiles are also stylish and work well in high-traffic spaces and wet rooms. They are very durable and come in versatile colors from light to dark. Hand-painted, ethnic-inspired, exotic tiles can be super charming as well. I love them in smaller doses, on a backsplash, or for bathroom flooring.

budget flooring diy If you don't like it but can't afford to replace it, you might be able to paint it! My Hollywood Hills house had terra-cotta Saltillo floor tiles throughout the entire upstairs space. I really wanted to replace them with wood flooring, but I didn't have the money. The color didn't fit with my existing furniture or the look I was going for. Kishani and I decided to paint the tiles in a high-gloss, rich black paint. We had to do several coats, but the effect was superchic—and it cost thousands of dollars less to paint the tiles than it would have to replace them. I loved the look, and it was an easy and affordable way to totally transform the space without a lot of money.

supermomma flooring Tip To keep a little order, we take some inspo from the Japanese and take our shoes off before entering the house. Folks, I don't care how expensive your shoes are, if you've worn them outside, they are really dirty. And your baby, like it or not, will lick the floor for fun, so do all that you can to keep it clean. Apart from the obvious hygienic reasons, and general wear and tear, taking your shoes off is also a way to enter your house or a friend's house with respect.

doors

In every home we have, we have seriously sexy, *come-on-baby-light-my-fire* doors. Who knew doors could be sexy, but they are. We have extra-glossy, shiny, wet-looking doors. Best of all—if you know how to do it—this is a true DIY project. I am

giving you the exact step-by-step instructions here because *I cannot tell you how many people have asked me how we get this look.* This is not a quick project, but it is oh so gorgeous and glamorous that it's worth the time. Dan Scotti agreed to dish on his specific technique and give you all the details. And for you supermommas, these glossy doors and cabinets are a dream to wipe down, so they're totally grubby, germy kid-hand-friendly!

luxe door and cabinet diy If you want to re-create this look, follow the steps below as directed by Dan Scotti. This look is gorgeous on a front door, any interior/exterior doors, or kitchen/bathroom cabinet doors and drawers. It does take quite a bit of time and elbow grease, but it is *so* worth it. If you don't have a lot of time, try it on a single featured door!

1. **PICK ANY SUPERSATURATED DARK SHADE OF PAINT.** We customized an incredible deep, rich blue by Fine Paints of Europe for the cabinet doors in the kitchen and for the doors throughout the house. For the front door of our place in Mexico, we picked this stunning, bold bluish turquoise.

2. **SAND DOWN WOOD DOORS AND APPLY A PRIMER; ALLOW PLENTY OF TIME TO FULLY DRY.** With high-gloss paints, sanding and preparation is absolutely critical. The surface must be perfectly smooth because high-gloss paints will show every little imperfection. Although you should spend the most time sanding and preparing the surface before primer and the first coat is applied, it is also important to sand between coats. If you are using a paint color with a dark hue, I recommend using a tinted primer. When you go to the paint store, just tell your supplier that you want a tinted primer and they will know what to do.

3. **USE GOOD PAINTBRUSHES (NOT SPRAY PAINT OR ROLLERS) TO THEN PAINT ALL THE CABINETS AND DOORS IN YOUR CHOSEN SHADE.** According to Dan, a good paintbrush is key, because quality brushwork by hand delivers a richer, more refined look. As he says, "I'm a huge fan of applying high-gloss paints by hand brushing rather than by spraying. It takes a great deal more time, but the finished look is far superior. I should point out that high-gloss paints will show the direction of the brushstrokes even after the paint has dried. Thus, it's important to be cognizant of that fact. If you are painting a cabinet door with a recessed panel, a good rule of thumb is to paint the vertical stiles and the recessed panel with long vertical strokes, and the horizontal rails at the top and bottom with long horizontal strokes."

4. **APPLY AT LEAST TWO COATS OF PAINT.** The darker the hue, the more coats you will need to apply in order to achieve a rich, deep finish. The absolute minimum is one coat of primer plus two finish coats of paint. However, if your time and budget allow, applying three coats of finish paint is ideal. Paint with a high-gloss finish can be applied to just about any surface. Thus, it is fine to use on MDF (medium-density fiberboard) cabinetry.

5. **FINISH WITH A CLEAR, HIGH-GLOSS PAINT THAT IS SUITABLE FOR INTERIOR OR EXTERIOR WORK.** Dan's favorite high-gloss paint product to use is "Hollandlac Brilliant" from Fine Paints of Europe. Because this product contains oil, it has a relatively long drying time. You will need to wait at least one full day between coats. High-gloss paints that do not contain oil are also available, such as Eco Brilliant from Fine Paints of Europe and the Advance line of paints from Benjamin Moore. The Eco line has 90 percent less VOCs than conventional paints.

I've been a longtime fan of midcentury modern design as well as Danish and Scandinavian design. I love a minimalistic look, but not cold. I love using wood instead of metal when designing a space, to keep a light and airy feeling. I always accent a room with pops of color like Missoni blankets and throw pillows.

—RACHEL ZOE

the kitchen

The great Frank Lloyd Wright almost always designed his houses with the kitchen as the central space and for good reason. The kitchen is the heart of the house. We absolutely live in ours. Our kitchen is open concept, which is very functional for the needs of our growing family. When I am working in the kitchen, I can still chat with Scott who might be watching TV across the way in the living room and also keep an eye on the kids who are cruising around between here and there.

What I *love, love, love* in a kitchen:

* **OPEN SHELVING** This look is directly inspired by restaurant kitchens. Open shelving on top allows for easier access to day-to-day items like plates, bowls, mugs, and more. Having open shelving requires a degree of organization and harmony among your dishes.

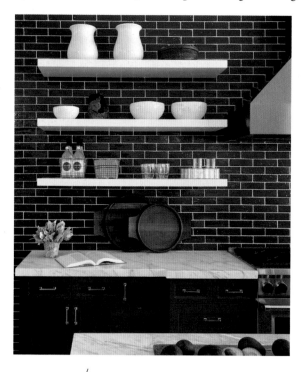

It keeps you honest! If you have a hideous hodgepodge and hoard every mug you've ever owned, well, then this likely isn't for you (unless you keep those dishes in the cupboards and drawers below). I store and display my everyday use white dishes and a few specialty pieces stacked neatly on the open shelves. It makes for really easy table setting and dishwasher unloading, and also showcases some of our pretty ceramic pieces, stoneware, and bowls.

* **SUBWAY TILE** This look is simple and elegant, and I never tire of it in all its various iterations. In our Los Angeles home, we ripped out all the cabinets and tiled the whole back wall in deep navy subway tile with a high-contrast

grout. It's gorgeous paired with the white ceramics on the open shelves and our dreamy, creamy countertops.

- ✳ **CARRARA MARBLE COUNTERTOPS** As I've mentioned, I love Carrara marble. It makes everything around it look better. But keep in mind that it can stain if you don't wipe up spills right away. That's sort of part of its charm, but if that's not for you and you want to get the look for less, go with some of the engineered marble options. They are a close second these days! And if you can't commit to an entire marble countertop, get a bit of the look with marble accent pieces on display, like a serving bowl or cheeseboard.

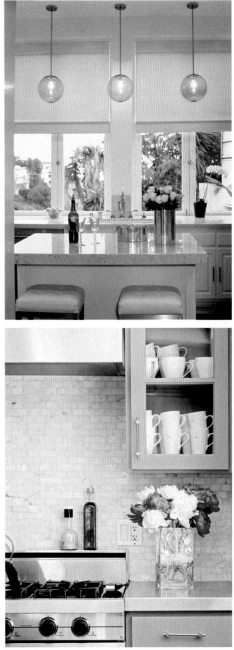

marble alternatives:

Quartz	Caesarstone
Silestone	Cement stained white

- ✳ **CASUAL, COMFORTABLE KITCHEN SEATING** Whether it's an island, a bar, or a breakfast nook next to the kitchen, I like accessible, casual seating in the kitchen so that guests and the home chef can still chat, connect, and gather. And we do so much socializing in the kitchen that the seats and barstools have to be comfortable!

- ✳ **STATEMENT LIGHTING** Pendant lights over a bar or island are so chic. Or a dramatic chandelier. We have the absolute coolest, giant basketweave chandelier over our breakfast table, which I absolutely love.

- ✳ **FLOWERS, ALWAYS FLOWERS** A kitchen just isn't a kitchen without a vase of fresh flowers, whether they're picked up at the grocery store or straight out of your garden. Fresh flowers are welcoming, and they add a feminine flourish to the room meant to nourish.

✳ **SHADES OF CREAM AND WHITE WITH MOODIER ACCENTS** You can never go wrong with a white kitchen, but we chose to balance out the fresh white of our foundational elements with deep charcoal and navy. I've done this in a few kitchens and love the look. It has the freshness of an all-white kitchen, but it is much more interesting.

the living room/family room

For most of us, after the kitchen, this is where we spend the majority of our social time. It's where we all pile onto the couch, read the paper, gather together after dinner—or take an afternoon nap. This space has to be family-friendly and truly livable.

What I *love, love, love* in a living space:

✳ **A KID-FRIENDLY OVERSIZE COUCH** You've got to have something that you can all fit on and that is super comfortable. Comfort is number one when it comes to the family room or living space.

- ✳ **A STURDY, STYLED-OUT COFFEE TABLE** Even though our living space is casual, a dressed coffee table elevates the look and keeps it stylish.
- ✳ **COMFORTABLE CHAIR(S) AND SIDE TABLE(S) FOR READING OR RELAXING** The TV doesn't always have to be on, and believe it or not, I don't always want to be vertical. And men love to have a big, comfy chair.
- ✳ **BUILT-IN BOOKCASES** I love built-in bookcases or a hack that looks like them. To me, it gives the living room a homier, cozy feel.

- ✳ **MODULAR SEATING** This functional seating can be pulled in or moved around for bigger groups and is a great idea if you don't have a lot of space but do have occasional guests.
- ✳ **LUXURIOUS AND COZY BLANKETS, PILLOWS, AND THROWS** There is nothing better than snuggling up with your loved ones on the couch. You've got to have blankets and comfortable pillows to keep you warm.
- ✳ **VINTAGE LIGHTING** I am a sucker for vintage lamps. I love the glazed, ceramic lamps from the 1950s and 1960s. They just look so cool.
- ✳ **BASKETS FOR KIDS' TOYS** In our last house, the living room doubled as the playroom, so baskets for quick cleanup were an essential. If yours doubles the way ours used to, you shouldn't always have to look at toys. Have some grown-up storage units, and store children's toys in chests, ottomans, and pretty baskets.

my (not-so-dirty) little secret: outdoor fabrics inside

Use textured outdoor fabrics in your living spaces, especially with kids. Outdoor fabrics can be beautiful, they're easy to clean, and they last! These fabrics are a godsend and they hide a multitude of sins when you have kids. Tiffany Harris taught me this trick, and I've never looked back. Trust me, I've spilled countless glasses of wine and the kids have spilled their deep purple berry smoothies on our couches, and guess what? With a little soap, water (perhaps a few expletives), and elbow grease they're as good as new!

QUALITY OUTDOOR FABRIC OPTIONS

Generally speaking, there are two options: 100 percent solution-dyed acrylic or 100 percent spun polyester. Solution-dyed acrylics are soft, flexible, and feel very similar to natural fabrics, such as cottons, that you would use inside the house. They also perform significantly better and last much, much longer when it comes to weather resistance and sun fading. The fibers are dyed in a color solution before the cloth is made (rather than printed onto the cloth afterward), which gives them their durability. Generally, most solution-dyed materials are certified for at least fifteen hundred hours in the sun. The spun poly just doesn't have the same soft hand—or the durability. While the acrylics are more costly, they will last longer and are a much better investment.

SUNBRELLA: While there are definitely other kids on the block, Sunbrella is kind of the queen bee of outdoor fabrics. These fabrics are known in the industry to have some of the best pattern and color choices. They are generally solution-dyed acrylic, extremely colorfast, durable, and both stain and weather resistant.

GEOBELLA: These fabrics are considered more eco-friendly because they are made with 100 percent polyolefin yarns, which have a wool-like feel. They are also solution dyed, so they're extremely durable and colorfast.

CHELLA TEXTILES: These are considered by designers to be the cream of the crop. They are solution-dyed acrylics, superdurable, and come in many chic choices—but they also come with a bigger price tag.

BELLA-DURA: Made from solution-dyed polyolefin, these fabrics feature a huge variety of stylish pattern and color options.

master bedroom

For me, this space needs to be classic, luxurious, supremely comfortable, and clutter-free. I truly believe in making a bedroom a retreat. As a mom, this is one of the only places I ever have a little alone time with my husband. I believe a bedroom should always be a sanctuary from the rest of the house and from the outside world.

What I *love, love, love* in a master bedroom:

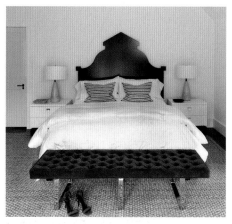

* **A LARGE FLUFFY BED AS THE FOCAL POINT OF THE ROOM** It should look inviting and totally comfortable. You should always want to get in it but have to hold yourself back—that's how comfortable your bed should look.

* **LUXE LINENS, PREFERABLY WHITE** We spend a lot of time in bed! I buy the nicest we can afford.

* **SYMMETRY** More than anywhere, I love—I *need*—this in the bedroom. Two nightstands, two lamps.

* **WINGED HEADBOARDS** I have a true affection for these in master bedrooms. They are classic, stylish, and easy to keep clean.

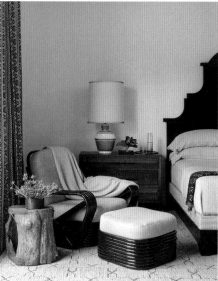

* **A BENCH, SIDE-BY-SIDE FOOTSTOOLS, OR A SMALL SETTEE AT THE FOOT OF THE BED** Perfect for slipping on pants and shoes any time of day, this is an item that also ups the elegance of the room.

* **A COMFY CHAIR** This is essential for late-night infant feeding or to curl up on with a book.

* **BOOKS** Keep one or more on the bedside table, always within reach.

* **SEAGRASS OR TEXTURED WALLS** They make a room feel cocoon-like. The exact vibe you want for a tranquil resting space.

the bathrooms

While I need a simple Zen-like oasis for my master bathroom, I like to have a little fun with the powder room! Bathroom decor can be a challenge, but the payoff when done right is totally worth it.

What I *love, love, love* in a bathroom:

master bathroom

- ✳ **BATHROOM BLISS** Cool, calming colors are a must. Whites, lighter-shade woods, and grays are my go-tos.
- ✳ **MARBLE OR MARBLE ALTERNATIVE WHENEVER POSSIBLE** It is simple, classic, and always luxurious. I feel like I am at a spa in Europe.
- ✳ **GLOSSY WHITE OR LIGHT NEUTRAL CABINETRY** Again, I like to keep things crisp in a bathroom. Glossy cabinets look chic and are easier to clean.
- ✳ **HIS/HERS SINKS IF SPACE ALLOWS** Now, this is certainly a luxury, but that way everyone has plenty of space.
- ✳ **ENOUGH STORAGE** Pedestal sinks are pretty in powder rooms, but in a master—I want storage and cabinetry. I've got to be able to hide

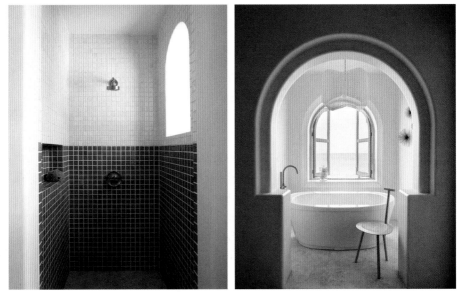

away toiletries, hair tools, razors and shavers, extra toilet paper, and cleaning products.

✳ **POLISHED CHROME OR NICKEL FIXTURES** You just can't ever go wrong. The cool tones balance so beautifully with bathrooms.

✳ **DIMMABLE LIGHTING** You've got to be able to set the mood when in the tub!

✳ **SPEAKING OF TUBS, OVERSIZE TUBS ALL THE WAY** A gorgeous stand-alone porcelain tub is the most glamorous, but any oversize tub will do. I love my tubs and truly couldn't live without one.

✳ **SUBWAY TILES OR PENNY AND MOSAIC TILES** They are always classic.

✳ **SPA ESSENTIAL** My must-haves include fluffy robes, slippers, and white terry-cloth towels in reach.

the powder room

Here, I like to take risks. I think of it as a little jewel of a space, where you can experiment, have fun, and even get a little wild if you wish.

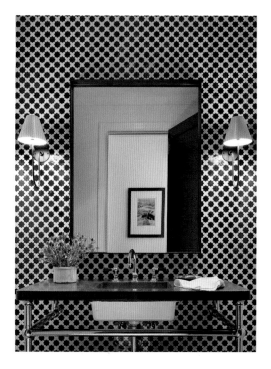

✳ **EXOTIC WALL TILE OR BOLD, PATTERNED WALLPAPER** Because the space is usually small and separated from the rest of the house, it's the perfect place to experiment and do something interesting.

✳ **A STRIKING MIRROR AND UNIQUE LIGHT FIXTURES OR SCONCES**

✳ **AN INTERESTING PIECE OF ART** In our powder room, we have an image of juicy, oversize red lips that makes a big, smoochable statement.

✳ **A FEW SIMPLE LUXURIES** When we have guests, I bring out delicious-smelling hand soap and lotion and those extra-thick, luxe butler towels you often find in the bathrooms at fancy hotels. That way no one has to dry their hands on a damp, used hand towel.

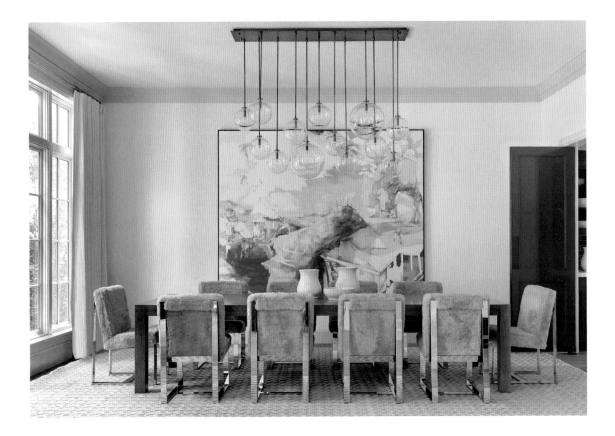

the dining room

We eat most meals in our kitchen, but we like to use our dining room when we have dinner guests or family in town. It's a slightly more formal space, but it's still cozy, and it makes us feel like we are celebrating a special occasion.

What I *love, love, love* in a dining room:

* **A BIG WOODEN DINING TABLE** There is just something magical about a long, natural-wood dining table. It feels so nice to sit at and talk around for hours, and it's always beautiful. It can be dressed up or dressed down, like a farm table, a French country table, or a modern and simple Parsons table. I also love a lived-in wood trestle table that holds hundreds of tales told over food and wine.

* **COMFORTABLE DINING CHAIRS** These are a must. Before you invest in yours, always sit in them first!

Once you start living in a space you have to pay attention to how you use the house and each area and be willing to change something if it isn't working. In our house in Mexico, we entertained a lot and always had friends over on the spur of the moment. So we ended up replacing our long, more formal dining table with a bar-height table and barstools. There is something that is really social and nice about bar-height dining that makes things feel more relaxed and easy. It changed the whole vibe when we entertain.

—CINDY CRAWFORD

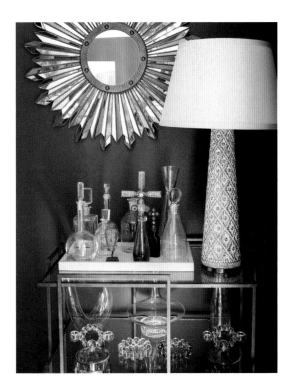

※ **A DRAMATIC STATEMENT CHANDELIER** It must be dimmable (of course) and in proportion to the table. Think of it as an oversize piece of art that creates conversation.

※ **A BAR CART OR STYLISH WINE CABINET/CUPBOARD** This way, you don't have to get up to make a drink or anything. And they always just look so chic!

※ **TAPERED CANDLES IN VINTAGE OR CRYSTAL CANDLESTICKS** For some reason, candles on a more formal dinner table really make it. I love to light candles when we have guests over. It's just an added touch that does so much.

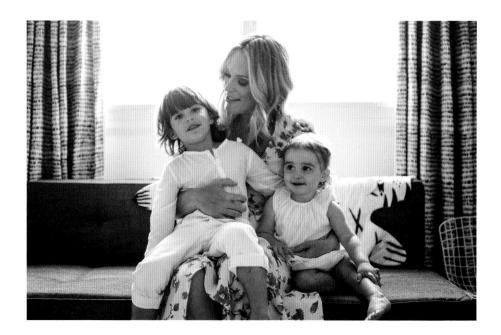

your *special* spot

Every home should have that little nook or space where you can kind of tuck away and have a special moment. Mine is the landing at the top of our stairs, right in between the kids' bedrooms, where we have a low couch with a lamp and a basket with a soft blanket and oodles of books. This is where my children and I have our special quiet time together before bed or early in the morning. Both Scott and I truly cherish this time and this spot, where we read to our little ones in the quiet light of the morning or the shadowy moonbeams of the evening.

Understanding how you live is essential to the design of a house. People will spend a lot of money on design, without thinking about how they will actually live in a house. A room needs to suit not only your aesthetic needs but also your personal needs and the way you live. And different rooms provide you with different feelings and different opportunities. Have a cozy room where you can snuggle with a kid. A room where you can pull up an oversize pillow and drink a margarita on the floor. Design your spaces around these things you enjoy.

—TRIP HAENISCH

the entryway

I won't say much about the entryway other than that it's where you make your first impression! The entryway should be inviting and should have symmetry—it is the first thing that your family and your guests see when they enter your home. It serves as a transitional space, a barrier between the outside and your inner space. So don't neglect it.

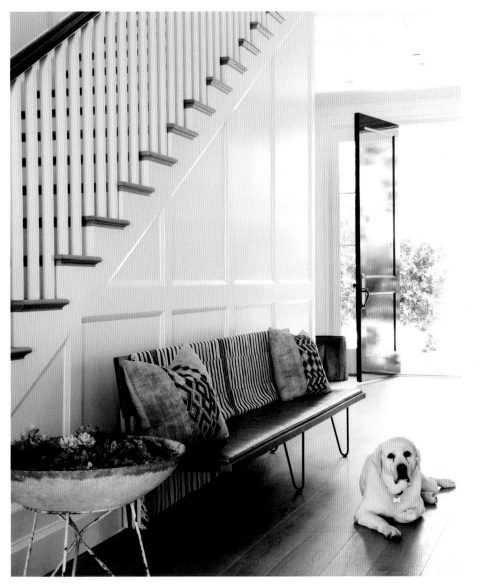

children's *spaces*:

NURSERY, BEDROOMS + PLAYROOMS

When it comes to kids' spaces, they are all about safety, functionality, fun, and of course, style. I also 100 percent believe that the space and what's inside it should grow with my children. Like it or not, supermommas, they are going to grow up—and it happens so darn fast. I know. Let's not even talk about it! The day Brooksie doesn't want to snuggle me will feel like Armageddon. In true me fashion, I always seek inspiration somewhere for their rooms. Keep in mind that children's spaces and bedrooms are part of the house, so they should still be an extension of the aesthetic of the rest of your home.

NURSERY

The nursery is an interesting space because it is temporary, but the pieces that you choose for it don't all have to be that fleeting. I want the nursery to reflect sweetness, functionality, stylishness, and serenity. Most important, I want some of the pieces and the design to be able to transition and grow with the child. Or be moved out of the room and used somewhere else when we are done with it. As Tiffany says, "Function prevails in a nursery when making decisions, but with so many great products to choose from, style doesn't really have to be sacrificed."

What I *love, love, love* in a nursery:

* **THREE-IN-ONE CONVERTIBLE CRIB/TODDLER BED/TWIN BED** This is just a win–win–win. Functional, affordable, and stylish. I absolutely love how these grow with your child. While you can splurge on a crib if you plan on having multiple babies, you really don't have to.

* **ROCKING CHAIRS OR GLIDERS** Every mom knows just how important these are. My word of advice to any tall mommas out there: just make sure the back of the rocker or glider is tall enough to rest your head. Jennifer DeLonge gliders are top of the line; we used one in Brooks's nursery. They come in so many beautiful fabrics. Monte Design gliders are luxe too. Babyletto makes great, affordable gliders as well. One of the rockers I used for Brooks we recovered and now have in a guest room. There is nothing nursery about it—it's just cool.

- ✳ **BLACKOUT DRAPES, BABY** Tiffany's number-one recommended splurge is on custom blackout drapes—so they fit the space perfectly and block out as much light as possible. Choose a double layer if you are purchasing out of a catalog. While everyone has a different philosophy on what worked for their family, the darker the better for ours! And it really is a great investment because kids often will continue to nap in their rooms until they are four or five.

- ✳ **DRESSER MEETS CHANGING TABLE** Tiffany and I both prefer a true dresser with a separate changing table option. The fully integrated one doesn't grow with the child. In Scarlett's room, we purchased a dresser and had a tray made that sits perfectly on top so that when she is out of diapers (almost there!), she has a dresser she can use forever.

- ✳ **ORGANIC BEDDING** When it comes to my precious babies, I won't have it any other way. I use all-organic cotton bedding and coco-mat mattresses made of organic, natural materials. Babyletto and Naturalmat USA are great sources.

- ✳ **NEUTRALS AND COLOR** Nurseries need to have balance. While they should be calming and serene, they should also be playful and inspiring. Brooks's and Scarlett's nurseries were very soft neutrals and colors. Very serene. With Grey's, we decided to have a little more fun and really punched up the color and pattern factor.

- ✳ **A MOBILE** I love to see an original mobile. Babies adore them and so do I. Learn to make one yourself or buy one from an Etsy artist. There are so many adorable creations.

Tiffany's nursery Tips Noise . . . annoys. If you have a choice on what room your baby takes in a home, try to choose one that is farthest away from the main family living space. That way if you have friends over or older children, you can still live in your living spaces without having to quiet down when baby is sleeping. Another helpful tip of Tiff's for noise cancellation? Sound machines. She said that when she had twins, she purchased two—one to place by each of their heads—so that if one baby woke up screaming in the middle of the night, the other wouldn't. Rugs in baby rooms also help absorb noise.

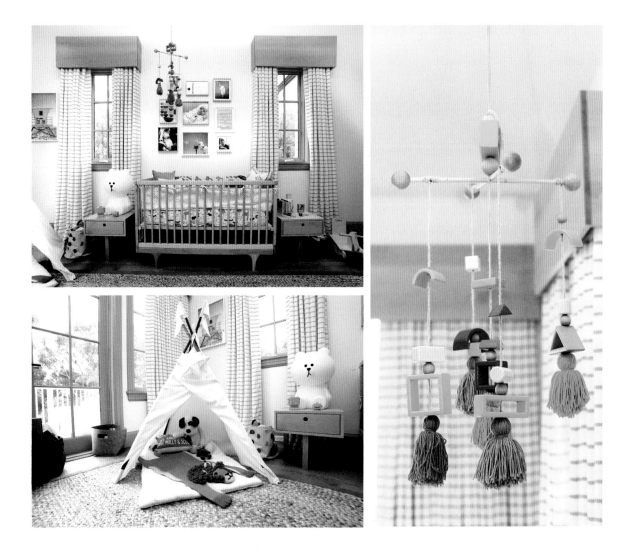

grey's nursery

While the foundation of Grey's baby pad is white and soft, we really punched up the color palette this time. We decided on a zoo theme and chose playful primary and secondary colors to brighten the space. Cerulean blue, yellow, orange, and creamy white are contemporary and fun. I adore all the soft, cozy textures in the room, the whimsical wallpaper, and the overall cheerful, happy vibe. You absolutely cannot exist in this room without a smile on your face! Totally appropriate since he is definitely my smiliest munchkin. The nursery-vibe shoe seems to fit!

Every day, even if I get home later than I'd like and the girls are already in bed, I can't help but climb in with them for all the cuddles. And without fail, I sing each of them four songs—the same sweet lullabies that I've sung to them since they were born. It's my favorite part of the day.

—JESSICA ALBA

CHILDREN'S BEDROOMS

Kids' rooms should be playful and reflect their unique personalities, but that doesn't mean a room needs to be childish. Don't forget, children's bedrooms are part of the house. We chose sophisticated but whimsical lighting; light woods and color palettes that blend with the rest of the house; and design details such as curtains, rugs, and art that are a reflection of our house's overall design aesthetic. You should want to spend time in your children's rooms. When choosing furniture or investment pieces, what's most important is to select major pieces that will grow with them.

What I *love, love, love* in a kids' bedroom:

* **FURNITURE THAT FLOWS** When furniture blends with the rest of the house, it gives the house a cleaner, calmer, more put-together vibe.
* **FURNITURE THAT WILL TRANSITION** Obviously, not everything will transition. Children grow up in size and mind-set, but children's furniture should be able to take them into their tween/early teen years.
* **LOW-PROFILE, ECO-FRIENDLY CARPETING OR WOOD WITH COZY RUG** I am a wood or carpet person for bedrooms and floors. Tile is too cold and hard a surface. The floors have to feel good on the feet and be cozy enough for tots and adults to have tummy time together.
* **CLUTTER-FREE** I firmly believe that a kid's room needs to have only what is necessary, with a few special toys and decorative pieces. Keep the toys, clutter, and distractions to a minimum. They not only play there—they also sleep there.
* **STORAGE AND CUBBIES** I talked at length about this in Chapter 3. I am a big fan of modular storage that children can access on their own. Wood, felt baskets, stackable bins, or other cubbies for books and soft toys are great. Selecting storage pieces in all the same color keeps things stylish and orderly.

✳ **LITTLE TREASURES** While I say to keep clutter at bay, I am still a sucker for certain special mementos. In Brooks's room, we have a signed Brooks Robinson baseball on the shelf, and in my babies' rooms we have their hospital bracelets from when they were born in wood and Lucite frames. Having those precious memories around the house is so important to making the house a home.

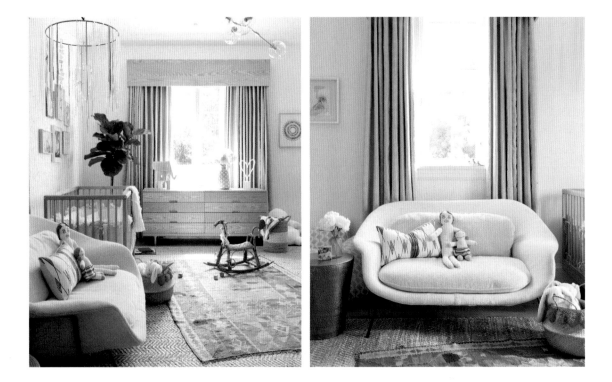

scarlett's room

I was given a gift in this adorable cardboard box with rose gold, pink, and white printing. That became the color palette inspo for Scarlett's room. That was it! And instead of splurging on this pricey chandelier for both the kids' rooms, we bought the knockoff and spent our money instead on custom built-in shelving and curtains. We decorated her room with handmade toys that we found on Etsy! There are so many incredible artisans making the sweetest little pieces, and they often will customize colors to fit your room and theme. My absolute favorite thing in Scarlett's room is the custom mobile made by an artist in Los Angeles. It's magical!

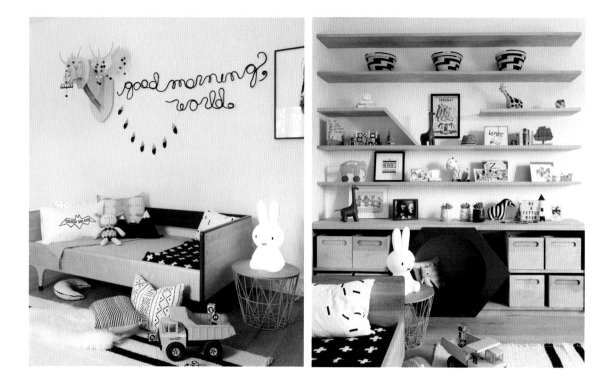

brooks's room

Brooks was totally crazy for Batman, and that's all he talked about. So Batman theme it was! Based on that, we decided we'd do a cream, white, and black color story, with a few touches of sunshine-yellow for vibrancy and fun. We did a really easy DIY in his little bathroom and applied black stick-on Batman decals to the white walls. They are supercute, geometric, and come off easily if he ever gets tired of Batman (not likely very soon!). But my favorite piece would be the GOOD MORNING, WORLD sign we had made especially for his room. Because that's how I want him to wake up to the world—excited and with a smile on his face! We have wooden cubbies that house and hide toys, shelving with a few favorite books, the signed Brooks Robinson baseball Scott bought for Brooks, and the hospital bracelets I wore the day he was born—these are the mementos I'm a softy for.

When choosing your color palette for children's spaces, choose wisely. Keep in mind that your children and their belongings themselves often bring a lot of color. Books, stuffed animals, toys, and other objects often inject lots of color into the space—so you don't always have to add more.

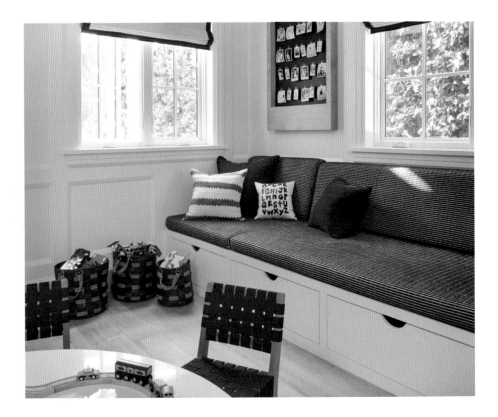

THE KIDS' PLAYROOM

In our previous house, we didn't have a playroom. Our living room was also the playroom. I'm sure a lot of you can relate! In fact, the train tracks and train that Grandpa Ray gave Brooks were pretty much permanently on the coffee table. Baskets and bins held the toys—and yes, all of us were a little squished in there on big game days, but we managed. In the house where we now live, I was really lucky to get a playroom. It has a big, long, cushioned banquette, with soft-close storage

drawers underneath, a kid-size table and chairs, chalkboard, television, baskets for toys, and built-in shelves for displaying specialty items and storing more books and toys. I love a well-laid-out playroom because it makes my life so much easier. It's just off our kitchen/living space, so although it's separate, I'm still able to peek in to make sure all is well! When a playroom is orderly and has all the basics that kids need, they play better, share more (fingers crossed!), and get along.

What I *love, love, love* in a playroom:

* **OUT-OF-SIGHT STORAGE** Cubbies that tuck away into shelving or drawers. Gotta have 'em. I prefer kid-friendly pieces, so the kids can help with the cleanup. We chose bench seating with front storage drawers, rather than the kind of storage benches that open like a chest, because drawers are a lot easier for young hands to maneuver. Whenever possible, choose soft-open and -close drawers to avoid tears and squished fingers.

* **SHELVING** Shelving is essential too. I like to place fun display items on the top shelves, where they're hard to reach. We have a vintage toy dump truck of my brother's up there!

* **KID-SIZE SEATING** A table and chairs for coloring activities is a must.

* **BIG BASKETS** Basics! For quick toy cleanup, these are musts for me around the house, especially in kids' spaces. Baskets are an easy way for kids to manage the cleanliness of their spaces on their own, and in a pinch, baskets can hide a lot of sins when doing quick prep for unexpected guests.

* **FUN ART** One of my all-time favorite things in this house is the HAPPY MESS neon sign we had made for the playroom. It's fun and stylish— and pretty much summarizes our life, especially the playroom. Ha!

outdoor living *spaces*

Growing up in humid Kentucky summers and cold winters, and living in Paris and New York, where the weather is similar, believe me, I know how lucky we are in California! With fairly temperate weather year-round, outdoor living is a big part of the Southern California lifestyle. Having a well-designed outdoor space here enhances the look and feel of your home and your life. I love an outdoor space that feels like a fresh extension of the home! We use furniture that is durable and designed for the outdoors but that feels as comfortable and looks as chic as the furniture you'd have inside. My approach to designing the outdoor spaces in our homes is to bring the indoors out—and the outdoors in. Depending on where you live, an outdoor living space may or may not get a lot of use. But designing one can be as simple as claiming the space on your balcony or deck or even a little area you designate in your backyard.

What I *love, love, love* in an outdoor living space:

 ✳ **AN OUTDOOR "LIVING ROOM"** This has the traditional elements of a living room but is perhaps a bit more rustic, though still refined. I like to include casual seating using chic outdoor fabrics, couches to cozy up on, a large coffee table, and independent side chairs. It should be arranged to encourage comfort and conversation.

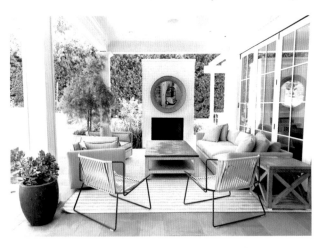

 ✳ **OVERSIZE RUGS AND STYLISH ACCESSORIES** A few times a year, often seasonally, I'll change up the pillows. I love pillows in exotic textiles and fabrics, such as our gorgeous, geometric, black-and-white African mud-cloth pillows. They feel rustic and chic at the same time. We even have a large round mirror in a zinc frame hanging above the fireplace. It definitely ups the chic factor of the outdoor space.

 ✳ **WARMTH** Even in California, it does get chilly at night, especially in the winter. We have a big basket with blankets and throws, so they're

easy to grab and wrap up in whenever the breeze blows in. We also installed heat lamps in the overhang. Heat lamps are a bonus but are so nice for comfort. When you have them, you and your guests tend to stay outside and hang out longer (and possibly have one glass of wine too many!).

* **LIGHTING** I personally love lanterns on side tables. They add elegance and ambience. We also have little white lights strung in the trees in the backyard. They are affordable and create a sense of calm, wonder, and magic—a simple touch that delivers a lot. Our last house had these gorgeous big globe pendant lamps that hung from the ceiling on either side of the couch, which added a truly sculptural element and created symmetry.

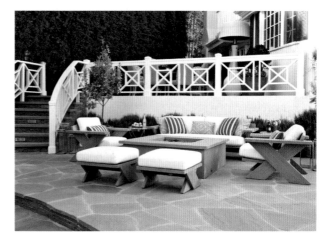

* **FIREPLACE OR FIRE PIT** There is something about gathering around a fire! We splurged and had a fireplace installed—it was either that or the outdoor pizza oven, and that was too pricey. I love having a fireplace because it just brings people together. But even if you can't do something built-in that requires a gas line, check out your nearby big-box and outdoor retailers, which sell all manner of pretty and modern stone fire pits and chic fire tables that run off a propane tank. They are easily installed, affordable, and well worth it for the ambience they offer.

* **WATER FEATURE** We are lucky to have a pool—and looking out onto it never gets tiring. It's an absolute dream for the kids and their friends on a sunny summer day. Simply adding a water feature, like a fountain or even a birdbath, to apartment patios, smaller decks, and garden spaces helps deliver a calm, serene vibe.

* **SUN AND SHADE** Don't forget that outdoor spaces need shelter, especially from the sun. If setting up an outdoor dining or living space, make sure you have built-in or modular sun shelter options. Canvas umbrellas are always classic, vine-covered pergolas (like I had at my Hollywood Hills home) are rustic and elegant to dine under,

and built-in sun shades and awnings (electric or manual) are timeless. Sun shades made of sail material are affordable options for modern homes and, depending on your level of handiness, can be installed on your own.

 ✳ **EASY-CARE LANDSCAPING** When it comes to the backyard, I love contemporary landscaping that looks and feels lush but doesn't require too much maintenance. For our Los Angeles home, we chose to plant large beds of hostas and sculptural dogwood, yummy-smelling night-blooming jasmine, a row of beautiful birch trees (which we dressed with the twinkle lights), and a variety of evergreen shrubs. We also planted a lot of native drought-tolerant plants, such as milkweed, and other plant species that support the health of the natural environment and ecosystem. We used neutral gray concrete, stone, and pebble pathways for backyard flooring. I am also a huge fan of decorative oversize planters, in which we plant easy-care succulents and citrus trees. (I have a kumquat tree that I have moved from house to house! We use it in the winter and spring to make specialty cocktails with a tangy, puckery twist!)

ACCESSORIZE!

There is a reason why home staging has become so popular when selling a home for top dollar. As with personal fashion, the right accessories can truly elevate the look of your home. Rugs, pillows, throws, art, wall hangings, and other special objects add style and personality to a space. So often, the true soul of a home comes alive in the accessorizing.

lighting + ambience

Never underestimate the power of lighting to set the mood and to make a house feel like home. It should be soft and pretty, warm and inviting. Here are my lighting essentials:

 ✳ **DRAMATIC CHANDELIERS AND HANGING LIGHT FIXTURES** I love a bold, unique chandelier in a space in your house where you

want to make a statement, like the entryway or the dining room, and especially in rooms with high ceilings.

* **DIMMERS** Dimmers are essential for setting the mood. I have them installed for all my overhead lighting, if possible. When dimmers aren't an option, choose floor lamps and table lamps with three-way bulbs.

* **WARM, SOFT LIGHTING** Warm lighting always looks better and softer than cool lighting. I prefer this kind of lighting in every room, even in kitchens and bathrooms. *Especially* in kitchens and bathrooms.

magic carpet ride

I have a borderline obsessive love for rugs. There is something about a beautiful old rug that just embodies elegance and style. Rugs truly do make the room, and they are an opportunity to add elegance, warmth, and personality to a space. Here are some classic rugs I love that stand the test of time:

* **KILIMS** Kilims are durable, flat-weave tapestry rugs, made of wool that comes from Turkey, North Africa, the Balkans, Pakistan, and Afghanistan. These rugs can feature a variety of beautiful patterns and colors depending on the artisan's location and tribal associations.

* **MOROCCAN + BERBER** Morocco has a rich tradition of rug making that goes back to the Paleolithic era. Some of the most popular Moroccan rugs today are the thick, wool high-pile rugs that come from Fez, Rabat, and especially from the Beni Ourain

tribe. With their light shades, natural dyes, and diamond-shaped patterns, they are popular designer go-tos.

* SEAGRASS, JUTE, OR SISAL These are contemporary, flat-weave rugs made from natural fibers. They are very affordable, look great in coastal, farmhouse, and contemporary homes, and are eco-friendly. They can be used indoors or outdoors and make for great layering rugs. Keep in mind that they retain a natural fiber smell, and they can stain and be a little harder to clean than a wool rug.

* ORIENTAL OR PERSIAN A true *Persian* rug is made in Iran, while what we call Oriental rugs are made throughout Asia, including India, China, and Turkey. Authentic versions of these are made of 100 percent silk or wool and are hand knotted. The most expensive versions are those with the highest knot count. These rugs are characterized by intricate floral and geometric patterns that have been passed down by region. They tend to look incredible in traditional homes but also add warmth, class, and contrast to contemporary spaces.

* DHURRIE Handmade in India, these flat-weave rugs can be made of either wool or cotton. They often feature simple geometric designs in repetitive patterns. Modern dhurrie rugs are generally very affordable and have both a casual and an elegant feel. I *absolutely love* striped dhurrie. They are endlessly classic, and they up the style ante and fit virtually any space! I've had a striped dhurrie rug in every home I've ever owned.

* SHEEPSKINS AND HIDES I always love a sheepskin rug or a natural or faux hide, either as a decorative element in a space, or to lie down on with a loved one and read a book. They are classic and stylish.

If you are looking to make an investment in a high-quality handmade rug, here is what to look for:

* WEAVE Look for "hand woven" or "hand knotted" on the label. Avoid the "hand-tufted" label as it is deceiving (these labels indicate a hand- and machine-made hybrid). Also, truly hand-created rugs generally will not have any kind of backing, such as rubber or plastic.

* MATERIALS Look for 100 percent first-grade wools or silks, and whenever possible, stick with hand spun. A natural wool rug will

have a very subtle sheen to it—but will not shine at all. A high-quality silk rug, on the other hand, will have a very high shine. Cruelty-free silk rugs are made with bamboo silk rather than silk from silkworms.

* **COLORS** Color and pattern will vary, but higher-quality rugs will use natural colors or vegetal dyes, which are considered superior to their chemically dyed counterparts.

* **FAIR TRADE** For contemporary rugs, to ensure the artisans were paid a fair wage and worked in fair working conditions, look for the fair-trade certification.

stylist secret

When it comes to rugs, folks, size matters! Go big or go home. A rug that is too small for the room will actually make the room appear smaller, and this is especially true for living and dining areas. However, I know that large Oriental, Persian, and kilim rugs can be expensive, so buying a supersize one is generally out of reach. Instead, try layering rugs to achieve the same effect; it's a trick home stylists have done for years. Start with an oversize rug in an affordable organic material like sisal, jute, seagrass, or a cotton dhurrie. Alternatively, have a custom, low-pile carpet made in the appropriate size and have the edges bound. Place this foundation rug under your seating zone, or in the center of your room. Next, layer a smaller, more exotic wool or silk rug on top. You achieve a similar look without breaking the bank!

art has *heart*

The right piece of art can be an investment and serve a variety of purposes in a space. Even when working with a tight budget, I'd recommend scouting a unique, affordable piece by a local artist rather than buying from a big-box retailer. Here are a few more tips for selecting and placing art in your home:

* ❋ **USE ART TO ADD A SENSE OF FUN.** While I tend to be conservative with furniture and installation choices, art is a place where you really can have fun and experiment.
* ❋ **USE ART TO EVOKE A CERTAIN VIBE.** Art can totally transform a space. Think about the energy you'd like to bring to a room and make sure your art choices reflect that in both color and theme.
* ❋ **CHOOSE ART FOR A COLOR POP.** In my homes, the basic color palette is always neutral, but I love to use colorful art to add movement and personality to each room.
* ❋ **LET THE ART BE THE FOCAL POINT.** When in doubt, place an oversize piece of art on a wall and let it do all the talking, like we did in our dining room.

for the *love* of books

I love studying the books in a person's home. They are a peek into the mind, manner, and interests of the people living in the house. Whether you have just a few on your nightstand or coffee table, a bookcase in the living room or a study, or an entire room outfitted to New York Public Library proportions, books are essential to making a house a home. Here is an easy, breezy Anna Wintour–worthy bookcase makeover that you will love:

Quick Bookcase Makeover:

1. Start with an all-white or very light-colored bookcase.

2. Paint the back wall of each bookshelf (the side that faces out) a dark, glossy shade. We chose a rich charcoal navy. This can be done professionally with expensive built-ins, but it's also easy to do on your own if you want to add a little extra style to that IKEA bookcase that you already have.

3. Once the paint has dried, pile on the books! Leave some open space on the shelves to let the dark color peek through, and stack lighter-toned books horizontally.

4. Step back, and prepare to love your bookcase like never before!

bookcase bling My favorite bookcase is probably in our Hamptons home. We have fresh white bookcases in the living room filled with bright yellow vintage *National Geographic* magazines. It took a while to scout them all off eBay, but we got there and the end result is this pop of color that is so contemporary and fun. Not to mention, I absolutely adore spending a lazy summer afternoon in that room paging through the incredible stories and mind-blowing *Nat-Geo* photography!

designer *secrets* for making a home look more expensive

Whatever your style, there are certain things that just ooze chicness and glamour. These are some touches, tricks, and details that can give a space that extra design polish:

1. **GO BIG.** I'm not necessarily talking Philippe Starck gargantuan lamps, but I do suggest erring on the side of slightly larger rather than smaller. While things absolutely need to be in proportion and balanced, an object that has a large presence tends to add more significance to a room. An oversize photograph, painting, mirrors, or rug almost always work this way.

2. **INCORPORATE SHIMMER.** A selection of reflective surfaces balanced with earthy matte surfaces can up the luxe factor on a room. Think a crystal vase; chrome hardware; silver picture frames; or high-gloss paint on feature doors, cabinets, or window frames.

3. **ADD LUXE LAYERS.** Using a mix of materials, textures, and tones always gives a space a more custom look and appears more thought out. Mix materials such as glass, wood, and chrome and layered textiles, pillows, and rugs. The originality always feels luxurious and timeless.

4. **KEEP IT CLUTTER-FREE.** While layers add dimension to a space, the quickest way to more style and sophistication is to take a few pieces away to let the room breathe. An overstuffed space looks tired, whereas a streamlined, clean space appears fresh.

5. **INCLUDE BLACK-AND-WHITE PHOTOGRAPHY.** This always looks chic. Period. There is something endlessly cool about black-and-white photographs. Over the years, Scott and I have collected images we love and have featured them in various spaces. To me, they fit every space and never get tired.

6. **OPT FOR SOFT LIGHTING.** Harsh, fluorescent lighting can make even the nicest furniture and surroundings (not to mention skin tones!) appear dismal. Good lighting on the other hand bathes furnishings in better light and can make lesser-quality pieces look, well, better! Look for warmer rather than cooler lighting, which tends to give off a more golden glow. Also, whenever possible, install dimmers or use three-way bulbs so that you can adjust the degree of lighting.

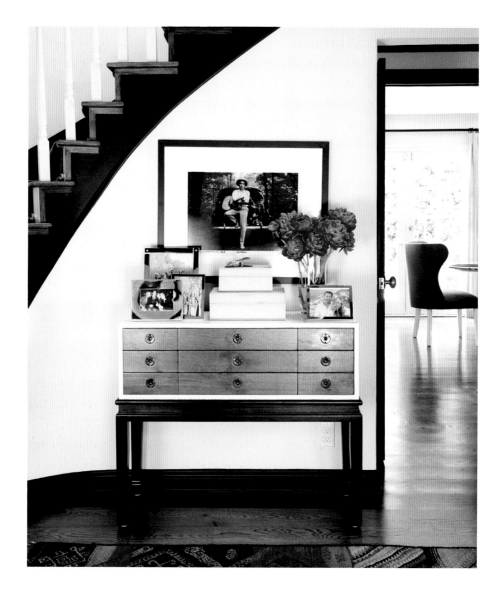

7. **ADD A ONE-STATEMENT PIECE.** One unique, high-quality furnishing or accessory in a room can truly elevate everything else. You could have mostly budget, contemporary furnishings and, say, one gorgeous Herman Miller Eames chair—and all of a sudden everything looks more expensive just by association! Think—it's the exact same in fashion. A great pair of shoes or a show-stopping handbag can transform the whole look.

8. **INVEST IN CUSTOM DRAPES.** All the furniture in the house could be flea market or budget, and then, *wham!* A dramatic set of custom drapes on an elegant brass rod can do wonders. Another true designer trick is to mount the curtain just an inch or two below the ceiling line or crown molding (rather than just above the window frame). Make sure the drapes hit and slightly bend at the floor, like a pant leg. This gives the illusion of a less boxy room and elongates the entire space.

9. **ADD SOME VIGNETTES.** A vignette is a grouping of objects, like a still life, that can add form and style to an empty area or space and instead create a unique focal point. Well-designed spaces always have featured vignettes. For some reason, a vignette can make a room. Whether it's a well-curated coffee table, or a vignette on a bar cart, shelving, or an entryway console, it is a sure way to add style, personality, and sophistication to a specific space.

My final piece of advice regarding design is to *take your time*. Don't just fill the space or rush into decisions because something is on sale. Home designing is like dating—don't commit to a big piece unless you really love it. And if you can't find something you really love, or can't find it in your budget, *wait*. Sometimes we do have to make compromises, based on our budget, our timing, or availability, and that is okay. Today, elegant, quality design is accessible at every budget. When it comes to home design, remember above all that your space should be a reflection of you and your family. Your home should meet your needs and you should feel good in it. In the words of Frank Lloyd Wright, "There should be as many kinds of houses as there are kinds of people and as many differentiations as there are different individuals." Have fun, be creative, take your time. And work to create a home that is timeless and that will serve your family. Make the space yours, and it will give back to you.

TOP 10 takeaways

1. Start out by getting design inspiration from classic designers, social media design stars, or even public spaces. Study the fundamentals of design and get started. Create a mood board and get designing!

2. Invest the majority of your budget in installations—cabinets, countertops, and flooring. Save money on the trendier pieces or on items you can always change out easily and upgrade later.

3. Choose a more neutral foundation when it comes to larger furnishings and pieces because it tends to be the most versatile and timeless. But definitely use color, and use it wisely. Choose one or two accent colors and layer them in for interest.

4. The house should have a common narrative, and while the rooms can be different, they should all flow together and tell a similar story. That goes for children's spaces too. They can be whimsical but should still be sophisticated.

5. Mix and match. Everything should not be purchased at the same store. Don't be afraid to blend different eras, the masculine and feminine, or other contrasting pieces for a richer, more layered effect.

6. Find ways to up the elegance of your space without breaking the budget. Make a statement in the room, hang drapes properly, and create unique vignettes to add value to your space.

7. Don't be afraid to have a little fun—whether it's with a piece of art, a colorful side chair, or a whimsical powder room. Everything can't be serious when it comes to design, and it shouldn't be.

8. Choose fixtures, furnishings, and flooring that will function well for your family—and that is stylish. Never pick something just because it looks good. It has to work for you too! And if you do have children, try out indoor/outdoor fabrics. You won't be disappointed.

9. Don't ignore lighting. Whenever possible, choose warmer shades over cooler, and add dimmers where they make sense.

10. Take your time. Don't rush into purchases. You don't have to do everything all at once. Don't worry about what others like. Make sure that you focus on creating a home that serves you and your family . . . your personal style and needs . . . and that you will love!

design & decor
my inspiration

AMBER LEWIS @amberinteriors, AmberInteriorDesign.com. California bohemian with a touch of elegance. I love Amber's unique eye for design.

EMILY HENDERSON @em_henderson, StyleByEmilyHenderson.com. Vintage inspired and approachable. She is great inspiration for a family home.

JUSTINA BLAKENEY @thejungalow, TheJungalow.com. True bohemian design. I love her passion for colors, prints, and plants in the home.

PALOMA CONTRERAS @ladolcevitablog, LaDolceVitaBlog.com. Paloma's style is so wide ranging that there's something for everyone . . . especially if you're in need of some great color inspiration!

SARAH VAN PETEGHEM @sarah_cocolapine, CocoLapineDesign.com. Sarah meshes minimalism with functionality perfectly. I love her use of crisp whites and wood.

SYD & SHEA MCGEE @studiomcgee, Studio-McGee.com. I love their bright and clean aesthetic.

For more Design & Decor inspiration, plus shopping and sourcing tips, visit MollySims.com.

ch/5

keeping sh*t real

I ended my first book with a chapter called "I Made That Sh*t Happen." *Because it was true.* I wasn't born looking like a supermodel. But I knew I wanted to make a living and a name for myself as a model—that was my dream. So I did everything I could to position myself for success. There were so many hurdles I had to jump (and sometimes trip over) in order to make my professional dreams a reality, and I've dusted myself off more times than I can count. The same went for my personal life. Before I met Scott, I was frustrated, unhappy, and unfulfilled in my romantic relationships. So I made a choice to change because I didn't want to be in dead-end relationships anymore. I got really honest with myself about what I wanted, and I committed to my clearly defined relationship goals. The effort paid off in dividends, and when I finally met Scott, I was ready for *the one.* Scott's patience, kindness, generosity, and total dedication to his family and friends are things that I admire deeply. I thank the stars every day for him.

Wherever you are, whatever your age or your circumstances, I believe that it is possible to create the life you desire. It's about being clear with yourself about what you want, envisioning that life, and then taking steps to make your goals reality. At the same time, you also have to accept the fact that life is a work in progress! Just when you think that you have what you want, and you're getting comfortable, life hits you with a new challenge. At age forty-three, with a husband and two wonderful kids, I thought I was somewhat settled. And then, *bam!* I was pregnant again, with baby #3, and everything was new again and changing and more challenging.

Today, when I wake up in the morning as a forty-four-year-old, I am waking up as a wife, a mother, a friend, and a professional who wears many hats and who still hasn't given up her heels. (As a matter of fact, eight months into my third pregnancy, I was still wearing heels because I *could.*) My life today is worlds away from where I was in my twenties: single in the city and able to sleep in long past 6:00 A.M. But I don't miss it. Because I've evolved, and I've changed. And I love my life today as a momma of three with history behind me. I'm old enough to know now that the

only day we are given is today. Today, we have to make the best choices we can. Today is the day we have to tell our loved ones we care about them. Today is the day we have to make the change in our lives that we've always wanted to make. Not tomorrow—but today. Today is the day that I choose to live, love, and honor the life that was put before me. The good, the bad, the ugly—and everything in between.

Because when you've got a busy life and you're juggling family and career, it's all too easy to get caught up in the idea of doing everything perfectly and *being perfect*. The perfect wife, mother, hostess with the mostess—the perfect [*fill in the blank*]. In the age of social media, this

is all heightened. We live in a pressure cooker of perceived perfection. And despite the fact that women have had advances in rights and financial power, current research shows women in the United States are actually less happy today than they were in the 1970s. As women, we have more opportunities than ever—but we aren't more fulfilled. There are plenty of hypotheses as to why. Perhaps some are out of our control. But one thing I do know, as women, we are a strong, resilient force to be reckoned with. We support, love, and care for our children, our homes, our friends, and our families. Many of us put the well-being of others before ourselves; we are inherent caretakers. Mothering others, whether we are biological mothers or not. Never putting our needs first. Putting them on the back burner.

In this final chapter, I offer some advice to you on keeping things in perspective. Because life, and especially life with a family, is not about perfection or even aiming for it. Life, on the other hand, is about priorities—sifting through the endless clutter and chaos that this world throws at us and keeping our priorities in sight and our heads on straight. Life is about sucking the marrow out of it. Living it. And loving it. It's about knowing what you can physically do and letting go of the rest. Life isn't about being perfect. Perfect is a unicorn, people. It doesn't exist. Life is about *keeping sh*t real*.

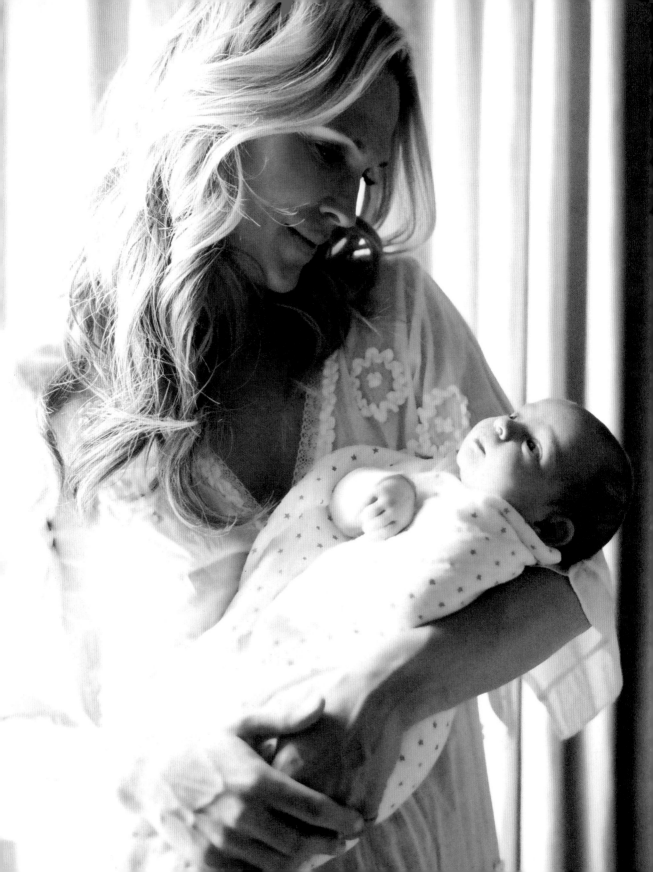

Motherhood is a sacred, scary surrender. If you are a supermomma, you will remember like yesterday the first time you held your baby in your arms. You will never forget it. It's unbelievable. The rush of love that you feel for your children is truly a love you've never felt before—it's so big, so encompassing, so spiritual, and so human. Motherhood is magical, illuminating, and humbling, and yes, totally terrifying. You are a mother, but you are not superhuman. As your children grow and become bigger people, you learn you cannot fix everything. You cannot eliminate the challenges, obstacles, and scary things in this world. The one thing motherhood is not is *easy*. And nobody cares.

Easy is overrated. Absolutely nothing worth having is easy. The things that we work hardest for end up being the things that we treasure most. Motherhood is a blessing. I used to get down on my hands and knees and pray for it. I believe I wanted it so badly that I willed it to happen. Everything I do, I do for my kids in some way. But I won't pretend that every day is magical. Hell,

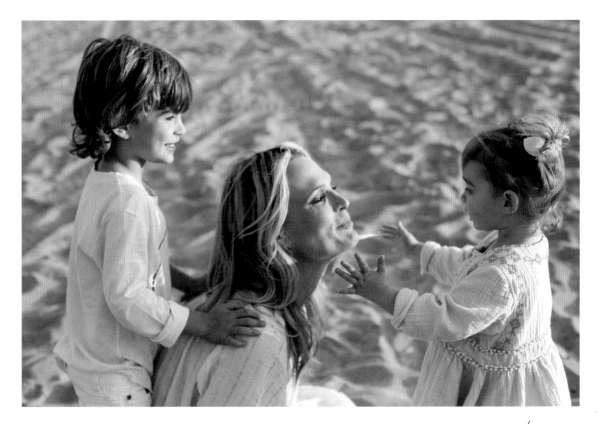

no. There are days when the fatigue sets in, then the frustration, then the fear. There are days when I am so exhausted, I want to cry—but I don't even have the energy for that. There are days when I long for the freedom I had before these teething, whiney, stubborn, needy ankle biters came into the world. But I also know this won't last forever. They won't always need me the way they do now. They'll grow up. They'll get too big to want to cuddle in the morning, or crawl into my lap at night.

That day will come and that will be okay. Because motherhood changes, evolves, and moves through different stages—as our children do. We change, evolve, and move together. Ultimately, you just want the very best for your children, whatever that means to you. Whoever they are, you want them to find their place in this life, their purpose, their sense of self-worth, self-love, and security. You want them to wake up most days ready for this world. And you want to protect them from everything to ensure that they will. But you won't be able to. We can't. And we shouldn't. How would the stone ever become a diamond if it never was polished in the storm?

As the mother of three children under five, my worries tend to exist more in the present and putting out the daily fires, serious and less so. Knowing that this is a challenging stage that we will pass through keeps me going. They won't be little and cute forever. Especially after those long nights when no one has slept a wink

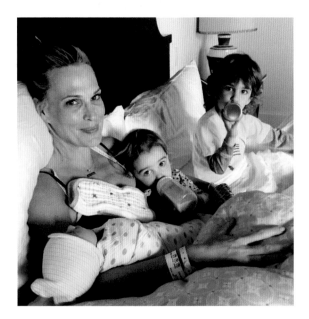

because (1) Brooks had a sore tummy, (2) Scarlett had nightmares, and (3) the newborn was being, well, a newborn. I know that my blessed cup runneth over. But at the same time, sometimes it runneth over *with sheer exhaustion*, like I'm one of those international pop stars you always hear about checking themselves into clinics for tiredness.

Despite those days, I am grateful for everything my children have given to me (apart from sleeplessness). Motherhood has given me the opportunity to learn and be taught by my children and our ever-changing circumstances; it's not just about learning how to change a dia-

per in my sleep and warm a bottle to the perfect temperature. Some lessons we all share, and others are just things we learn about ourselves as individuals. My kids have taught me valuable lessons about being human, lessons I perhaps would never have had the privilege to learn without their presence. Motherhood is a gift, but it's also a choice I made and a path I chose. I know that it's not the right path for all women and that there are many other paths to follow. But it is something that I desperately wanted, and I knew that starting a family was the right next step for me and Scott.

About that pursuit of perfection, one thing I know for sure is that more than anything it is totally disempowering and disabling. As mothers, as women, as human beings, we need to pledge together to throw judgment and the quest for perfection out the window. We are so hard on ourselves and *on one another*. What we really need is to be a supportive community; what we don't need is to compare ourselves as women and mothers to what we see on blogs, TV, or social media. What you are seeing there is an illusion. It's an edited version of real life. You're not getting the behind-the-scenes footage. I am not posting the brownies that I pretty much burned for Brooks's snack day and didn't have time to redo on my Instagram feed. Because no one wants to see that. But trust me, for every recipe I post that I get 100 percent right, there are plenty that I don't.

I'd like us women to (drum roll please) . . . throw the idea of perfection out the f*cking window. And give it a good stomp with your motorcycle boot, flip-flop, stiletto, or five-toed running shoe (God forbid you actually own those, but to each her own—not judging!). As women and mothers, we need to get real on social media, and we need to build strong communities of other like-minded moms around us for support. Because believe it or not, there is as much positive mom-community building happening on the Internet as there is the bullsh*t. We are actually supporting one another. Let's keep doing it—and do more of it. Remember what Henry Miller said: "Cluster together like stars." In a cluster, we all shine more brightly. We have to do our best, seek quality advice, share quality advice when we have it, and work for common goals.

momma drama +
supermomma support

The "Mommy Wars." Yes, they are real. And yes, they are fought over everything. People will judge you on your birth plan, the names you pick for your children, everything and *anything*. You name it, and women will war over it. Breast-feeding versus bottle feeding, dark versus light at naptime, attachment parenting versus free-range. Work *from* home versus stay *at* home versus work *outside* the home.

Human beings are all different. As moms, we are different people. We are different ages, races, and from different economic backgrounds. We have been raised with different priorities, various family structures, and with vastly different choices, challenges, and opportunities in front of us. These unique variables are the reasons why we don't all think alike—and may often see things differently. And that is a good thing.

I understand the urge to judge. Sometimes judgment comes from a good place. You want to help. You want to give advice. You want to see another prosper as a result of your sage wisdom and experience. Or maybe you are really just a judgy a**hole. Regardless of your motivation, you've got to keep in mind that judgment can be as hurtful and damaging to yourself as it is to others. Motherhood is not a competition, it's not a race, and it's not always black and white. What I've learned by spending time with other supermommas is that most of us are all just *trying to do our best*. We all feel guilt, stress, insecurity, and occasionally unbridled

anxiety over many of our decisions. How many times have you second-guessed yourself over a decision? As I go through the application process for schools for my firstborn and evaluate our options, I can't help but feel the weight of the world on my shoulders. And yet we will evaluate, choose, and move forward with our choice of school. Another mother going through this experience will process the information differently and perhaps would make a different decision.

There is no one right way.

It is all too easy for us to judge when you are only looking at an issue from your point of view. Instead, open your eyes to the fact that we are all facing unique challenges, and we all have to try to do the very best for our families based on our unique set of circumstances. What works for some simply won't work for all.

There is no one right way.

There are going to be many schools of thought on how to do something "right." Follow your gut. Listen to your heart. Learn from your errors. Just do your best. And be more open hearted and accepting to other parents doing things in different ways. Count to ten before you judge.

You have to try not to judge your parenting too harshly. And you have to talk to other moms. It's so important. You have to let it out. You have to say to one another, I'm so frustrated! *You have to laugh. Other moms will almost always understand. We have to share with one another because there is so much we can get out of one another's support. There really is a great community in other moms. I'm so lucky to be a member of the motherhood club.*

—JENNIFER GARNER

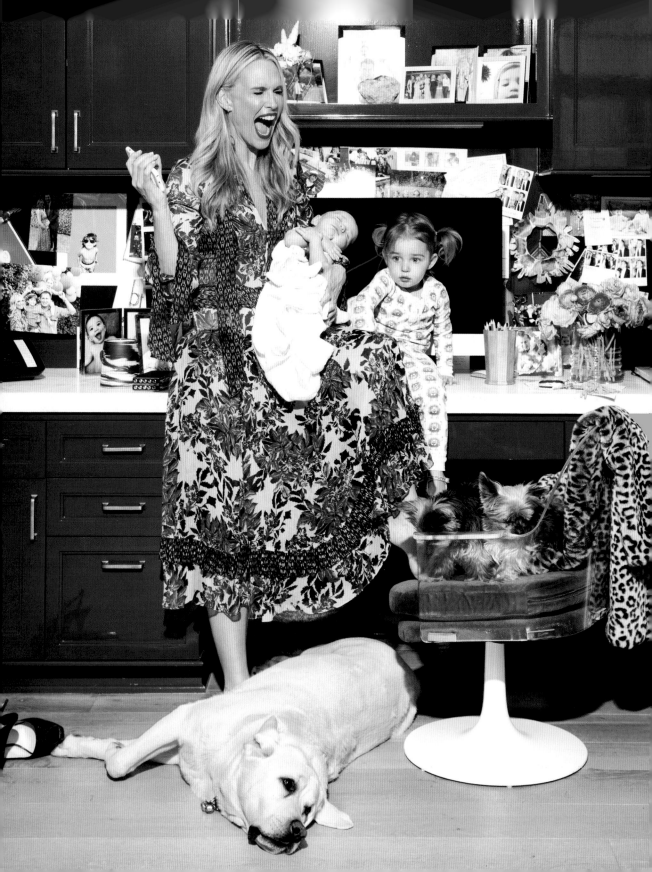

work, *work*, work, *work*, work

To work or not to work—that is one of the big debates in the world of the Mommy Wars. My younger years were spent modeling all over the world: Paris, New York, London, Hamburg. I didn't have a family yet, and I could take a job anywhere and at any time. Such freedom gave me the ability to meet many of my professional goals by the time I was thirty. Then Scott and I got married, my first son was born, and I slowed things down career-wise. We had that option financially. It was also my choice and something I wanted to do for me, for our family, and for our son. You absolutely can have a full-time, kick-a** television career and be a supermomma at the same time (just look at the incredible Mariska Hargitay). But for me at that time, Scott's career was on full speed; he was working a lot and traveling a ton. I had the opportunity to step back, so it made the most sense for our family. But before long I was anxious to work again, and I eventually did.

Now that I have three children, I continue to make career choices based on my family as a whole. I've made the choice to focus on opportunities that require fewer hours and less travel, ultimately giving me more quality time at home. And sure, that means that sometimes I pass up lucrative opportunities that I would never have turned down when I was younger. But I prioritize. Too much time away from the kiddos is always a deal breaker. But what's interesting is that having children has also opened up new doors for me professionally. I keep an open mind and seek out new kinds of work.

As a working momma, I've forged completely new territory and explored scary, foreign frontiers. I've shifted my career in a direction that feels more compatible for me and my family in order to make it all work. I write a blog, publish lifestyle content on my YouTube channel, and collaborate with brands on a variety of proj-

What might I say to my younger self? Approach each day as a new day. Every day will present its own challenges and every day will consist of doing your best to find the balance between work and home life.

—RACHEL ZOE

ects, and I still act, audition, and host television shows and events. While in some ways I've slowed down, in other ways I've actually sped up because I'm doing so many different things now. As a woman, you should not feel that your career aspirations are over because you have children. I've written two books and become a *New York Times* bestselling author *after having children.* Jessica Alba started the Honest Company after having her two beautiful girls. *After.*

Sheryl Sandberg famously addressed women in the workplace, encouraging them to "lean in" to their careers and fight for their opportunities and equal footing at work. I totally agree that as women we need to continue the fight for equality and opportunity. As women, we've fought hard and *leaned in* for the right to own property, to vote, and to be given equal opportunities in the workplace, and we continue to lobby for equal pay and other worthy goals. As women in the workplace with kids, it's important that we work toward and define our collective goals: goals for appropriate maternity leave, for better child-care options, and for a generally supportive environment for parents of young children. It's important that we band together in favor of these policies, as they benefit not only the individual family but also the company, community, and society.

But I also think we need to continue to lean in to and encourage one another outside of the workplace. I hear women who have professions outside of the home disparage mothers who have chosen to stay at home all the time—and vice versa. This is ridiculous. If either partner wants to and has the means to be an active, at-home parent, this should be commended—just as a woman would be commended for continuing to take on professional challenges and grow her career outside the

home. It's ridiculous there is any debate over this. We are unique individuals and mothers, and there is no one cookie-cutter option that will work for all of us.

So for me—the lean-in directive doesn't just apply to the workplace. As women, I think we need to continue to evaluate where we are and lean in wherever and however it makes the most sense to us as individuals and within the context of our family. More than anything, I want all of us mothers to support one another's choices graciously, because remember, we are all just trying to do our best. Lean left, lean right, lean in, lean out—and lie down if you have to, because Lord knows we are all tired!

inner work for *supermommas*

As parents, we are always learning and adapting as our kids get older, change, and develop different needs. As women, professionals, wives, mothers, and friends, our needs are always changing too. Below are a few of the big issues that I find myself constantly navigating, some of which you might be navigating too. They are ongoing, and I'm doing my very best, but some days, some weeks—maybe even some years—are better than others.

1. **SETTING BOUNDARIES** This can really be a tough one. But children need to have boundaries. They are total crazies sometimes! Boundaries need to be set for our children—and also for ourselves. As parents, we have to be clear about what we will and won't put up with. While my children are my number-one priority and most of the time the center

of my universe, they cannot and should not be the center focus *all the time*. My children push the limits, and occasionally, when I don't have the energy, I give in. Lately Brooks has been going to bed about an hour later than his bedtime. We made a few exceptions recently because his daddy got home from work late—but Brooks has really been pushing it, and it's been a nightmare to get him to bed. I am working on setting boundaries and following through with my children when they leap over them. Children must experience consequences and the impact of a line crossed. This is teaching them not only respect for one another but also respect for themselves and self-discipline.

2. **BEING THE "YES WOMAN"** I used to say yes to literally everything. I tried to be there for everything and everyone. People who really, really mattered in my life suffered as a result of me spreading myself so thin. And I suffered too. I am learning to occasionally say no to things. I cannot go to every baby shower, wedding, or playdate. I am learning to prioritize, decide what's important, and let everything else go. And most important—not feel guilty about it. By letting go of what is not as important, you create room and time for the things that truly matter.

3. **SELF-ACCEPTANCE** I had so much trouble breast-feeding with all three of my infants. I tried every time, but it never worked for me at length. My milk did come in small rations, one little drop at a time, but only for a few weeks. The first time, I was truly devastated and did everything in my power to try to make it work. I drank all manner of home remedies, met with the best lactation specialist—but no *leche*! I was depressed and felt like a total and complete failure. It didn't matter. All three babies were beautiful and healthy. But I had to learn to accept the reality of my body. It didn't make me any less of a mother. I still bonded with each baby during bottle feeding and woke up for every sleep feeding. Some of you won't relate because you probably had a freezer full of breast milk! But for me, my challenges with breast-feeding have helped me learn to acknowledge my limitations and accept those things that I don't have control over. And to be kinder to myself. This self-acceptance is, of course, a daily battle. But it's something that I to continue work on. Basically, I am working on not being so darn hard on myself.

4. **ACCEPTANCE OF THE LITTLE ONES** You might think that your toddler absolutely must be sleeping through the night by eight weeks, finished with the bottle by age two, and diaper-free by age three, and so on. But the truth is . . . who cares! If they are a little behind, it's really no big deal. You've got to sometimes be a little easier not only on yourself, but also on your children. Positive encouragement is good—but too much pressure or force isn't. I promise you, they will get there. Continue to encourage them and before you know it, they'll be on their way.

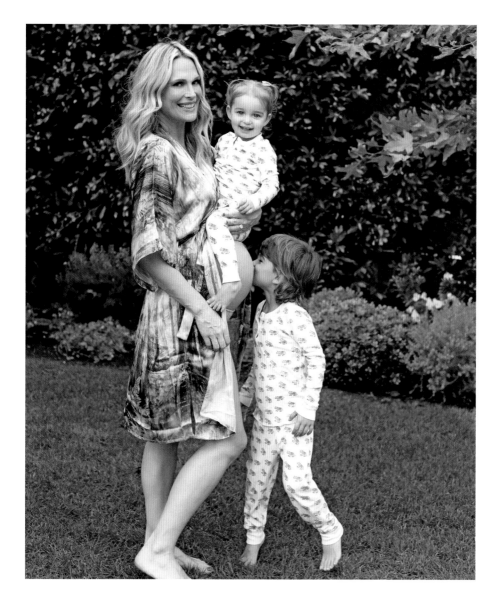

me(-ish) time

When I was researching this book, I read some statistics that were honestly terrifying. A private study of nearly two thousand moms in England found that women reportedly have only seventeen minutes of "me time" per day, and that probably includes going to the bathroom and showering. Congratulations, supermommas, you have seventeen minutes total to go to the bathroom alone. Most of us are nodding our heads because we know how true this is and how we often have to tag-team with husband, partner, babysitter, or loved one to have a few minutes just to hop in the shower. Yikes.

Before I had my children, I could sleep in until 11:00 A.M. on a Sunday if I wanted to. Those of you with babies know that there is simply no more sleeping in. Vacation used to mean going somewhere with someone where I could drink, get tan in a bikini, and relax. Now *I just want to go somewhere I can sleep*. If you could wrap sleep hours up in a box and give them to me for Christmas, I would be in heaven. For those of you without children, you may be in the same boat. Working long hours or out late with clients, burning the candle at both ends and not making time for yourself—we can all relate.

While I am lucky to have home-based child care, which is hugely helpful, and I

have a flexible work schedule, I still work forty hours a week. And I am still up at the crack of dawn changing diapers, making breakfast, and slipping wiggly arms, legs, and toes into sweaters, socks, and shoes. And (most days) I am happy to do it. But I am also keenly aware of needing space away from my mini-beings. I know with 100 percent certainty that I need to take time to recharge and enjoy life as *Molly*, not just as momma, so that I can actually be a better mother to my kids and a better partner to my husband. I believe, airplane-style, that we have to put on our oxygen masks first and then help others with theirs. We have to check in with ourselves. As moms, we have to make time for ourselves. If we don't make the time for ourselves, we simply will not get it. That goes for single women too. A lot of us sacrifice so much for our careers, our bosses, our family, and our friends that we leave our own selves in the dust.

Me time for each of us means different things. For me, it most often means carving out time to be with my close friends. Or enjoying a wedding weekend away with the hubby and no kids in tow (praise be!). Often it means having a no-time-limit, no-interruption (kids/husband) phone conversation with a girlfriend or shopping. I almost never shop. So when my shopping-addicted *amiga*, Emese, is in town, we shop till I drop. For an hour, two hours—maybe even an entire afternoon. True retail therapy isn't about buying things—it's being able to shop without worrying about car seats, strollers, iPads, snacks, or toddlers hiding between the racks! The other thing I try to commit to once a year is a spa weekend with a girlfriend. Last year, I didn't make the time. But this year, I was on it! We have daily massages, colonics (yes, I believe in them), facials, and trashy magazine time. It is a vacation for body, soul, and brain. I don't think about work. I try not to worry about the kids. I just relax and enjoy time to myself. Most of the year I am thinking about everyone else, but when I am there—it's 100 percent about me. And if I want to read the *Daily Mail* and the *New York Post* all day long, I do and *I don't give a damn.*

My best me time *is early in the morning. I'm an early bird. I get up before everybody—every morning—and I take a Jacuzzi outside . . . by myself. No one wants anything from me yet. That's my creative time. I'm in nature; it's my gratitude time. I walk through my day and how I want it to go. I work out the kinks in my head. I imagine how the day is going to go and I set my intentions. Then I make a cup of tea—and then the rest of the house starts waking up.*

—CINDY CRAWFORD

everyday *supermomma* success secrets for keeping sh*t real

Being a mom is the most trial-by-fire experience I've ever encountered in my life. The learning curve is up and down and steep and long—and doesn't ever seem to end. And I mean that in the best way possible. The woman I am today and am still evolving into continues to be shaped by many of the life experiences and challenges being a momma presents me. Being the birther, caretaker, number-one diaper changer, and mom of these three little ones has taught me more about life than I ever would have imagined. And I am so grateful for the lessons they have taught me. Here are just a few of them:

1. **BE A BEGINNER.** The first time we become mothers, we obviously haven't done it before. We are beginners; there is no way around it. What a life lesson this is! Becoming a mom taught me that it's okay to be a beginner and it's actually a good thing. I shouldn't be afraid to be a beginner more often, even as I get older. It's okay to start something new later in life. As adults, we often think it's too late. We're too old. That is just total bullsh*t. I had a baby at forty-three. If there is something you want to start—just do it. Only by being a beginner can we as humans continue to live and breathe.

2. **ACCEPT LOSS.** I've had the experience of being pregnant, watching my baby grow from the size of a sesame seed to a raisin, and seeing the baby's heartbeat. And then, at the next appointment, that baby's heartbeat was *gone*. It is devastating. There is endless questioning, testing, and searching for answers that sometimes never come. Once you've had a miscarriage, other subsequent pregnancies feel more fragile. For those who have been through this experience, I can only say I am sorry. I understand more fully grief and loss after having a miscarriage and that it is simply unavoidable and a part of life. As we get older too, loved ones around us—young and old—become ill without explanation. Some get better and some don't. Life is a mystery. It is fragile. True grief is only healed by time and our acceptance of the experience. Perhaps it never fully leaves the heart, but thankfully, it becomes a shadow of what it once was.

3. **BELIEVE IN MIRACLES.** As an "older" mother (I was thirty-nine, forty-one, and forty-three when each of my babies were born), I think you more fully understand the miracle of this experience. It's not just wham, bam, thank you ma'am! Having a child means getting to believe in miracles again—because one happened. If that one miracle can happen, there must be more out there.

4. **CHANGE IS CONSTANT.** I am essentially the same as I was before becoming a mom, but also vastly different. This doesn't mean I'm better, but I am different, and I am grateful for the change. Since I have become a mom, there has been a seismic shift in my priorities, my ability to love, my compassion, and my strength. It's a vulnerable feeling being a mother. **You want to control everything, but as a mother, you realize very quickly that you can't.** Things are constantly changing. Once you have one stage of life down (say, potty training), another whole new challenge presents itself. This is life—not just motherhood. But for whatever reason, this truth is crystallized in parenthood. We must learn to move with change and not to fight against it. We must remain open, because change can be the best teacher.

5. **SOMETIMES LIFE STINKS (LITERALLY), BUT LIFE IS STILL GOOD.** Yep, like a poopy diaper. Life is definitely not always fair. As a mom, you know this. You feel this deep in your bones. The first time your infant is sick you think, *This poor wee little thing is sick. It's just not fair.* They are so fragile. But there are reasons behind baby illnesses—all those coughs and colds strengthen their immune systems. We learn to accept. Scott and I have very close friends whose daughters were recently diagnosed with an extremely rare illness. It's not fair. But all you can do is fight, believe, hope, and ultimately accept.

6. **LIFE TAKES COURAGE.** I have never been more afraid in my life than when I was pregnant with my very first child. I was afraid of everything—that I wouldn't eat healthy enough, for example. And then, because of my age, there were all the tests that accompanied a high-risk pregnancy—around every corner was the possibility of bad news. While I knew everything would probably be okay, we couldn't be sure. You become a mom the second you are pregnant and the joy and stress begins then and there. There were so many decisions. After the birth, I was so, so tired, but I actually had trouble sleeping (for the first

time in my life, people) because I had so many doomsday thoughts. Some of that comes with the dip in your hormones, but also . . . I just didn't have the confidence in myself. I didn't know what I was doing. Rule #1 (as most of you know) is never wake a sleeping baby, but guess what? I would! Because sometimes I just needed to know he was still breathing. I sound like a crazy person, but that is how I felt: a little crazy. Three babies later, lying here today with my infant, Grey, there are still harrowing moments of uncertainty, but now I trust myself. I know that I can do it. That certain things are in my control and certain things are not. It can be scary, **but things that are worthwhile always demand courage.**

7. **MEET IN THE MIDDLE.** Sometimes I feel like I am *so* right. I should change my middle name to Right, that's how sure I am about being right. But then I have to ask myself, "Do I want to be right, or do I want to have friends and be loved?" It's not so much about keeping the peace as *being the peace*. When it comes to your relationships with your husband, your children, and your friends, sometimes you have to bridge the gap between right and wrong and simply extend your hand and meet them in the middle. To do this, **we have to pause and be sincere and receptive to seeing things from the perspective of others.** In relationships, it's important to be able to let go of being right in order to be a *supermomma in the middle*.

8. **DON'T SWEAT THE BROKEN STUFF.** I was taught to take extremely good care of my things. You might call me OCD. Having children is an advanced lesson in not sweating the small stuff—and that includes the *broken, dirty, ruined, stained, cracked, and destroyed-within-an-inch-of-its-life stuff*. The other day a TV repair guy came to fix our brand-new flat-screen TV that was acting up—and it fell off the wall, hit the floor, and smashed into a trillion pieces. Ten years ago, I probably would have gone crazy on the guy. Today, I laughed, looked him in the eye, and said, "No worries, mate," like I was some kind of lady Crocodile Dundee. And that was the end of it. Once you have kids, you literally do not have time or energy to worry about broken or dirty stuff. Probably because you just have to do more laundry. Because that sh*t never ends.

9. **DON'T GET TOO COMFORTABLE.** A ship is safe in a harbor, but that's not what it's made for. Same goes for us . . . in our homes. Our house is comfortable. Plush rugs, cozy couches, central air—but there are also four walls. Walls keep scary things out, but walls also keep us in. Children certainly make you step out of your comfort zone time and time again. Which is a good thing. When we get too comfortable, don't challenge ourselves, and don't try new things, we aren't really living life to the fullest and exploring all that we are as mothers and as individuals.

10. **YOU STILL NEED YOUR FRIENDS.** Just because you are a mom doesn't mean you always have to be momma-ing around. You need your friends. Stay in touch with them, connect with them both with and without your children. Do not sacrifice all your girlfriend time or who you are, thinking it will make you a better supermomma. Your friends enrich you. Your children are not adults: they will not talk to you about foreign films, the best new lipstick, the book you *have got to read*. You don't have to lose the other parts of you, past or future, because you are a mom. Being a mom should not make you less; it should make you more. Keep being you.

Most everything that I have and that I have earned I attribute to self-discipline. My ability to save enough money to buy my first house. My ability to persevere in my modeling career early on, when I was told that I was "too fat." My ability to have a growing family, despite growing in age myself. Self-discipline is crucial when it comes to achieving life goals and meaningful goals. Our ability to put off short-term gratification in order to meet long-term goals is what ultimately leads to achievement. Unfortunately, excuses so often get in the way of hard work. Procrastination can be a big one for me. That's why I work constantly with deadlines and calendars—I just plug it in and do. I don't have time to think *I don't want to* because it's on the books. I often place arbitrary deadlines on projects because a floating "whenever" deadline is simply not motivating enough. It will inevitably be postponed if it's not penciled, or penned, in! And when it comes to self-discipline, I believe that a change in perspective is sometimes all we need. Change your language from "I have to do this" to "I get to do this." See what a difference that makes? Assigning positivity to the task at hand helps us stay motivated to consistently follow through.

body talk

When it comes to body confidence, women of all ages (myself included) have some work to do. We need to take a closer look at how we communicate with our bodies and how we talk about our bodies to ourselves and to one another. Just think for a moment about the things we say to our friends and family members about our bodies: "I'm so fat." "I need to lose weight." "I hate my arms, my broad shoulders, my legs." For a lot of us, it's a constant body bash. We scrutinize, judge, and dishonor our own bodies. Our bodies are a constant topic of our personal conversations, and in addition, they're scrutinized on the covers of magazines, in Internet headlines, on TV shows, and so on. Women's bodies are *always* being talked about in one way or another—praised, shamed, and everything in between. And this constant body talk is affecting our kids. Because guess what? They are always listening. So always, always be aware of how you talk about your body in front of your children, and to your daughters especially. We've got to work to show our daughters that whatever state our bodies are in, they deserve to be loved.

Why? They believe in you and will believe what you say. Do not say anything that breaks them down. They will take it to heart. I had a friend who is smart and beautiful, but her mom always told her she had "her father's legs." She's an incredible dancer, striking, and supertalented. She has a knockout body. But guess what she hates about her body? Her legs.

Recently, the aging male body has come into the spotlight with the "dad bod" making headlines. But whereas the dad bod is kind of accepted, the mom bod is generally lambasted, albeit in backhanded ways. Think of how we celebrate women who *snap back! And just days after delivery!* After having Brooks, I did *not* snap back in any way, shape, or form. As

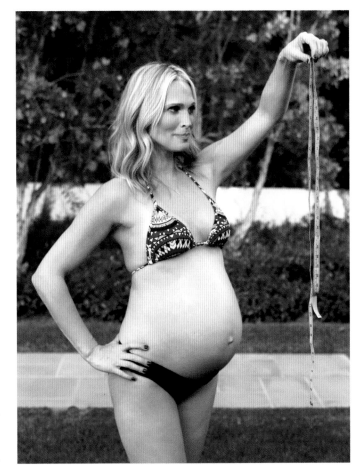

a matter of fact, I ballooned forward. I had such a hard time losing weight that I barely left the house for months for fear of being photographed and having my cellulite and mom bod making headlines. As I type this, I know it sounds crazy, but I know that so, so, so many women will relate. There is so much pressure!

To be brutally honest with you, since I've been pretty much pregnant or post-pregnant for the past six years straight, this has been a significant struggle for me. It has taken me years to stop the body bash happening in my own head and ultimately learn to truly thank, honor, and appreciate my body for what it's done and exactly as it is. For one, having babies connected me to my body in extreme ways. This awareness spread. It has also helped me realize that this body is not my enemy. It is my ally. This body has provided me with a living and a career for years. This body has taken me all over the world and provided me the opportunity for freedom and adventure. And most significantly, this body has grown,

birthed, fed, and snuggled my three babies. **Because of this body, I have been able to *do so many things I am grateful for.***

Just sit back and think for a few minutes about some of the things that your body has done for you. Maybe your body has fought illness and won. Maybe your body has raised children. When I was struggling with body confidence, I would think about this quote from Serena Williams, about her own struggles: "There was a time when I didn't feel incredibly comfortable about my body, because I felt like I was too strong. And then I had to take a second and think well, who says I'm too strong? This body had enabled me to be the greatest player I can be and I'm not going to scrutinize that. This is great. I mean, this is amazing." Maybe your body has climbed mountains, run races, swam across vast channels. Maybe your body has enabled you to care for elderly parents or work hard on a family farm. It's time to recognize all that our bodies do for us every day. Ask yourself what your body has given to you, and what you can give back to it.

not just any *body*

I've worked in Hollywood for years. And everybody knows that there isn't an industry out there that gives itself more accolades, pats on the back, and awards shows than this one! You know what there should be an awards show for? Women's bodies! I mean, what do men really have on us? They can whip out their favorite appendage and go anywhere without getting pee all over their leg. I'll give them that. But women's bodies literally build complex brains, strong bones, and *babies* inside the safety our uterus. *Just sayin'*. Give yourself a pat on the back every once in a while, will ya?

Our bodies yearn for physical fitness and challenges, healthy food and water, ample sleep, rest and recovery, physical touch and warmth. Our bodies don't yearn for this because they see cellulite or flabby arms, but rather they want it because they need it for optimal health. When we look at our bodies, we have got to start looking with different eyes. Why do we so often see imperfections? Why are we not seeing the other good stuff? The other truly incredible stuff? Our bodies are amazing—and so much of what goes on inside our bodies as women and mothers is still a mystery. Today, I am more connected to my body, my body's needs, and what my body does for me than I have ever been before. I've learned that I need exercise to feel good—not just to simply lose weight. Exercise is the kind of healthy, physical communication our bodies have earned and seek. I need to be kinder to my body and grateful to it. I need to check in with my body—and give back to my body because of how hard it works every single second of every day for me.

Most important, all of us women need to learn to change how we speak about our bodies to ourselves and to others. It's tempting to click on the article that exposes the supermodel's cellulite for all to see—because somehow it shows that we aren't alone. They are human too. And believe me, they are! But we all have to try harder and work harder to be kinder and gentler to ourselves—and to one another.

Aging is a biological reality that all of us share as long as we have the privilege to continue on this earth. And there are numerous benefits to aging. But in our culture, especially for women, aging is big fat negative. It's associated with all kinds of bad things that we are supposed to "fight." The language we use when we talk about aging is like we are in a war against nature and time: "Turn back the clock." "Try this new anti-aging miracle cream." "Fight wrinkles and sun spots." And I'd be lying to you if I said that I was completely kumbaya about aging—that I love every dark spot and undereye circle and fine line so much that I want to sing a song about it. Hell, no. It's especially hard when you've made a career in entertainment. But women everywhere worry about it. We don't just worry about aging because of the health challenges; we worry about aging because of how we will look. We worry about wrinkles, cellulite, sun spots, gray hair, sagging stuff, yellowing stuff, you name it.

I've made no secret about using Botox or having fat melted from my body by

lasers. The baby bump we all love tends to leave us with all kinds of baby bumps we don't! Then try having three. Amiright? But I have mellowed with time. My approach to using products, treatments, tools, and technology to maintain a healthy, youthful appearance is well researched, vetted, and always all natural. But there's this crazy catch-22. Women in the spotlight aren't supposed to age, but then if we choose to try to hang on to some of our youth, we're chastised: "What has she done? Collagen? Implants? Botox?" And then a million "experts" weigh in and pile on the ridicule.

I guess we're just supposed to stay youthful forever by drinking green tea, doing yoga, and avoiding sugar. Seriously? I'm not saying those things don't help, but c'mon. I don't care how old you are, when you are happy with the way you look, you feel better. And when I feel happier, and when I'm not worrying about my undereye circles or the trenches in my forehead, I'm better able to focus on the things that really matter. I'm not saying that I want to look thirty when I'm sixty. I just mean that I want to look as good as I possibly can when I'm sixty. When I feel like I look good, I simply perform better in every aspect of my life. So yes—you have permission to do whatever it takes to feel better about yourself. If that means cosmetic treatments, then go for it. We say women "look great for their age" and then simultaneously bash them for "having something done." Let it go. Feel free to do what you want. It's no secret that skin and other body parts don't stay young forever. As I've admitted before, I've done Botox, peels, face lasers, and body lasers, and I'm not afraid to say it!

Compared to other countries, the United States definitely lags behind in age appreciation when it comes to women and older people in general. As a matter of fact, Japan even celebrates Respect for the Aged Day. Why do we look in the mirror at our aging selves and focus on wrinkles and jiggly thighs rather than on the fact that as we age we become wiser, more patient, more compassionate, and more empathetic? Why don't we honor ourselves more?

The benefits to aging are many, if we choose to focus on them. That doesn't mean you aren't allowed to care about your wrinkles. It just means that you should focus less on that superficial stuff and more on the internal positives that aging brings. Age has brought me a confidence that I lacked when I was younger. It has brought me a feeling of contentment that I never knew before. Not to mention a feeling of accomplishment and a continued desire to challenge myself. Age has brought me experiences that have shaped who I am as a person, hopefully for the better. Why look back on youth when there is so much to look forward to?

how to truly age *gracefully*

1. **PHYSICALLY** Aging well is deeply connected to the physical. Having a physically strong body is important to me. Feeling physically strong also gives me mental strength and confidence to continue to live life to the very fullest.

2. **COGNITIVELY** Try to learn something new every day. Continue to challenge yourself intellectually. Our brains are fantastic elastic organs. They will continue to grow and expand as long as we exercise and

stretch them. This is the way to stay vital, agile, and youthful from the inside out.

3. **CREATIVELY** Stay sassy, supermommas! Old dogs can learn new tricks. Continue to live creatively and stay open to new ideas, opportunities, and challenges. Do not set limits on yourself as you age. A study published in the *Journal of Aging and Health* has found openness—the ability to entertain and be flexible to new ideas—is an indicator of longer life. Creative thinking reduces stress and ignites the brain's ability to stay healthy and mentally wealthy.

4. **EMOTIONALLY** Allow yourself to keep living, loving, celebrating, and experiencing all the magical emotions life has to offer. As we get older, sometimes we cut ourselves off from experiences that may lead to rich emotional rewards. Don't censor and restrict your emotions. Continue to allow yourself opportunities to live, love, seek, and find.

5. **SOCIALLY** Staying close to friends and continuing to nurture those bonds is a total youth injection! Think about how hard you laugh when you are with your best friends. Our friendships truly feed and nurture us, and they keep us young.

6. **WITH ACCEPTANCE** I won't linger on this—but the facts are the facts. No one actually gets younger. We grow and gain many things with age, but youth isn't one of them. When we welcome aging and don't resist it, we can blossom and experience all the pleasures that come with it: greater self-confidence, less giving of damns, clearer priorities, and an understanding of life that we can share with others. There is nothing more beautiful than that.

I turned forty six weeks after my third child. One thing that's nice about being a little bit older as a parent is that you are more settled with who you are, and you aren't looking for your child to define you.

—JENNIFER GARNER

SOUL GOALS

Whether you are in the profession you've always dreamed of, you are aiming to get there, or perhaps have detoured in an entirely different direction, rethinking and reevaluating goals is a good thing to do every now and again. While it's much easier to think of goals in terms of achievement or something material and tangible, because those things can be measured and counted, it doesn't hurt to also think of goals in less literal, quantitative terms. As Einstein said, "Not everything that can be counted counts and not everything that counts can be counted." It makes sense to dig deeper for different kinds of goals. I call them *soul goals*!

my *soul* goals:

* **COMPASSION** Being more compassionate brings us all closer together. The more compassionate we are, the more connected we are and the more connected we are, the more we can accomplish together.
* **FORGIVENESS** Gandhi called forgiveness the attribute of the strong. Letting go of anger and resentment is as much a gift to ourselves as it is a gift to the forgiven.

* **HONESTY AND TRANSPARENCY** When we are honest, we can love ourselves as we are. There are no games. There is no confusion. There is only truth. Honesty and transparency can feel very vulnerable, but do it anyway.

* **HELPFULNESS** Everybody could use an extra hand every now and again. I strive to be the person that doesn't just help in ways that suit me or that are easy for me. I put effort into the way I help, and strive to help out where someone really needs it.

* **INSPIRATION** When you have the opportunity to cheer someone on, do it! Genuine encouragement is a powerful force. We all know how good that feels! Your single flame can light a thousand wicks.

* **OPEN MINDEDNESS** When you have an open mind, other things will open for you and open up around you. In Zen Buddhism, there is a concept followers strive for called *shoshi*, or the "beginner's mind." It's a mind that's open, eager, and nonjudgmental.

* **PEACE MAKING** We all know those people who love to stir the pot. Be the one to close the lid.

* **PRESENCE** Live in the here and now, because that is all we are guaranteed.

* **PROBLEM SOLVING** Rather than dwelling on dilemmas and pondering on your problem, shift to problem solving and coming up with solutions. Ditch the blame game and adopt the make-it-happen mentality.

* **KICKING A**** The fact is, sometimes you've just got to put on your big-girl boots and go after whatever it is that you want. Stop fussing around and get going!

Eckhart Tolle wrote a book that I love called *The Power of Now*. It offers a psychological and spiritual sea change for people in reaction to the unrelenting pace of the modern world around us. It reminds you to slow down and live in the present. Honor the present. Be in the present. Like the power of the Now, there are other everyday superpowers that are totally free and available to you always. **We have superpowers inside of us that give us the ability to entirely shift our thinking from woe to wonder.** It is up to us to recognize these powers, harness them, and deploy them to strengthen and enrich our lives.

* **THE POWER OF CHOICE** This is a power you possess if you recognize it. We can choose our actions and our reactions to different events. Choices can be challenging—they can bring both sadness and happiness, stress and relief. Not everything works out. I've made sh*tty decisions, and afterward I've had to rethink things fourteen times. However, we must always appreciate that we have the opportunity to choose because it is a tremendous freedom. No, we don't always have control over outcomes, but we always have control over how we react. Each moment, we have the opportunity to make different choices than we've made in the past and better choices for our future. The choice is yours alone to stop smoking, quit drinking, spend more time with your children, take better care of yourself.

* **THE POWER OF GRATITUDE** Every single night I go to bed repeating, like a mantra, everything for which I am thankful and grateful. And every single morning I repeat the same mantra. Whatever we focus on expands. If we are focusing on what we have, we will not feel we are lacking. We will feel happier and more content. Gratitude unlocks the chains that tie us to disappointment. And neuroscience has proven that feeling gratitude stimulates the release of serotonin and dopamine in our brain, empowering us with happy chemicals and positive vibes.

* **THE POWER OF HOPE** Hope is the belief, the knowledge, the mental determination that something good will happen. Hope = possibility. Hope is an open road, a belief in blue skies ahead. Hope is necessary

to success and survival, and I believe it is directly connected to it. Without hope, what do we have? Hope will shepherd us through tough times and help us achieve goals. Hope isn't connected to wealth or power or fame, but hope is free to all—hope is where the heart is. And where there is heart, there is will, and where there is will, *there is a way*. Instill hope in your children and nourish hope in your life. Hope can be planted like a seed, so share your hope with others. The more hope we have backed by steadfast determination, the more our problems lose power.

✳ **THE POWER OF INTENTION** Everything begins in the mind. Everything must start with an idea. Setting your intentions for yourself, your life, your family, your work, your health, gives you a direction. You have the power to control your mind, where it goes and what it focuses on, and to determine what it wants. We create who we are through our intention, our vision, our actions, and our choices. But it all starts with the conscious intentions we set. If you don't determine it for yourself, others will determine it for you.

✳ **THE POWER OF WORDS** Words have so much power. Words have the power to inspire or tear down. By simply choosing different words,

an entire activity can change from negative to positive or vice versa. Regina Brett, whose book and life lessons took the Internet by storm, made a strong impression on me. Instead of thinking in terms of what you "have to" do, she suggests focusing on what you "get to" do.

I have to go to the gym. *I get to go to the gym.*

I have to pick up the kids. *I get to pick up the kids.*

I have to cook dinner. *I get to cook dinner.*

I have to go to work. *I get to go to work.*

It's such a simple word swap, but the change in perspective is powerful. And we choose those same words with our kids too. We'll say, "Get dressed please, let's go, you get to go to school" or "C'mon, you get to have soccer practice now." And so on. The emotions around the event shift from negative to positive. The baby bottle goes from being half full to half empty, with the change of a verb. As Henry David Thoreau said, "It's not what you look at that matters, it's what you see."

We have the power to choose language that lifts us up rather than weighs us down. Choose the language of love, not words that wound.

Being a mom has taught me so much about myself as a woman and what I'm capable of. What excites me the most is to watch my kids grow into the people they are going to become and to know my husband and I had a part in that.

—VANESSA LACHEY

With my forty-fourth birthday just recently behind me, I decided to challenge my-self to write down forty-four ways that I've learned to keep it real, stay grounded, and focus on what's most important:

1. **IT'S OKAY TO BE STRONG, IT'S OKAY TO BE WEAK.** Our society praises people, women and men, who are strong, bold, brave, and en-during. While this can be positive, sometimes the effort it takes to "act" strong is simply too much and eventually breaks us more. It's okay to admit vulnerability, too. Being vulnerable allows us to be true to our-selves, honest with others—and to be all that we are.

2. **SHOW PEOPLE YOU ARE GRATEFUL.** Thank your friends, thank your family, thank your babysitter, thank your coach—thank people when-ever you have the opportunity. Don't let good deeds go unnoticed—you have no idea how valued those two simple words are.

3. **CHALLENGE FIXED PERCEPTIONS.** Try to see the other side of situa-tions before you seek to defend your point of view. Yes, step outside your box and look around. You might see something you've been missing.

4. **LEAVE THINGS BETTER THAN YOU FOUND THEM.** This is a lesson I teach my children daily, and I promise you, it doesn't always go well. But I don't give up on it. We didn't have a lot growing up when I was young, so I was taught to take care of my things—all my things. I am teaching my children the same. And not to just treat their things with respect but also to treat others' things with respect. When they have a playdate at a friend's house, they know they have to clean up their toys and leave them just the way they found them—or even nicer than before!

5. **GIVE WHAT YOU CAN GIVE.** Some people can give money. Some peo-ple can give time. Some can give their talent. Every single one of us has something we can give. And giving releases natural endorphins in the body, creating what's known as the "helper's high."

6. **BE THE BIGGER PERSON.** *When they go low, we go high.* Famous words from former first lady Michelle Obama. It's true. Ditch the drama, float above the fray, and seek solutions rather than seeking to stir the pot.

7. **TAKE TIME OUT.** We are definitely overstimulated, and science tells us this. Stop rushing around. Occasionally slow things down. Take deep breaths.

8. **LEAD WITH LOVE.** I saw Dwayne Johnson (aka the Rock) interviewed on *Oprah's Master Class*, and he said something that was so moving. Talking about his daughters and what he wanted to teach them, he said he wanted them to learn to "lead with love." It's so easy to lead with fear, to be afraid and to teach your kids to be afraid, but he said that he tries not to do that. Instead, give your children the confidence to love, to trust, to try, to go for it, and to be brave.

9. **KEEP LEARNING.** I've always wanted to learn Spanish—and now I finally am. Keep your inner fires alive by continuing to feed them.

10. **ENJOY MORE, WORRY LESS.** I went to a coffee shop the other day and taped to the packaging around my sandwich was the message: "Enjoy more. Worry less." For a mother of three, that's easier said than done. But as the Dutch World War II activist Corrie ten Boom writes, "Worrying today does not empty tomorrow of its sorrow, but empties today of its strength." Worry is an empty emotion that accomplishes nothing.

11. **FIND <u>YOUR</u> FREEDOM.** When can you live and feel free? Is it when you sneak away to read a book? When you paint? When you write? When you dance or when you sing? Sometimes we get disconnected from the things that make us feel free. It's important to reconnect with these freedoms *and let yourself simply be.*

12. **ASK BETTER QUESTIONS.** Ask yourself what you have rather than what you don't have. Ask yourself what you can learn from an experience rather than asking "why me?" Ask yourself how you can improve a situation rather than dwelling on the dilemma. Improving our lives often lies in editing our own personal Q&A.

13. **COMMAND RESPECT, DON'T DEMAND RESPECT.** The way you treat yourself and others sets the standard for how others will naturally treat you. If you respect yourself and you respect others, respect will be given in return.

14. **CHALLENGE YOUR OWN SELF-LIMITING BELIEFS.** "I'm not smart." "I'm not adventurous." "I'm not [*fill in the blank*]." Whatever it is that you constantly tell yourself, *challenge it*. You can be anyone you want to be, but that starts with challenging your fixed mind-set.

15. **SAY BUH-BYE, BAE.** There are times when a romantic relationship, a friendship, or a job has overstayed its welcome in your life or in your heart. Maybe someone did you wrong. Like really, really wrong. Or maybe you did yourself wrong. Cut the cord, say *adios*, and set yourself free.

16. **ESTABLISH YOUR PRIORITIES.** Have them, identify them—write them down—and focus on them. The other stuff doesn't matter.

17. **GOTTA HAVE FAITH.** George Michael sang it best. Faith is essential to life. Before anything will happen, you must believe it can happen.

18. **POLICE YOUR PATTERNS.** We have positive ones . . . and bad, crappy ones. Patterns are just programs we have set with ourselves. Break the pattern and reprogram. Take inventory of your bad habits, write them down, and replace them with better ones. Your habits eventually add up to your life—how you spend your time and what you do.

19. **POINT YOURSELF IN A DIRECTION.** Even if you don't know where you are going, still point yourself somewhere. We often don't really face a direction but rather we sit cross-legged waiting for something to happen. Point yourself in a direction; any direction is always better than forever running in place.

20. **DIRECT YOURSELF, DON'T DISTRACT YOURSELF.** Today more than ever, there are endless time suckers. Identify them and get rid of them. They are just in the way of what you really want.

21. **ACT, DON'T OVERREACT.** This is something that I have really had to work on. In the past, when Scott and I disagreed on something, we massively disagreed. So I have been working on cultivating calmness and self-control.

22. **COOPERATE, DON'T COMPETE.** Sharing yourself with others does not diminish you. In fact, cooperation and social bonding is in our DNA—we are programmed to feel good after cooperating.

23. **SPEAK UP, DON'T SHRINK UP.** We women are notorious shrinker-uppers! We so often don't speak up for ourselves—whether it is at work or wherever. Take back your power and learn to stand firm in your passions and to confidently advocate for yourself as much as you advocate for others.

24. **TRAIN YOUR BRAIN.** A great book explores this: *Change Your Brain, Change Your Body.* Cravings can be controlled in the mind. Motivation can be controlled in the mind. And simple mental exercises can encourage a positive mind-set. Let's train our brain in good habits rather than bad.

25. **DON'T USE YOUR KIDS (OR ANYTHING ELSE) AS AN EXCUSE.** For those of us who have children, you know your kids are always your back pocket excuse for getting out of things and often for the way you act: "I'm sorry I haven't called, I've been so busy with the kids." While sometimes they are a legit excuse, often they are just your cheat for not doing something you promised you'd do.

26. **BE WHAT YOU WANT TO BE.** Do what you want to do. If you want to be a painter, *paint.* If you want to be a writer, you must write. If you want to be a pilot, take flying lessons. There is no magic pill or secret formula much beyond this. Start now.

27. **YOUR POTENTIAL IS ONLY AS LIMITED AS YOUR VISION.** Envision what you really want because you just might get it. There is no reason to sell yourself short just because you think it's easier to reach.

28. **WILL IS STRONGER THAN SKILL.** Gandhi said, "Strength does not come from physical capacity. It comes from indomitable will." I was never the smartest, but if I want to do something, I will bear down to do it! Capability is in the mind of the beholder.

29. **NOTHING BEATS A PEACEFUL HEART.** Believe it or not, being a good person, standing up for yourself, and living your life with integrity and honor is the best sleeping pill you'll ever take.

30. **TEACH EMPATHY.** Around the holidays, we clean out the kids' old toys and set them aside for children who don't have anything. We talk about it with them and teach them about giving back. We make it a conversation at the dinner table.

31. **ROLL WITH THE PUNCHES.** You cannot control everything. There are times when the outcome will not match your desires. When we stiffen up and don't go with the flow, the punch lands that much deeper.

32. **BE ABLE TO ACCEPT CRITICISM.** Take a breath and listen to what people are saying. Be less defensive and more discerning. If a criticism is useful to you, take it in, apply it, and improve. If it isn't useful, let it go. Don't let it fester.

33. **SPEAK UP BEFORE YOU BLOW UP.** Have a conversation regarding a difference of opinion before it turns into a collision.

34. **REVIEW AND REVISE.** Aka "the debriefing." Sometimes we have to have a debriefing with ourselves. We have to take a look at our day, our week, or something that happened, maybe that we weren't proud of, and think about how we could have handled that differently. We also need to do it in a positive way. Review things that went well and maybe even pat ourselves on the back!

35. **DEADLINES ARE A DO.** Deadlines will make you more productive. Sometimes I have to set deadlines for even the simplest of to-dos. Give yourself deadlines, big and small, and especially for those hard-to-reach tasks that you simply can't bring yourself to do.

36. **LEARN TO DELEGATE.** Ask for help and learn to assign responsibility to your family and those around you. Use modern technology to help you too.

37. **GO THE EXTRA MILE.** Don't half-a** anything that matters. Period.

38. ATTITUDE IS EVERYTHING. We truly don't know what is going to come our way—good, bad, or otherwise. We don't have control over a lot of things in our lives. But we do have control over how we react and our attitudes toward our experiences.

39. BE YOUR OWN BESTIE. Get out of your own way. Instead of being your own worst enemy . . . why not be your own best friend?

40. LOOK PEOPLE IN THE EYE. Look children, grandparents, friends, lovers—the cashier at the grocery store—in the eye. It's a sign of respect, presence, and equality. It matters and it means they matter and you matter. We all matter.

41. IT'S WHAT YOU DO, NOT WHAT YOU SAY. This is always a good reminder. Actions speak so much louder than words.

42. STICK WITH SOMETHING. ANYTHING! Find one thing you love to do and give it your all. Whether that is yoga, martial arts, learning an instrument—there is a tremendous sense of accomplishment and pride when you know how to do even just one thing well.

43. BE CONSISTENT. If you want people to trust you, believe in you, help you, and respect you, don't be all over the place. Be consistent. Be someone they can count on. Be able to count on yourself.

44. GO ON A SH*T-FREE DIET. Advice courtesy of writer and essayist Anne Lamott: Stop taking sh*t from people. If you don't want to do something, stop telling yourself you should, feeling guilty, and then doing it anyway. Just don't do it. I've been on a million and one diets in my life, but it wasn't until I got to this age that I actually tried this one. Stop taking sh*t from people and wasting your physical time and your spiritual energy.

WHAT MATTERS MOST

Looking back on a life can sometimes be like looking back on past lives lived—moments that happened ten, fifteen, maybe even twenty years ago can still send shivers up your spine, warm your heart, or bring tears to your eyes despite time and distance. **What matters most is the here and now.** My friends. My family and my community. And my work, because it helps support my family and keeps me feeling productive, accomplished, connected, and contributing. And of course, my babies. **What matters most to me is raising children who contribute and who do so with integrity, confidence, and compassion and a strong moral character and work ethic.** And while some of this can be taught within the family and by those we're closely connected to, many of life's lessons must be learned through experience. Sometimes I don't know if what we are doing is right, but all Scott and I can do is our very best. These are the talismans of my life today. Juggling them all is my

personal definition of success for who I am today. It's not always balanced and it's not always controlled, but it's everything I love. These are my priorities and these are what give me a sense of happiness, purpose, peace, security—and well-being.

What matters most to me is also found in the surprises that life presents and in the lessons that we learn. It's in all those moments we seek and find—and it's also in the moments in between. In the hustle and bustle of life, we can forget that it's also in these spaces and places where life has time to breathe that magic can happen. Writing this book is so fulfilling, because I get to explore the people, places, and things that truly mean the most to me. I want a happy, healthy home—because of its contents: these wide-eyed, soft-skinned (or furry!) mini-people inside. This book is a way for me to record some of these special moments and, in many ways, is my love letter to my family and to myself. **It's my reminder to breathe deeply, love completely, and live fully.** Not just for the big moments but also for the small.

Enjoy the calm chaos—treasure each moment and the "happy mess." Because the truth is, *supermommas*, you will miss it if it's gone.

acknowledgments

Everyday Chic wouldn't have been possible without this crew.

Special contributors I'd love to thank: Amy Neunsinger and Andrew Mitchell, for the beautiful cover and photography. Gia Canali and Erica Hampton, for always capturing the most precious moments with my family that are seen throughout the book.

Thank you to all the amazing experts and friends who have contributed to the making of this book. You have taught me so much over the years. I love making memories with each of you.

Thank you to Jeanne Kelly, who styled our recipes to picture perfection. To Dana Slatkin, Pamela Salzman, Michael Drabkin, and Catherine McCord, who have taken a girl who doesn't know how to cook and shown her the ways. To Elissa Goodman and Kelly LeVeque, my health gurus.

To Mimi Brown, Annie Belanger, and Benton Weinstock, who make my world and my tablescapes beautiful. To Michelle Pesce, my favorite DJ and the one who kept my wedding rocking well into the morning. To Nicola Vruwink, whose creativity brings magic to our lives. And to Stefanie Cove, my absolute inspiration: You've taught me what it means to be a hostess with style. You are my entertaining everything.

To Clea Shearer and Joanna Teplin, who made my home (especially my pantry) look like an absolute dream. You make me proud of my OCD. To my designing gurus Kishani Perera, Dan Scotti, Trip Haenisch, Kari Pohost, and Tiffany Harris: you've brought my design taste to a whole new level.

To my celebrity supermommas Cindy Crawford, Vanessa Lachey, Reese Witherspoon, Jennifer Garner, Rachel Zoe, and Jessica Alba: you inspire me endlessly. To Jill Spivack and Dr. Robin Berman, for being my parenting magicians.

To my loyal A team. Alissa Vradenburg and James Adams: you are the stars in my galaxy; you are my big dipper. To Andy McNichol: this book would not have

happened if it wasn't for you. To my editors, Carrie Thornton and Jessica Sindler, for your support and endless source of creativity.

Thank you to Heather Colcord for keeping it all together. Your obsessive sense of organization makes my world go round. To Courtney Cohen, my website and social media guru: you are the Dorothy to my Jerry Maguire. You complete me and all my sentences.

Nikki La Rose and Joey Maalouf, my glam squad: you *always* make me look my best . . . even when I'm running on only a few hours of sleep and with one child on my lap at all times.

To my girl tribe who support me endlessly: Michelle Lokey Carlson, Jessica Berg Prosser, Lauren Kucerak, Emese Gormley, Danielle DeMarne, Mimi Brown, Leigh Kilton Smith, Leigh Crystal, and Robyn Casady.

To Tracy O'Connor, we did it again! You're the Sasha Fierce to my Beyoncé. Thank you for making the words on the page come alive and creating the magic in this book.

My parents, Dorothy and Jim; my brother and sister-in-law, Todd and Alexis Sims; my niece and nephew, Merritt and Greyson: Thank you for always believing in me. I love you more than words can say.

To my Tribe of Five: My husband and partner, Scott Stuber, and my three beautiful babies, Brooks, Scarlett, and Grey: You are my everything and my magic. I love you to the moon and to the stars. And to my furry girls, Poupette and Chloe . . . and my Dukie up in heaven.

And finally to *all* my friends, fans, and the entire supermomma tribe: You make me feel supported and loved. I am forever thankful.

credits

Photographs on pages 18, 26, 32, 55, 57, 59, 65, 69, 78 (right), 94 (bottom), 97, 99, 113, 135 (top), 136, 160, 161, 252, 258, 269, and 270 all courtesy of Molly Sims.

Photographs on pages 1, 2 (bottom left), 3, 4, 5, 11, 60, 64, 76, 77, 78 (left), 79, 81, 83 (right), 84 (top), 85, 87, 92, 93, 94, 114, 123, 135 (bottom), 151, 162, 164, 165, 171, 244, 250, 251, 261, 267, 272, 274, 276, 277, 279, 280, 282, 285, 289, 290, 291: Gia Canali; 2 (top left): Brian Wright; 14, 54, 62, 115, 168, 174: Allen Daniel Photography; 10, 16, 17, 20, 22, 24, 27, 28, 29, 30,31, 36 (left), 38, 39, 40, 42, 45, 47, 48, 49, 52, 53, 56, 64, 72, 74, 100, 101, 103, 110, 112, 113 (top), 128, 133, 138, 139, 148, 150, 154, 178, 182, 189 (bottom left & right) 201 (top), 201 (bottom), 226 (left & right), 227 (left & right), 229 (top & bottom): Amy Neunsinger; 2 (right),25, 34, 35,50, 56, 66, 67, 84 (bottom), 90, 95, 105, 106, 144, 145, 147, 149, 157, 185, 187, 196, 204 (top), 221, 224 (top left & right), 249, 254, 255, 256, 259, 262: Erica Hampton; 36 (right): Elissa Goodman; 37: Kathryn Page; 86, 96: Braedon Flynn; 108, 109 (middle): Alexander Bauzon; 109 (bottom right), 122 (top left & right),189 (top left and right), 231, 233, 236, 237, 238: Jean Randazzo; 141, 201 (middle): Joe Schmelzer; 188, 203, 204 (bottom): Troy House; 190 (top left), 190 (top right), 194 (bottom), 199, 205,208, 210, 211 (top), 212, 213, 215, 217, 218, 219, 220,228: Peter Murdock; 190 (bottom left), 190 (bottom right), 193, 194 (top), 197, 200, 216: Richard Powers; 211 (bottom), 240: Justin Coit.